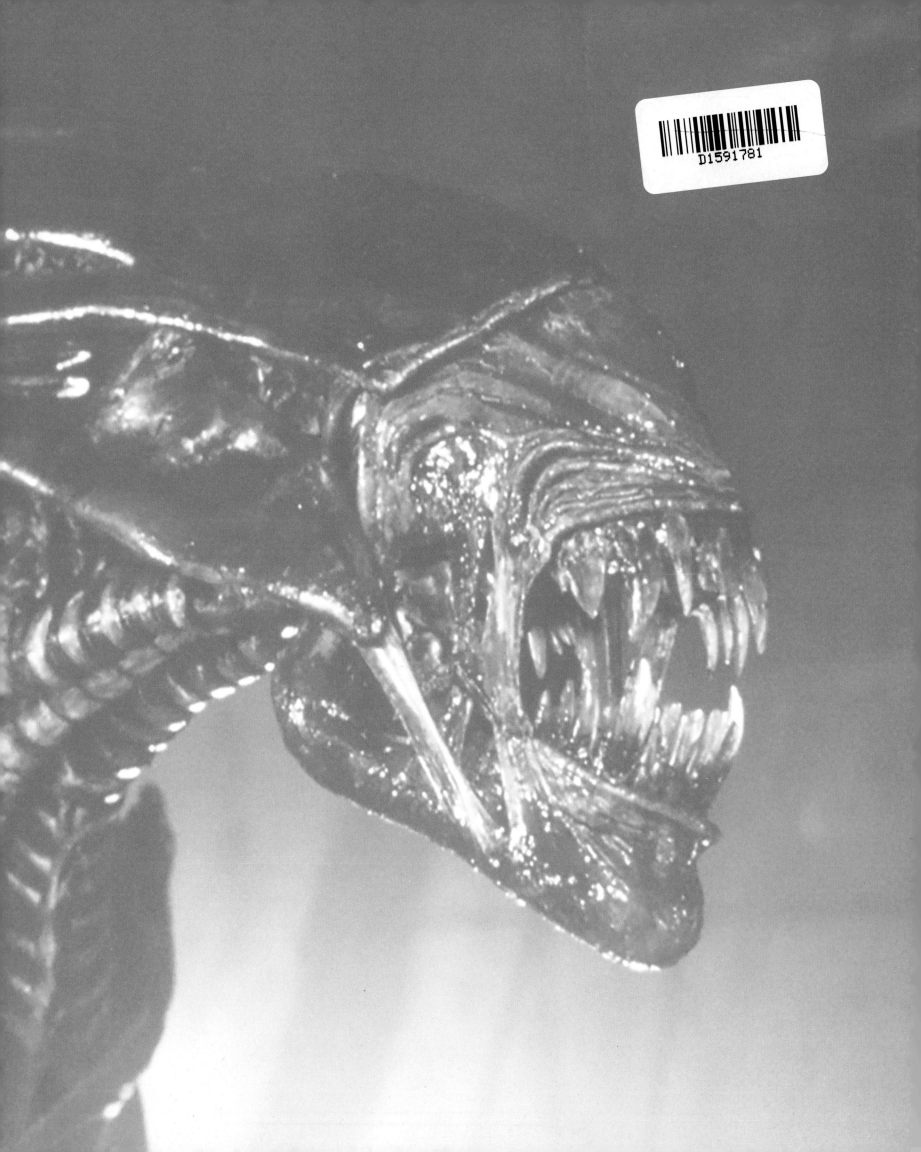

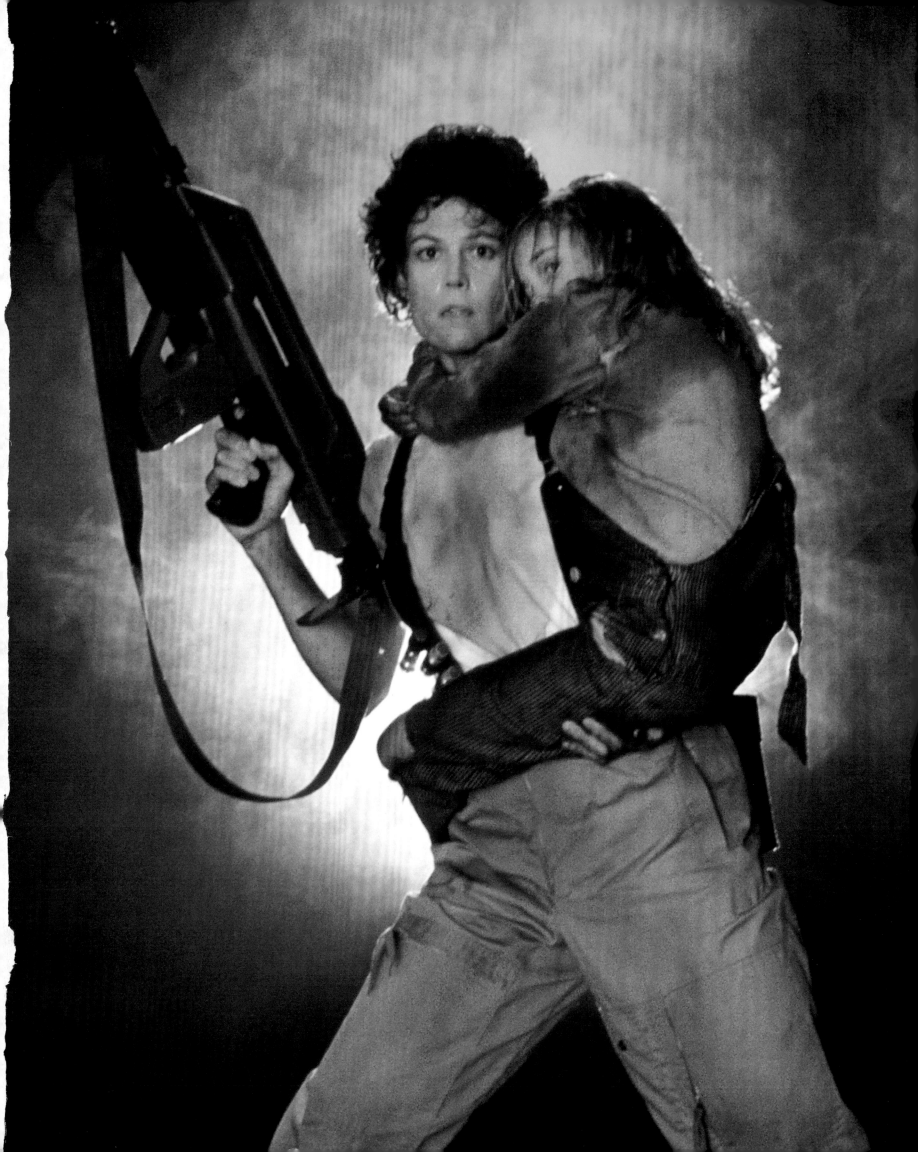

ALIENS – THE SET PHOTOGRAPHY
ISBN: 9781785651496

Published by Titan Books
A division of Titan Publishing Group Ltd.
144 Southwark St.
London
SE1 0UP

First edition: July 2016
10 9 8 7 6 5 4 3 2 1

To receive advance information, news, competitions,
and exclusive offers online, please sign up for the Titan
newsletter on our website: www.titanbooks.com

Did you enjoy this book? We love to hear from our readers.
Please e-mail us at: readerfeedback@titanemail.com or
write to Reader Feedback at the above address.

A CIP catalogue record for this title is
available from the British Library.

Printed and bound in China.

The author wishes to thank Andy Jones, Beth Lewis,
and Laura Price at Titan, and Josh Izzo and Nicole Spiegel
at Twentieth Century Fox.

Special thanks to Carrie Henn and Jenette Goldstein.

Every effort has been made to source and contact copyright
holders and those requiring likeness approvals. If any
omissions do occur, the publisher will be happy to give full

ALIENS™

THE SET PHOTOGRAPHY

BEHIND THE SCENES
OF JAMES CAMERON'S
1986 MASTERPIECE

SIMON WARD

TITANBOOKS

CONTENTS

CARRIE HENN: MEMORIES OF FILMING

THE KEY ROLE OF REBECCA 'NEWT' JORDEN IS PLAYED BY CARRIE HENN IN
HER ONE AND ONLY FILM ACTING ROLE. HERE SHE EXCLUSIVELY SHARES HER
MEMORIES OF FILMING THE SCIENCE-FICTION CLASSIC.

The stars just aligned.

We were living in the UK at the time; we had been since I was two and I loved it there. My mom used to pick me up and take me home from school for lunch, but on that day she was meeting friends in Stoke-on-Trent, so I had my lunch at school. I was eating in the cafeteria when Sarah Jackson, a casting agent, came round taking Polaroids of the girls. It didn't seem like a big deal; I didn't even tell my parents. My dad got the call: "They're really interested in Carrie's picture. Would she like to audition for the movie?"

My dad said, "Would you be interested?"

"Why? It's not like I'm going to get it."

I went and auditioned anyway, along with some friends of mine. It was in London, so the girls' families all got taken on a tour of the city while we were auditioning at the studio. My brother Chris was just in the corridor with mom, and they called him in to do the scene with me. They knew what they wanted, but hadn't found it yet—all the child actors from adverts would deliver their lines and give a big smile. Newt isn't a happy child.

After the audition they had me and a couple of other girls from my school read again, then they told me they were flying Sigourney over by Concorde and they wanted me to audition with her. *Ghostbusters* had just come out so I was like, 'I've got to get an autograph book!' I asked her politely and she signed it. Within minutes of meeting her I absolutely adored her. She's amazing.

I guess by that point they were pretty sure they wanted me but just wanted to see how I worked against Sigourney. I had no idea of the magnitude of the part and didn't really know what a huge role it was; I thought it was just a small cameo bit.

We read and they called me a few days later to say I got the part. I was eight when they found me, nine when we shot, and ten when the film came out. We started in September and then my dad's mother died the following February, so we finished just before that. Then I had to do voiceovers in March and we moved back to the States in May.

Because I was a child I didn't have to be in as early as the rest of the cast and crew due to child labor laws. My day was: schoolwork, then hair and make-up, then more schoolwork. After that we'd go over to the set, run through the scenes a couple of times, then go. I would often complain on set about my homework; I would wait to do my math at the very end because I hated math and sometimes some of my friends on the set would do some of it for me, leaving me less to do myself! I loved the

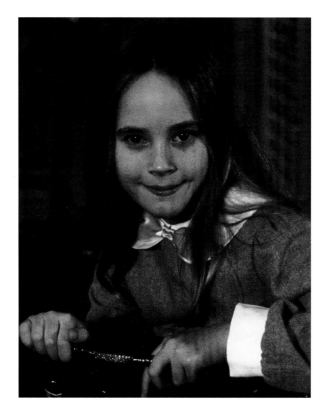

on-set tea breaks, though, because I'd get to help out doing the tea and handing out treats. At the end of the day my mom and I would run through lines for the next day, although I knew most of the lines anyway from the auditions. When we were all done I'd go for a swim in the pool.

James Cameron was always fantastic with everybody; even as a child I could see that. My dad recently told me that James had asked him at the time, "What do I do? Is there anything that would help working with Carrie?" And my dad just said, "You tell Carrie what you want and she'll do it." And I'm very much one of those people—you tell me what you want. And I did it. However, there were a few times when I'm sure the crew must have got quite frustrated with me about certain things because I was very specific about what I reacted to. There was one scene where I had to hide in the water and Sigourney comes up and I'm supposed to stick my hand up through the grate. I was laying underneath the grate and [Cameron] was up top (Sigourney wasn't actually up there yet, he was just saying her lines to me). On a cue I was supposed to stick my hands up through the bars and say my lines. And so James said, "When I say XYZ, you say your line." I said "Okay". But he didn't say it in the way he said he

LEFT: A promotional shot of Henn. CH: "I loved the dress so much I was allowed to keep it!"

RIGHT: Henn in make-up and costume as Newt, after being rescued by the marines. CH: "I think this is the first picture of me in costume with a smile that I have seen!"

FAR RIGHT: Sigourney Weaver, Henn, and Newt's precious doll (or what remains of it), Casey, in marketing materials. CH: "I was happy to lose Casey, I didn't have to worry about carrying her around anymore!"

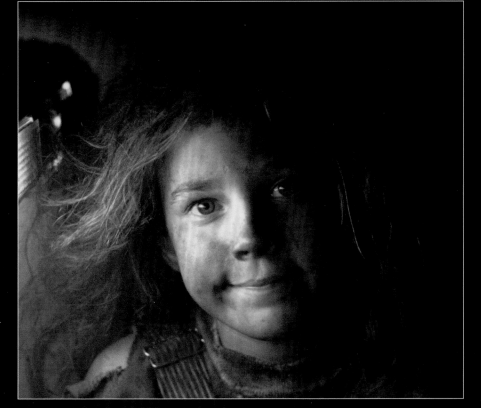
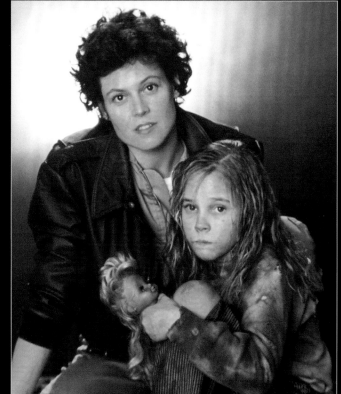
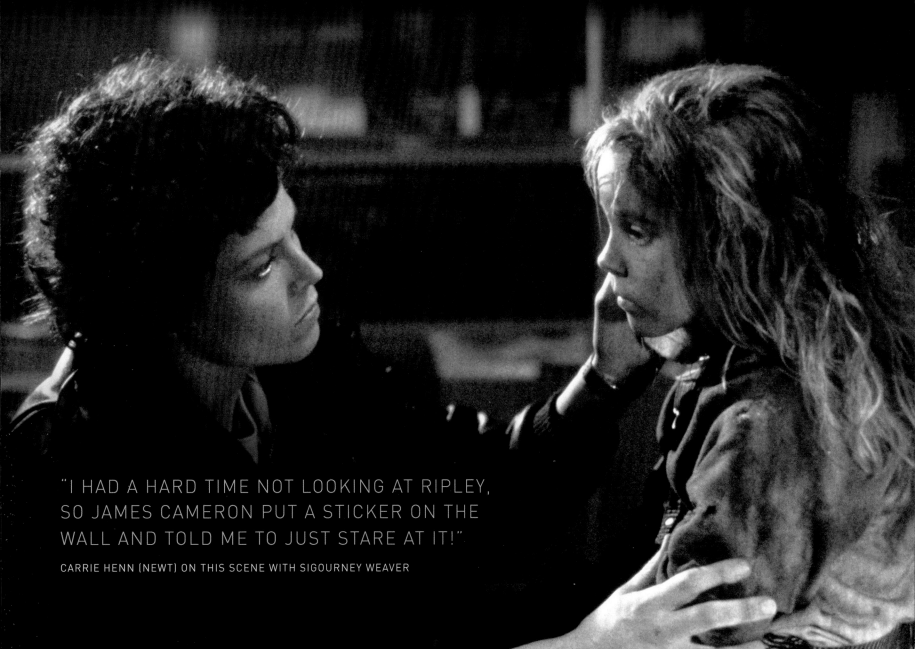

"I HAD A HARD TIME NOT LOOKING AT RIPLEY, SO JAMES CAMERON PUT A STICKER ON THE WALL AND TOLD ME TO JUST STARE AT IT!"

CARRIE HENN (NEWT) ON THIS SCENE WITH SIGOURNEY WEAVER

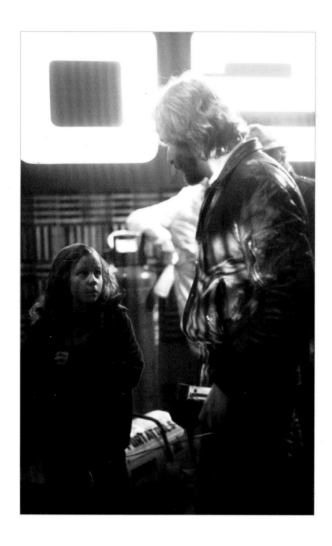

was going to say it, so I never said my line. So he said, "Why didn't you say your line?" I replied, "You never said it how you said you would". To which he could only say, "Well, I guess she got me on that one!"

He was funny, he was always trying to make me feel comfortable and if there was anything with the aliens or anything like that that might be a little bit different, he made sure he showed me what they were going to do. With the aliens, unless they were actually filming they had the heads off so they were just my friends, who were stuntmen, walking around. So it wasn't overwhelming and I don't know if it was done that way intentionally for me or if that was just the norm—I don't have any other movies to compare it to!

The marines used to run around Pinewood Studios in formation and practice running together, and I used to want to join in. I had my Cabbage Patch Kid, who was my pride and joy, so I'd run along behind them with my Cabbage Patch Kid under my arm because I didn't have a gun. They let me join in some things, so they definitely had that camaraderie.

What's interesting looking back now is that the marines all stuck together. Lance Henriksen in the movie was kind of a loner, so he was off on his own. Even Paul Reiser was a loner, and then Sigourney and I were like our own little entities as well. So the way it was on set was kind of how it was. Some of the marines I was closer to; Bill Paxton and I were very close. I had a table on set and I'd be coloring and he'd come and join me. But even in the movie he and I have a relationship, so

watching it now I definitely see how our off-screen and on-screen rapport did kind of jive to some extent.

There were so many wonderful moments, so many stories. We had a lot of fun. For the nest set, when Ripley finds me in the slime cocoon, we were on location in Acton. When we were done I tried to wash all the slime out of my hair in the trailer, but couldn't get it all out. They told mom and I they would put us in a hotel closer to the set, but we said, "Don't be silly, we'll just go back to our normal room." We got to the usual hotel and there was some big, fancy ball on—it was around Christmas time. We got into the elevator—me still in full costume— and these people in their suits and gowns got in after us. They looked at me with all this slime in my hair and scooted away to the other side! I was so embarrassed.

I was very lucky in that I got to see different sets and scenes being filmed. I didn't understand at the time how they were going to put it all together and make it look realistic, but it was really amazing to see the process and I wish I'd been a little bit older to appreciate it a little bit more. At the end of the film, when I get pulled across the ground, that secure set was massive and it was pretty tiring constantly being dragged around. It doesn't sound like it would be but it was mentally exhausting, that whole filming. They got me all hooked up on the harness and I said, being a typical nine-year old, "I have to go the toilet now." So they had to unhook me, take everything off so I could go, then I came back to do it and they finally said, "You know, Carrie, if we can get this done quick then over on such-and-such a stage they have

ABOVE LEFT: James Cameron directs Henn between takes. CH: "James was always so kind and helpful when we were filming."

ABOVE: Newt and Ripley find themselves trapped in the medical laboratory, trying to draw the attention of the marines. CH: "There were so many different parts of this scene that had to be filmed. It felt like it took days to finish it."

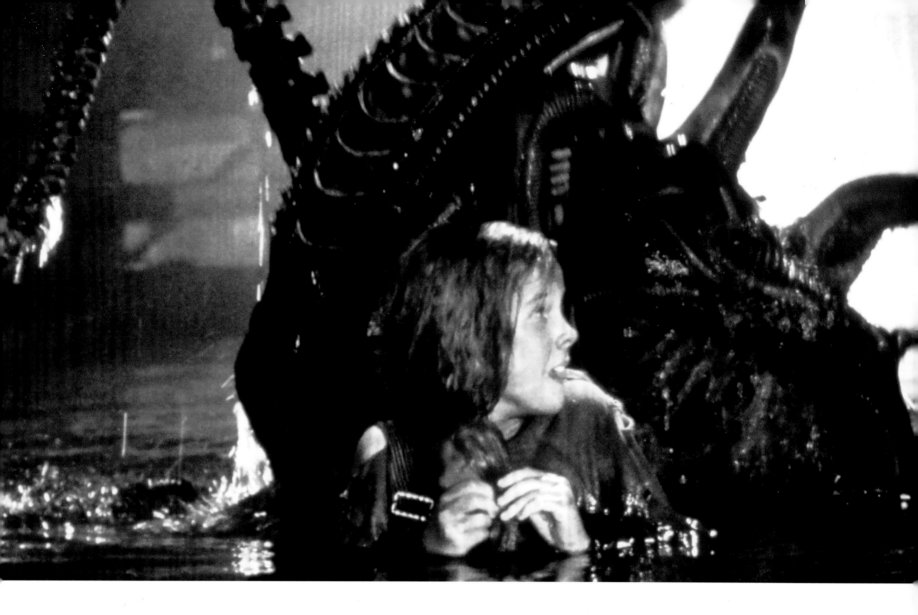

another set built…"This was where the aliens were actually flying around—it was really cool. The harness that was being used for pulling me across the ground was also the harness for flying. So they said, "If you can get this done, we'll let you go over to that set", and so I got to see them shooting and they let me fly around like Superman! Being the only child on set meant that I probably got a bit spoiled and when the shoot was finished, I don't think I really realised that it was over.

At the premiere, I was excited to see all my friends from the shoot again because we hadn't seen each other since the filming and many of the marines I hadn't seen in a long time, so I was excited just going there for that. And then I was excited because I knew a few of the other people who were going to be there, like Arnold Schwarzenegger! I was more excited about all that stuff. I couldn't attend the UK premiere, so my grandparents went in my place and were treated like royalty, so it was really special.

I didn't know quite what to expect when I went in to finally see the movie and it was neat seeing how it went from the filming to actually becoming a movie. That's when I realised, I think, that the director really makes or breaks a movie and truly appreciated what an amazing job Jim had done.

There was a scene that I had not seen being filmed where the marines are going to the medical lab and three aliens in tubes jump out. I screamed and didn't realise James Cameron was sitting behind me and he patted me on the shoulder and I screamed again because it scared me! And he said, "I didn't get you once, I got you twice in five minutes! That's great!"

"EVERYONE ALWAYS ASKS IF THIS SCENE SCARED ME... THE STUNTMAN IN THE ALIEN SUIT AND I WOULD SIT ON THE PIPES BETWEEN TAKES, DRINKING TEA AND PRACTICING OUR SWIM KICKS."
CARRIE HENN ON THE ALIEN KIDNAP SCENE (ABOVE)

I can't even describe Sigourney or our relationship. She's all class. She acted like my mother on set and a lot of the interaction was very natural between the two of us. She's just herself and so much of that is her upbringing: she's always so grounded, humble, and gracious. We met again at the *Alien³* premiere, then again a few years later for the Entertainment Weekly 25th anniversary shoot, where they got the whole cast together again. I was there with my husband and children, including my daughter, who is my clone. I told them to hang around because I really wanted them to meet Sigourney. I must have wandered off for a second because Sigourney suddenly appeared, and before she saw me she saw my daughter. She just stopped and stared, and said, "Who is this?" They said, "That's Carrie's daughter," and she immediately just started talking away to her.

We still email. My kids even send her a video for her birthday.

The memories are very vivid. It was an amazing experience from beginning to end.

Who knew it would be such a big thing 30 years later?

CAST AND CREW

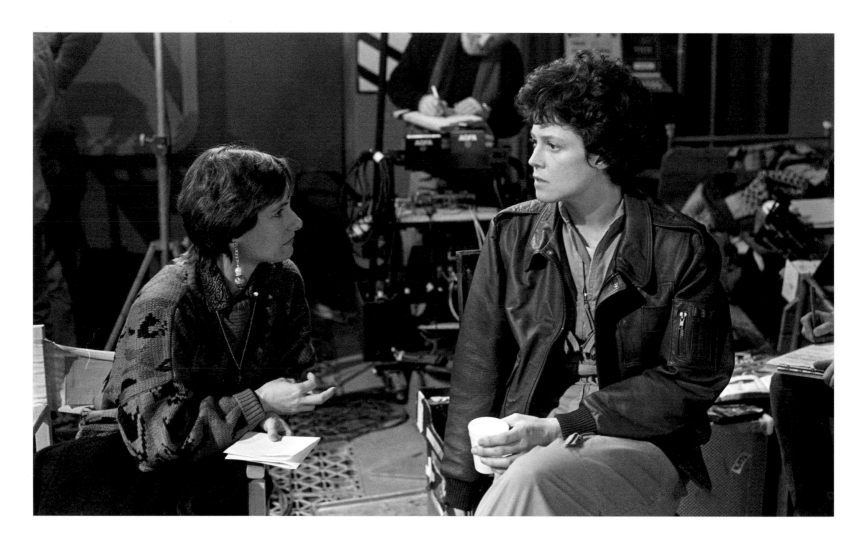

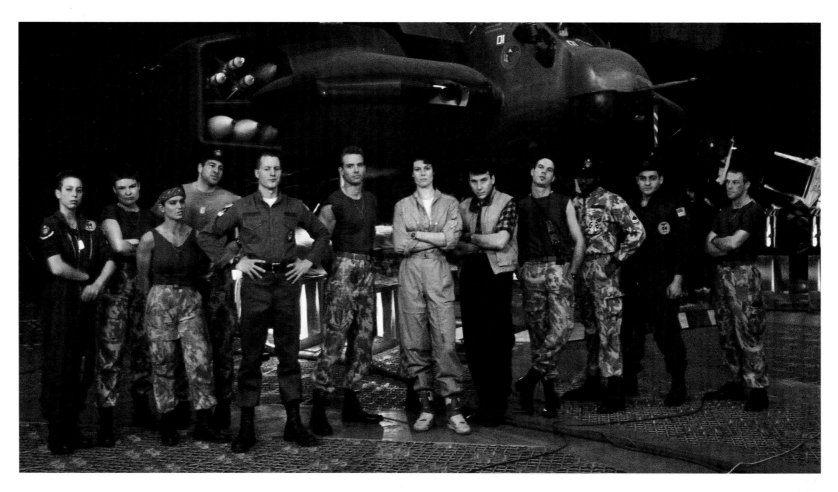

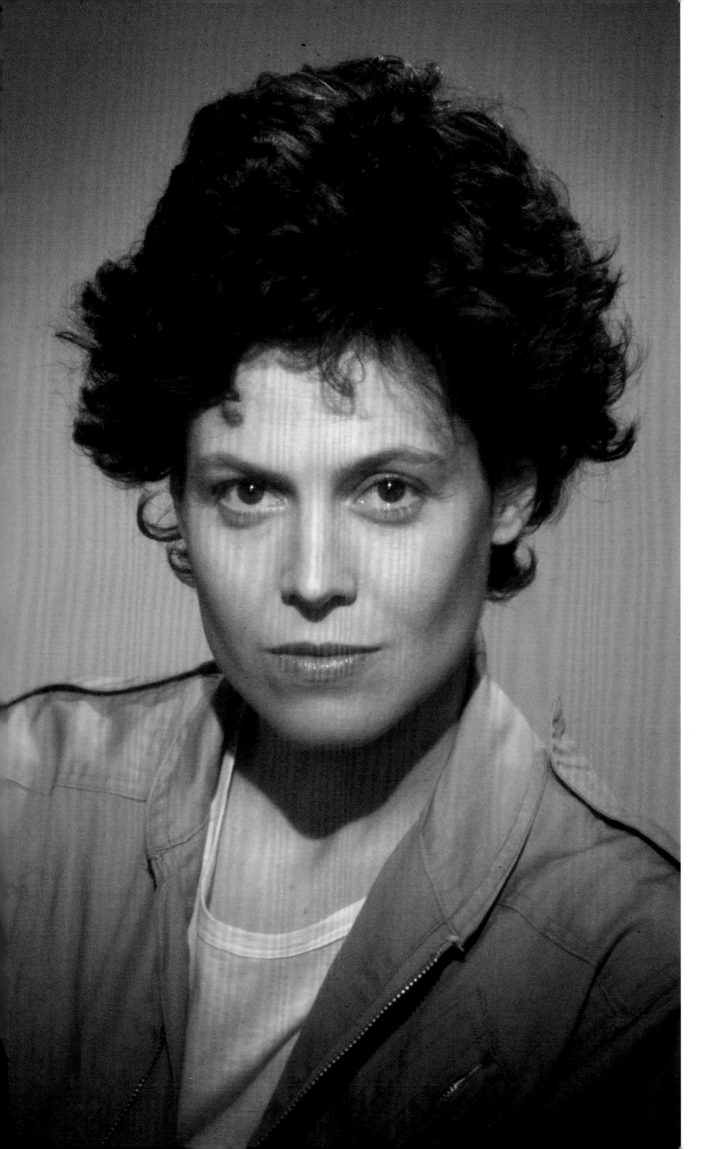

LEFT: As with the costume design throughout, Ripley wears realistic, all-but contemporary clothing. Her white t-shirt echoes the vest worn towards the climax of *Alien*—this is the same woman, but less vulnerable now and more prepared.

OPPOSITE TOP: Sigourney Weaver (Ripley) and producer Gale Anne Hurd, then-wife of director James Cameron.

OPPOSITE BOTTOM: A promotional picture of the main crew positions Ripley as the lead and Sigourney as the star, front and center, as opposed to posters and marketing for the original film, which relied less on the cast and more on the foreboding image of the egg hatching.

RIGHT: Al Matthews as Sergeant Apone. Matthews had served in Vietnam prior to his acting career.

FAR RIGHT: Jenette Goldstein won a Saturn award for her portrayal of Pvt. Vasquez.

BELOW LEFT: Paul Reiser as Weyland-Yutani company man, Carter Burke. The subtle costuming by Emma Porteous gives men's suits a very slightly futuristic feel.

BELOW RIGHT: Bill Paxton playing Pvt. Hudson, in the second of his four films with James Cameron. As with Jenette Goldstein, Paxton likewise won a Saturn award for his performance.

OPPOSITE: Rebecca Jorden, or 'Newt', played by Carrie Henn, here photographed strapped into the Armored People Carrier (APC).

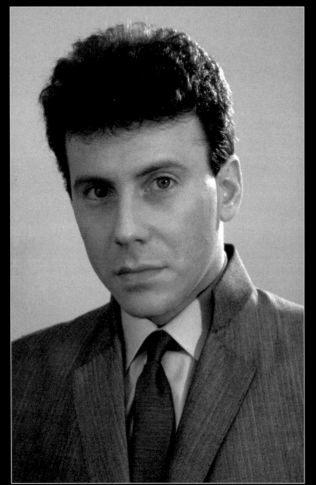

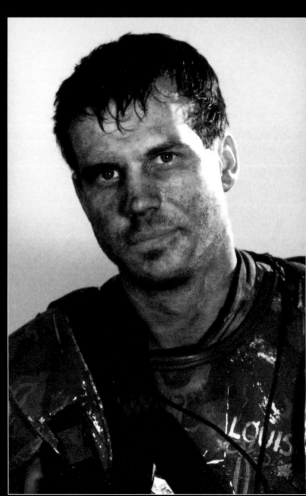

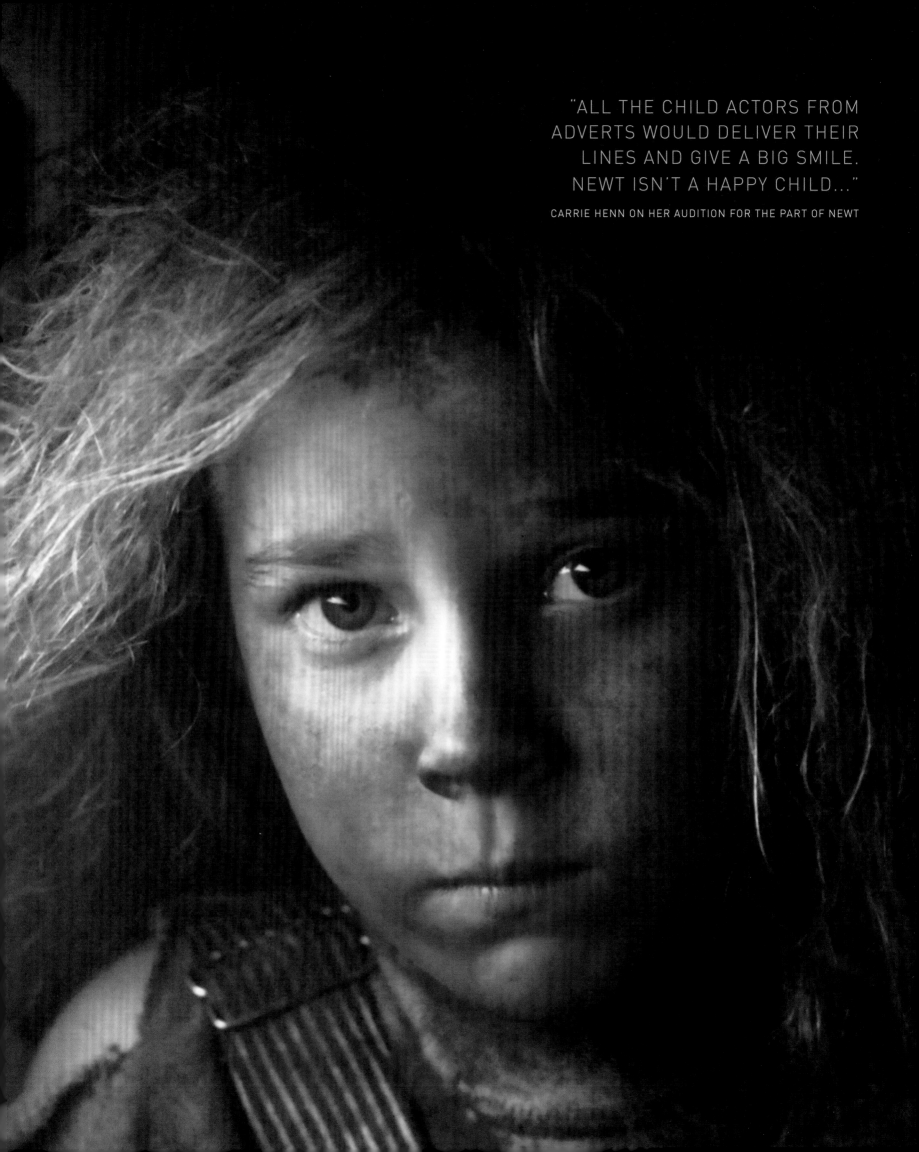

"ALL THE CHILD ACTORS FROM
ADVERTS WOULD DELIVER THEIR
LINES AND GIVE A BIG SMILE.
NEWT ISN'T A HAPPY CHILD..."

CARRIE HENN ON HER AUDITION FOR THE PART OF NEWT

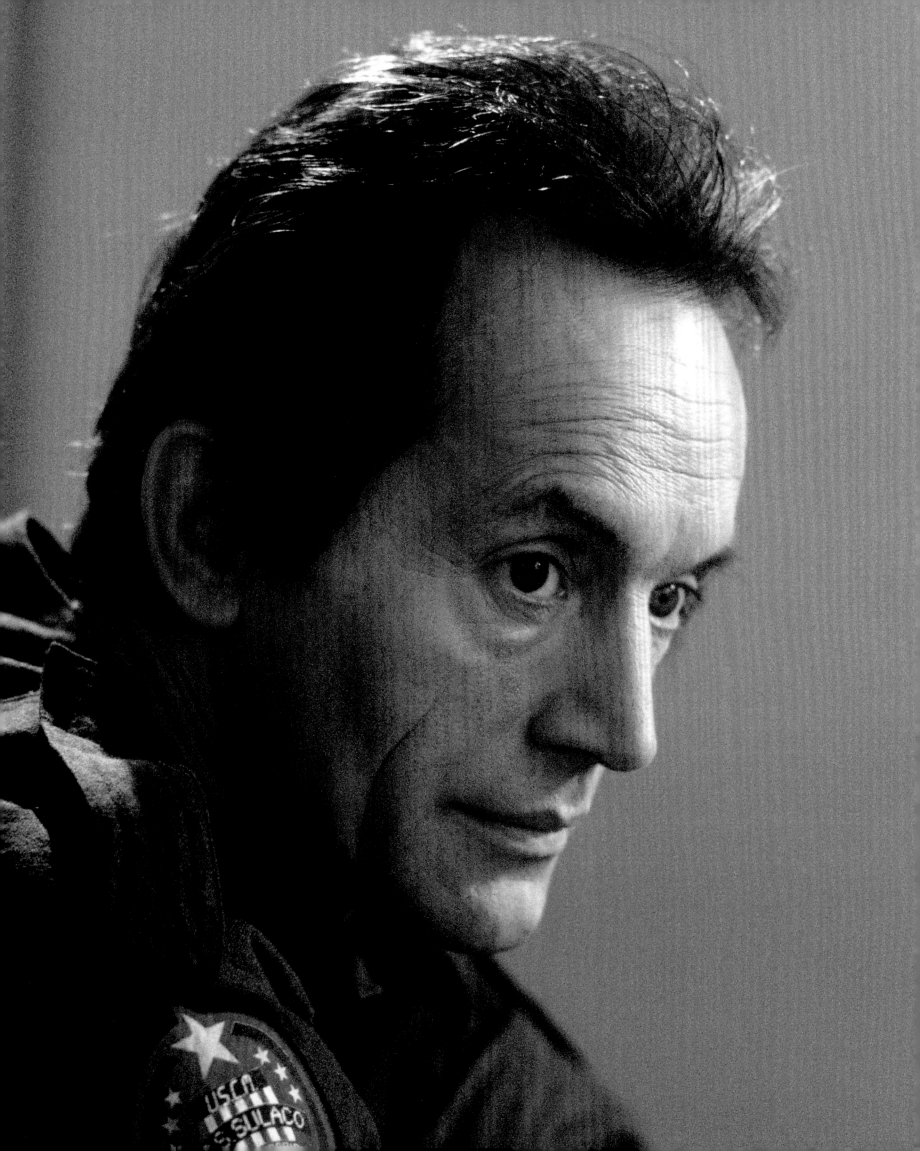

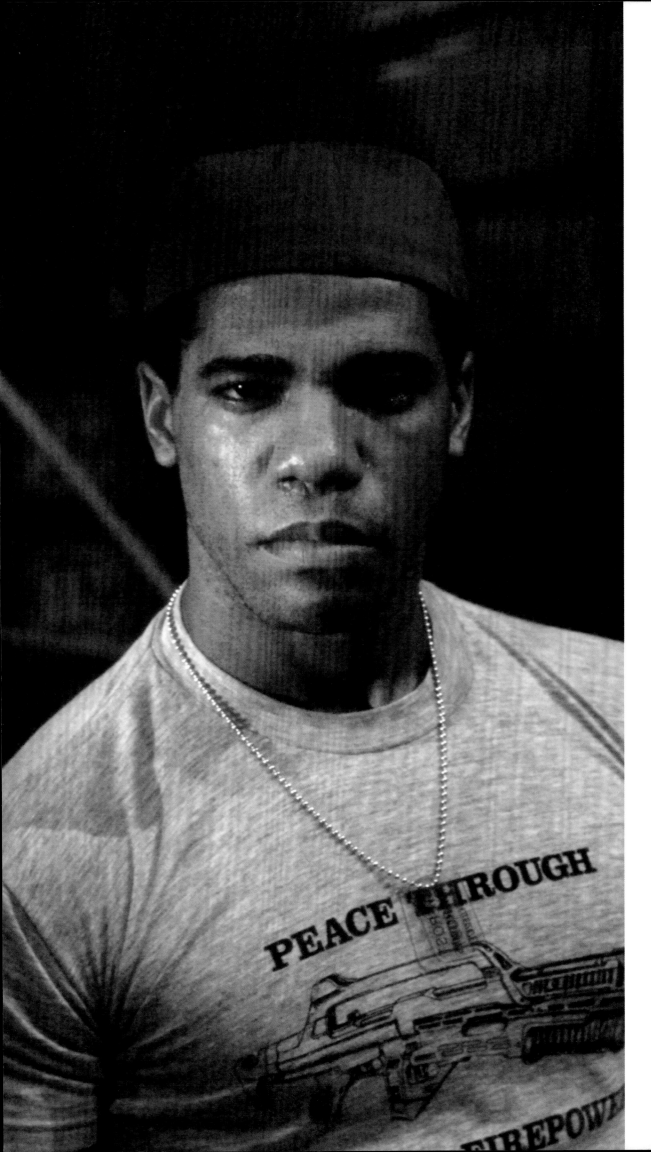

"LANCE HENRIKSEN IN THE MOVIE WAS KIND OF A LONER, SO [ON SET] HE WAS OFF ON HIS OWN."

CARRIE HENN

LEFT: Pvt. Frost (Ricco Ross) wears the bespoke Colonial Marine Corps. t-shirt, featuring a plasma rifle and the phrase, 'Peace Through Superior Firepower.'

OPPOSITE: An upgrade—in both personality and capability—from the previous film's android, Ash, Bishop is a Hyperdyne Systems model 341-B. Essayed by Lance Henriksen, Bishop prefers the term 'artificial person' to 'synthetic.'

17

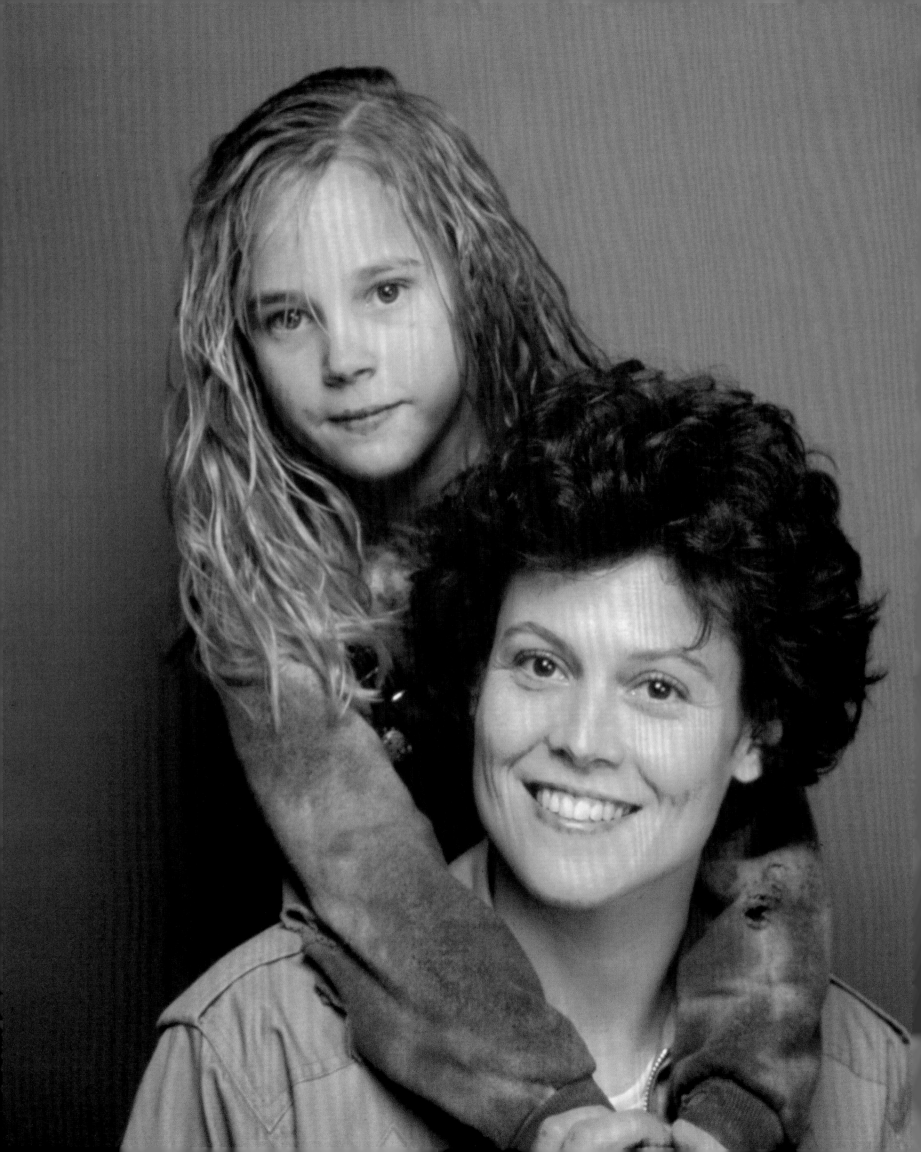

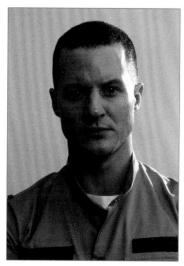

TOP: Cynthia Scott as Corporal Dietrich, the Hospital Corpsman, born 2154, died 2179.

ABOVE: William Hope as Lieutenant Gorman. Originally, Cameron had planned to cast mostly English actors as the Colonial Marines, but eventually chose a predominantly American troupe, along with two Canadian actors, including Hope

LEFT: In his second of three films for James Cameron, Michael Biehn plays Cpl. Dwayne Hicks. Biehn replaced James Remar in the role after two weeks of filming.

OPPOSITE: A publicity photo of Henn and Weaver. It had been a long (in Hollywood terms) seven years since the first *Alien* movie, so Weaver was placed front and center throughout the marketing campaign and established as the face and lynchpin of the franchise.

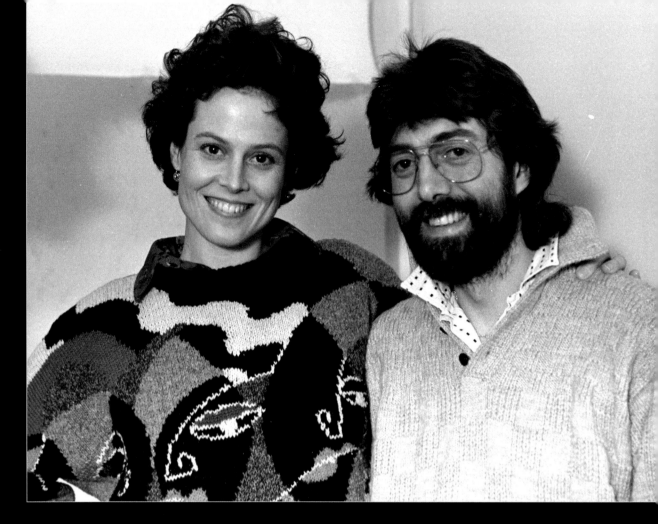

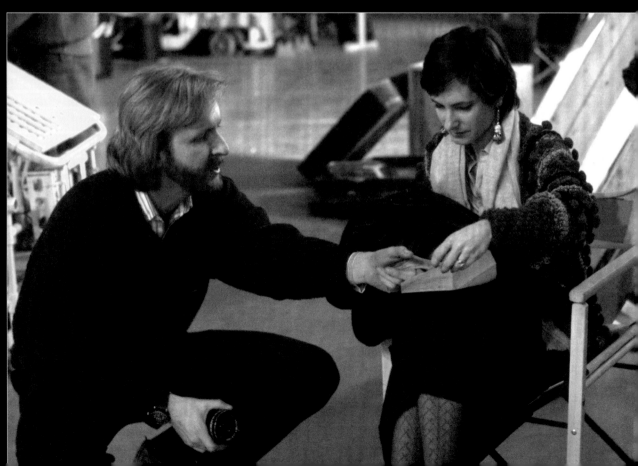

TOP: Alien effects creator and second-unit director Stan Winston.

ABOVE MIDDLE: Director of photography, Adrian Biddle.

ABOVE: Production designer Peter Lamont.

ABOVE RIGHT: Sigourney Weaver with make-up supervisor Peter Robb-King.

RIGHT Cameron and Hurd on the Sulaco set.

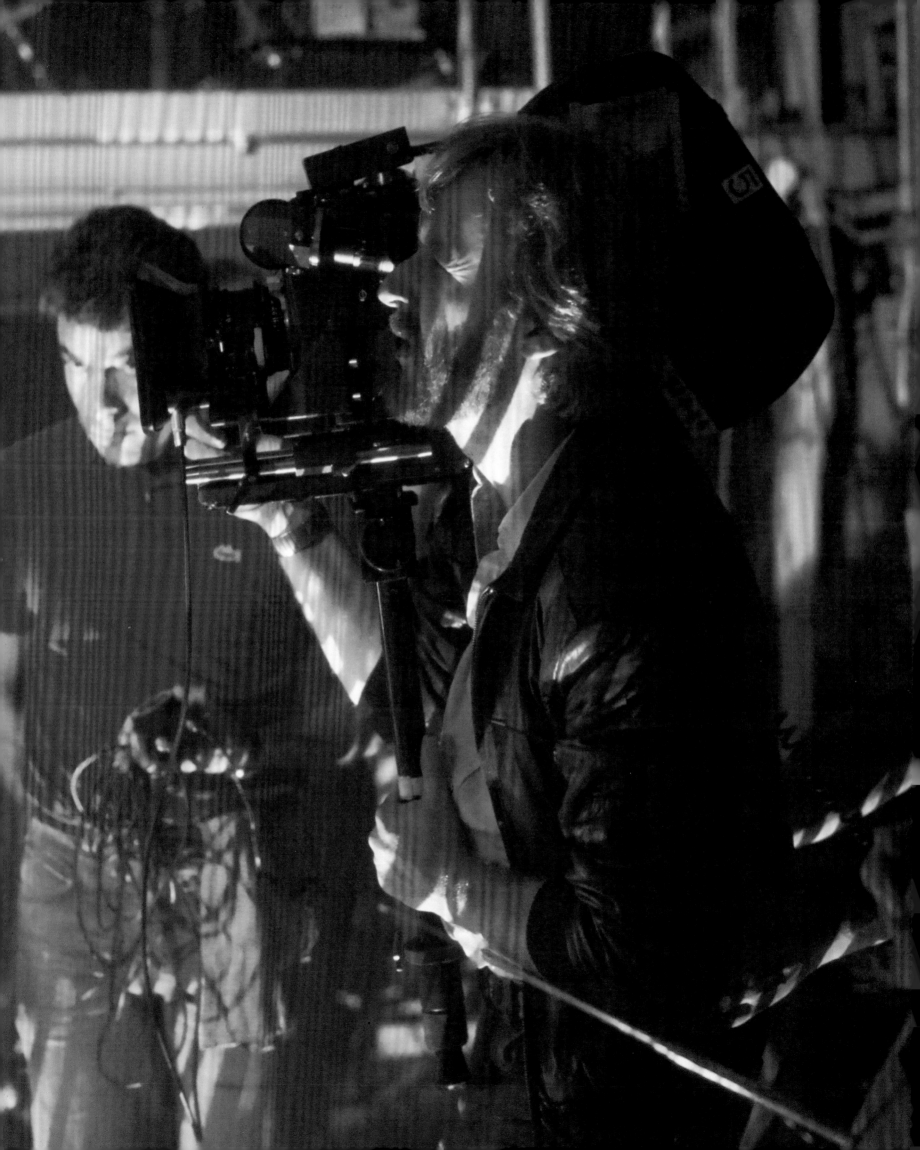

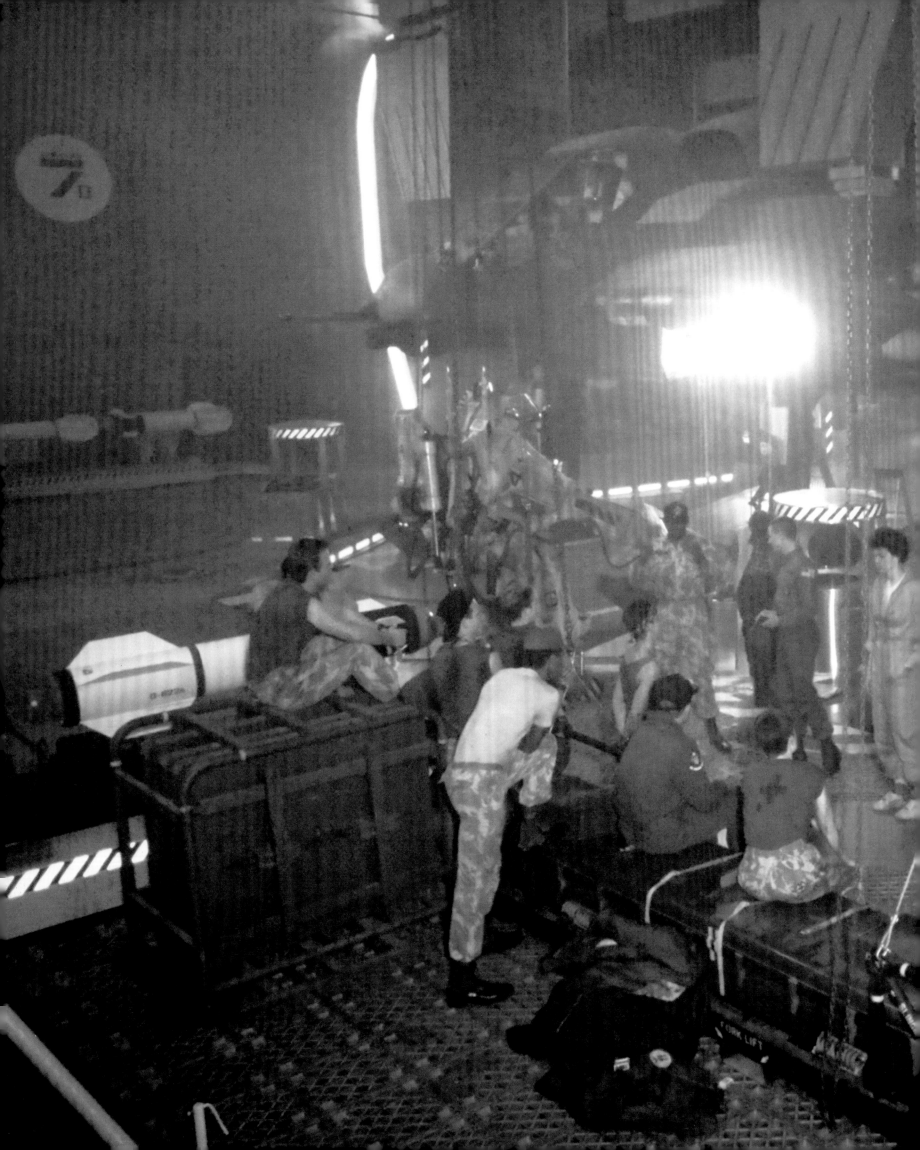

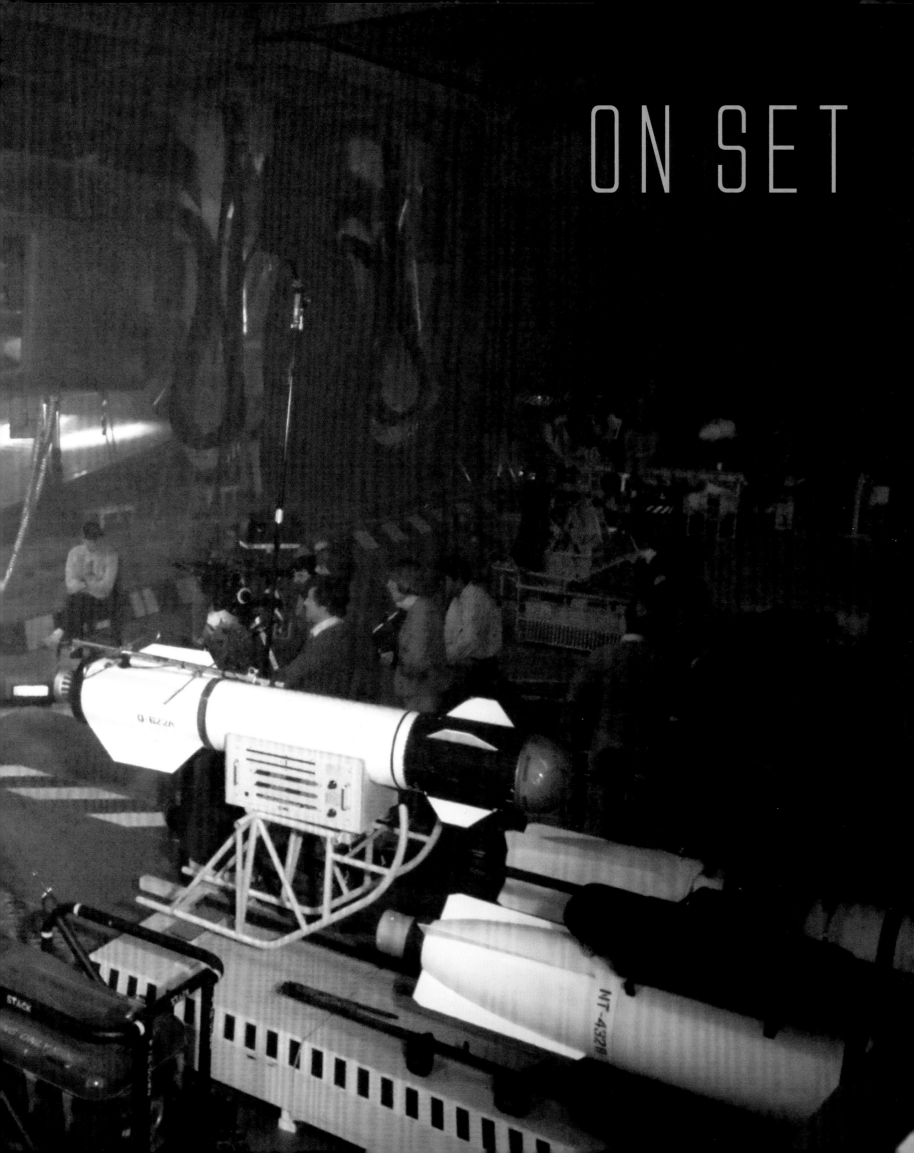

RIPLEY'S AWAKENING

WARRANT OFFICER ELLEN RIPLEY, NOC 14472, THE ONLY SURVIVOR FROM THE *NOSTROMO*, IS FOUND BY A SALVAGE CREW IN DEEP SPACE AND TAKEN TO GATEWAY STATION, OWNED BY THE WEYLAND-YUTANI CORPORATION.

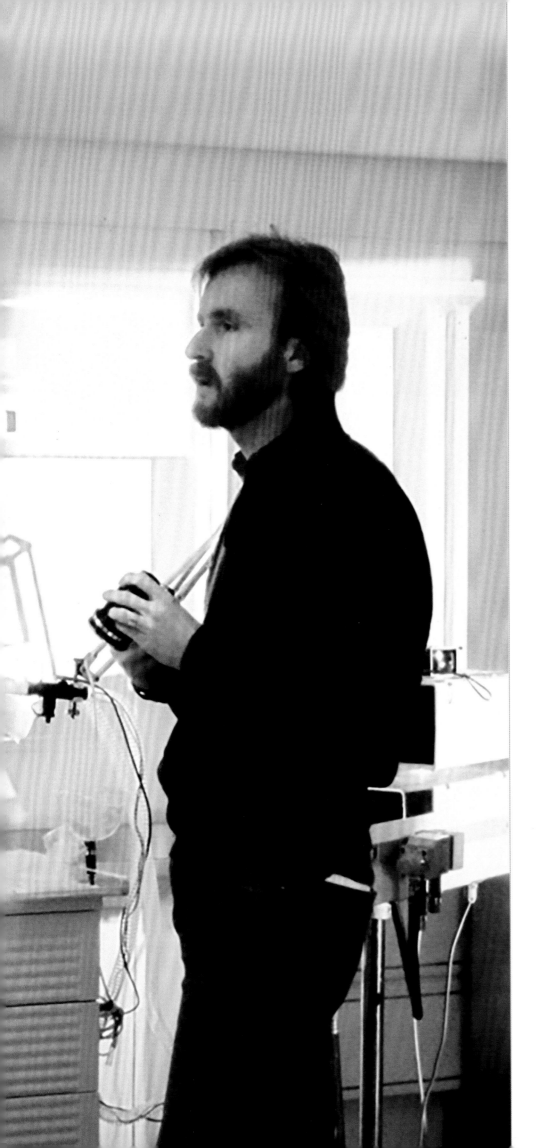

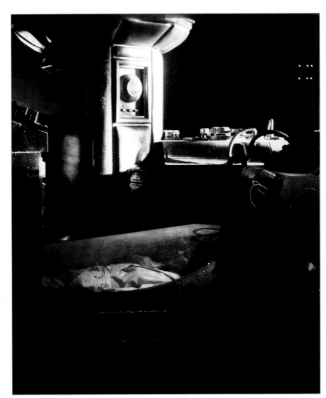

"I LOVED WORKING WITH JIM
RIGHT FROM THE GET GO.
THIS WAS HIS MOVIE FROM
BEGINNING TO END."

SIGOURNEY WEAVER ON WORKING
WITH JAMES CAMERON

ABOVE: *Aliens* picks up in exactly the same place *Alien* ended—the *Narcissus*—albeit 57 years later. For the sequel, the crew used the same design for the *Narcissus* as in the original. James Cameron was the voice of the salvage crew member.

LEFT: Ripley awakens in a very unsensational medical wing on Gateway Station, greeted by Carter Burke and her old friend, Jones the cat, who also survived the hypersleep journey. This scene is actually Ripley's nightmare, a residual fear of the alien striking at her immediately. This is in keeping with how heavily influenced Cameron was by Vietnam throughout the whole writing and designing process, making Ripley essentially suffer from post-traumatic stress disorder.

HADLEY'S HOPE

THE EXOMOON LV-426 HAS NOW BEEN COLONIZED AND NAMED THE COLONY HADLEY'S HOPE. THE INTRODUCTION TO THE COLONY AND ITS INHABITANTS WAS CUT FROM THE THEATRICAL EDITION OF *ALIENS*, BUT RE-INSERTED IN THE 1992 SPECIAL EDITION.

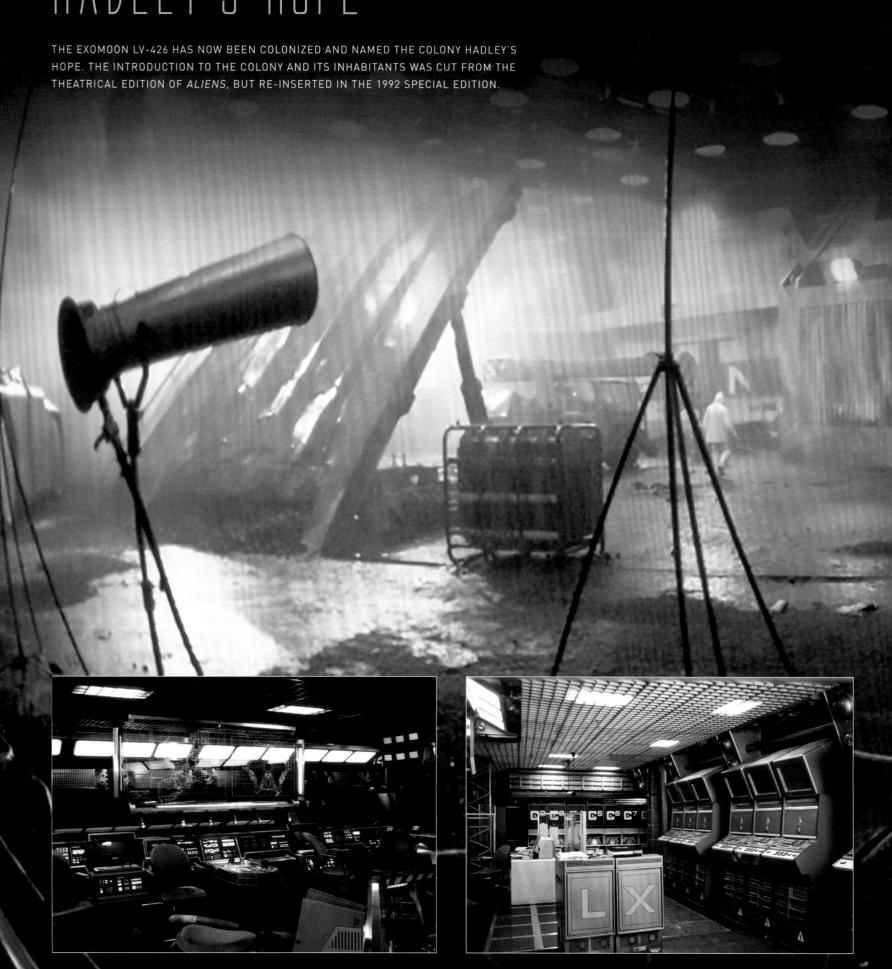

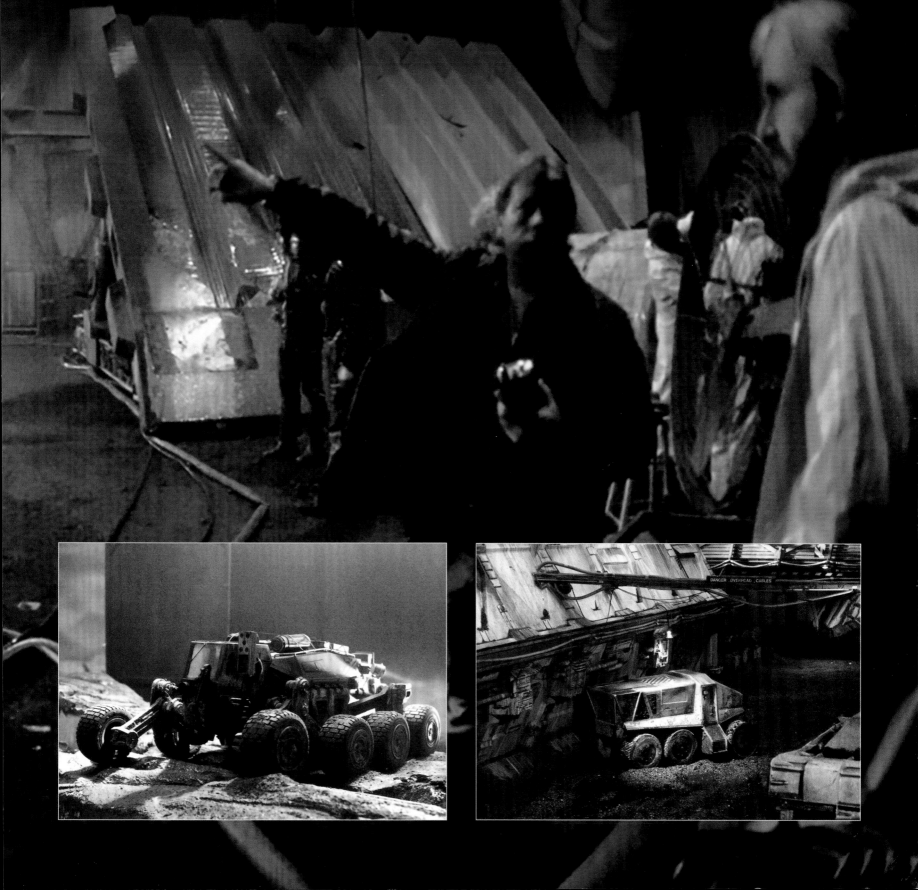

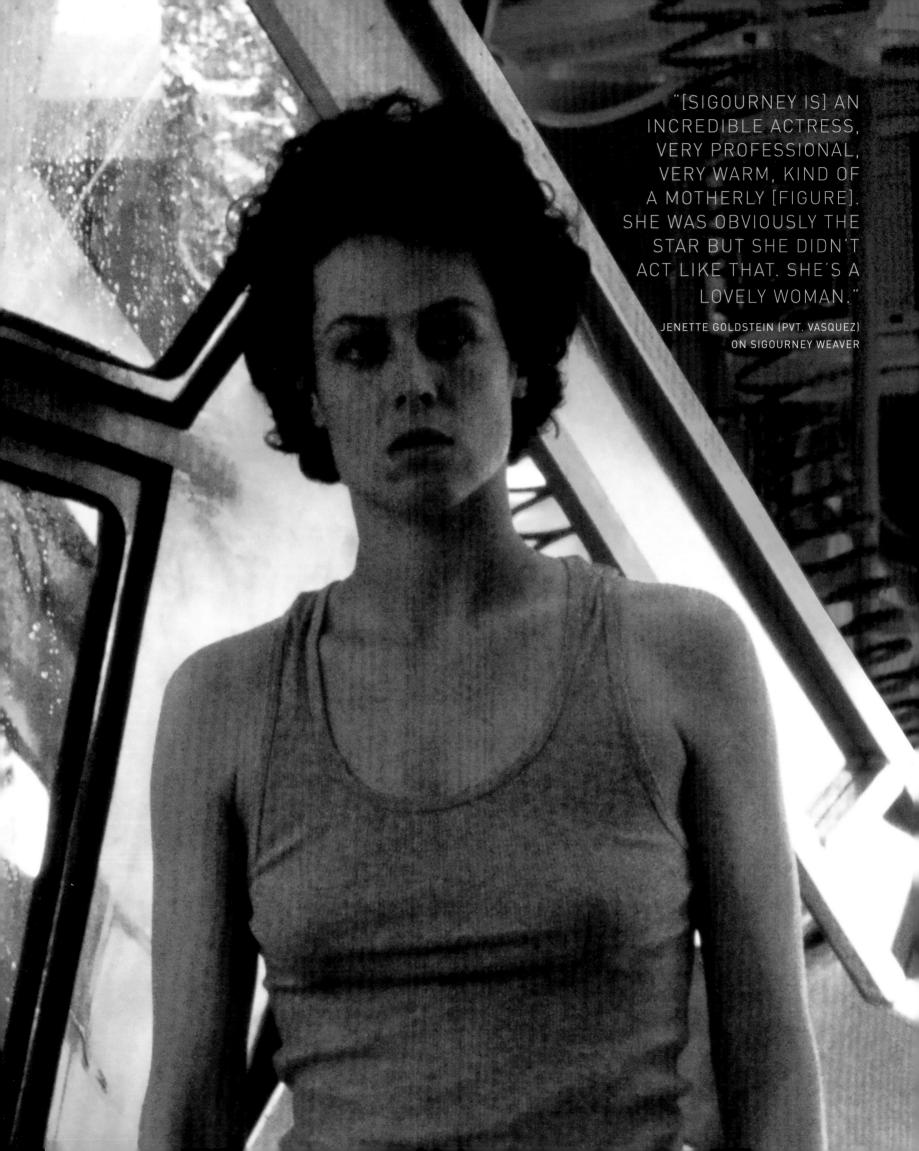

"[SIGOURNEY IS] AN INCREDIBLE ACTRESS, VERY PROFESSIONAL, VERY WARM, KIND OF A MOTHERLY [FIGURE]. SHE WAS OBVIOUSLY THE STAR BUT SHE DIDN'T ACT LIKE THAT. SHE'S A LOVELY WOMAN."

JENETTE GOLDSTEIN (PVT. VASQUEZ) ON SIGOURNEY WEAVER

ON BOARD THE *SULACO*

WHEN COMMUNICATION IS LOST WITH THE COLONY, WEYLAND-YUTANI SEND THE COLONIAL MARINES TO INVESTIGATE. RIPLEY IS ASKED TO ACCOMPANY THEM TO LEND HER EXPERTISE, AND SHE AGREES IN ORDER TO GRANT HERSELF CLOSURE.

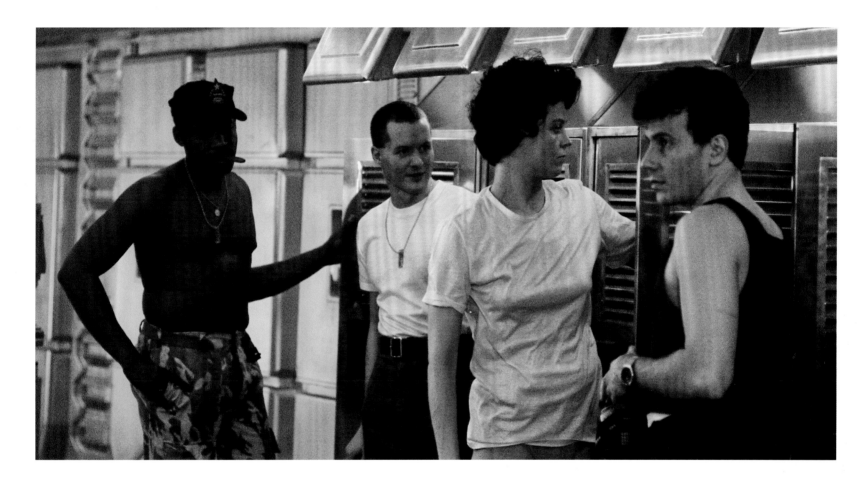

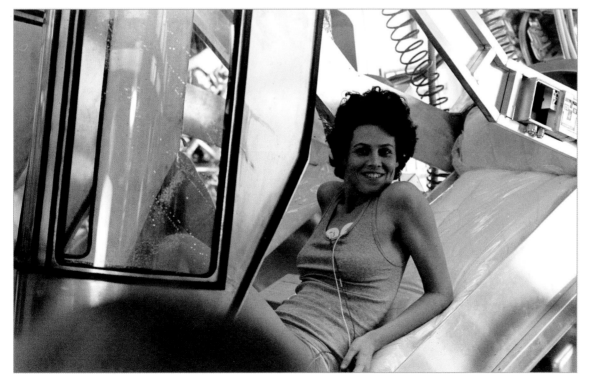

ABOVE: This is the audience's first introduction to the marines, mirroring how the key cast is met in the original film.

LEFT: Only six functioning hypersleep chambers were built. A mirror was placed at the end of the area on set to create the illusion of a longer row of sleeping inhabitants.

OPPOSITE: When designing the hypersleep chamber, concept artist Syd Mead was instructed by Cameron to think of it like "a car wash for people". The lids on the actual cabinets didn't have the budget to be raised mechanically, so wires lifted them open.

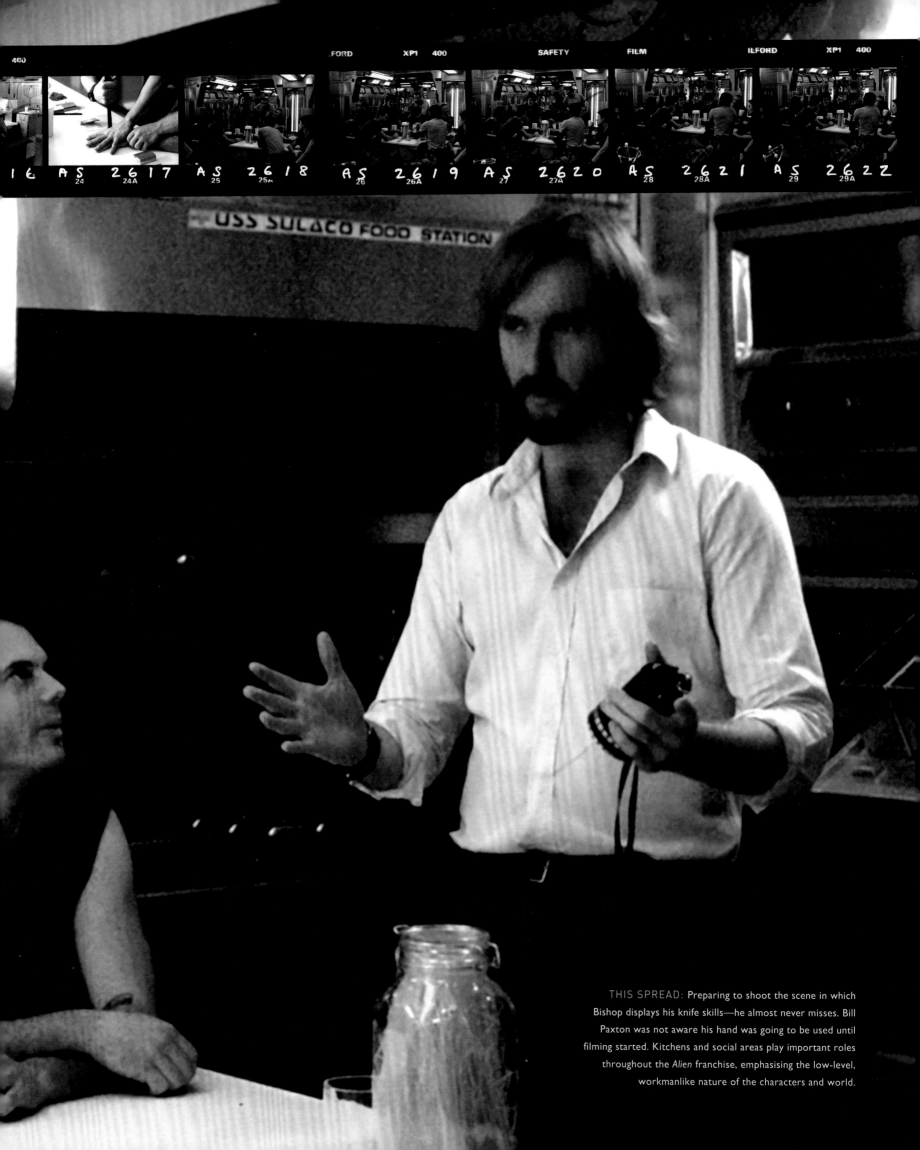

USS SULACO FOOD STATION

THIS SPREAD: Preparing to shoot the scene in which Bishop displays his knife skills—he almost never misses. Bill Paxton was not aware his hand was going to be used until filming started. Kitchens and social areas play important roles throughout the *Alien* franchise, emphasising the low-level, workmanlike nature of the characters and world.

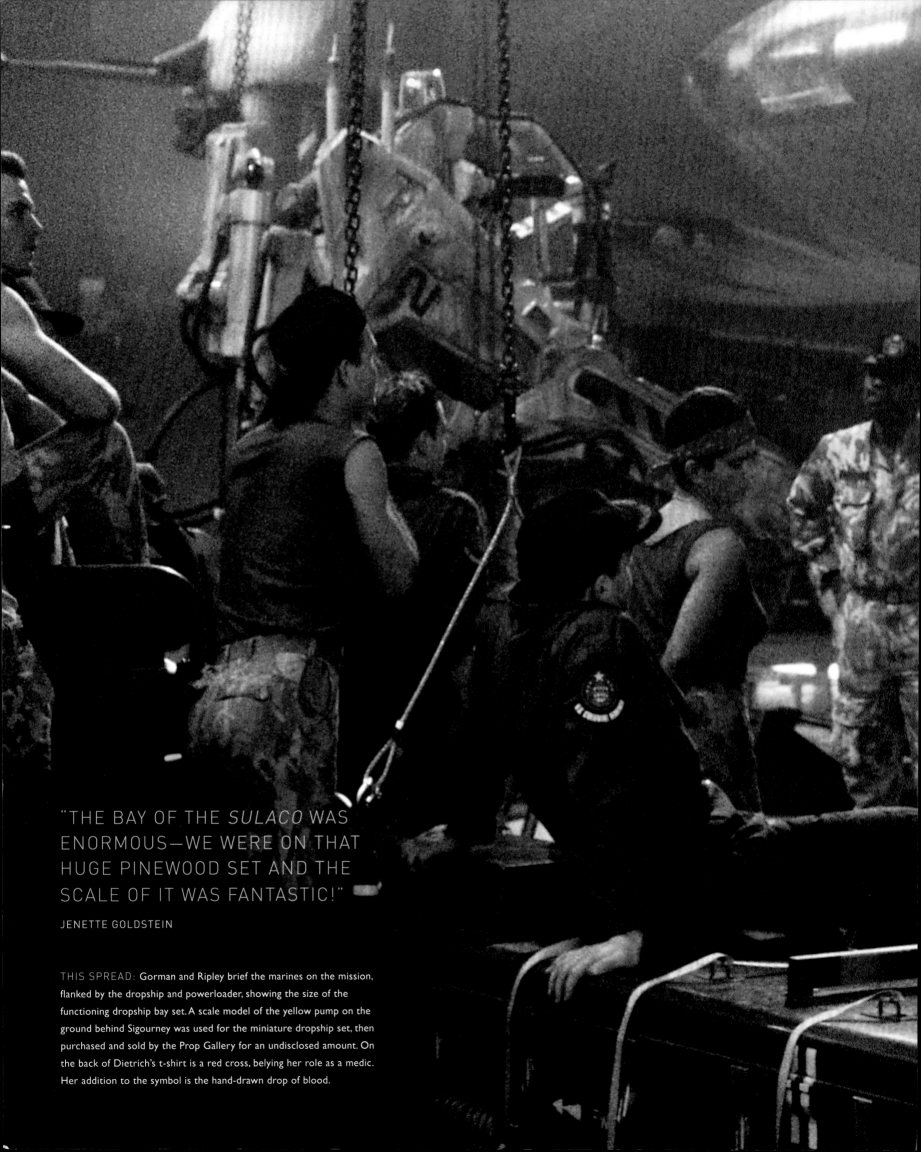

"THE BAY OF THE *SULACO* WAS
ENORMOUS—WE WERE ON THAT
HUGE PINEWOOD SET AND THE
SCALE OF IT WAS FANTASTIC!"

JENETTE GOLDSTEIN

THIS SPREAD: Gorman and Ripley brief the marines on the mission,
flanked by the dropship and powerloader, showing the size of the
functioning dropship bay set. A scale model of the yellow pump on the
ground behind Sigourney was used for the miniature dropship set, then
purchased and sold by the Prop Gallery for an undisclosed amount. On
the back of Dietrich's t-shirt is a red cross, belying her role as a medic.
Her addition to the symbol is the hand-drawn drop of blood.

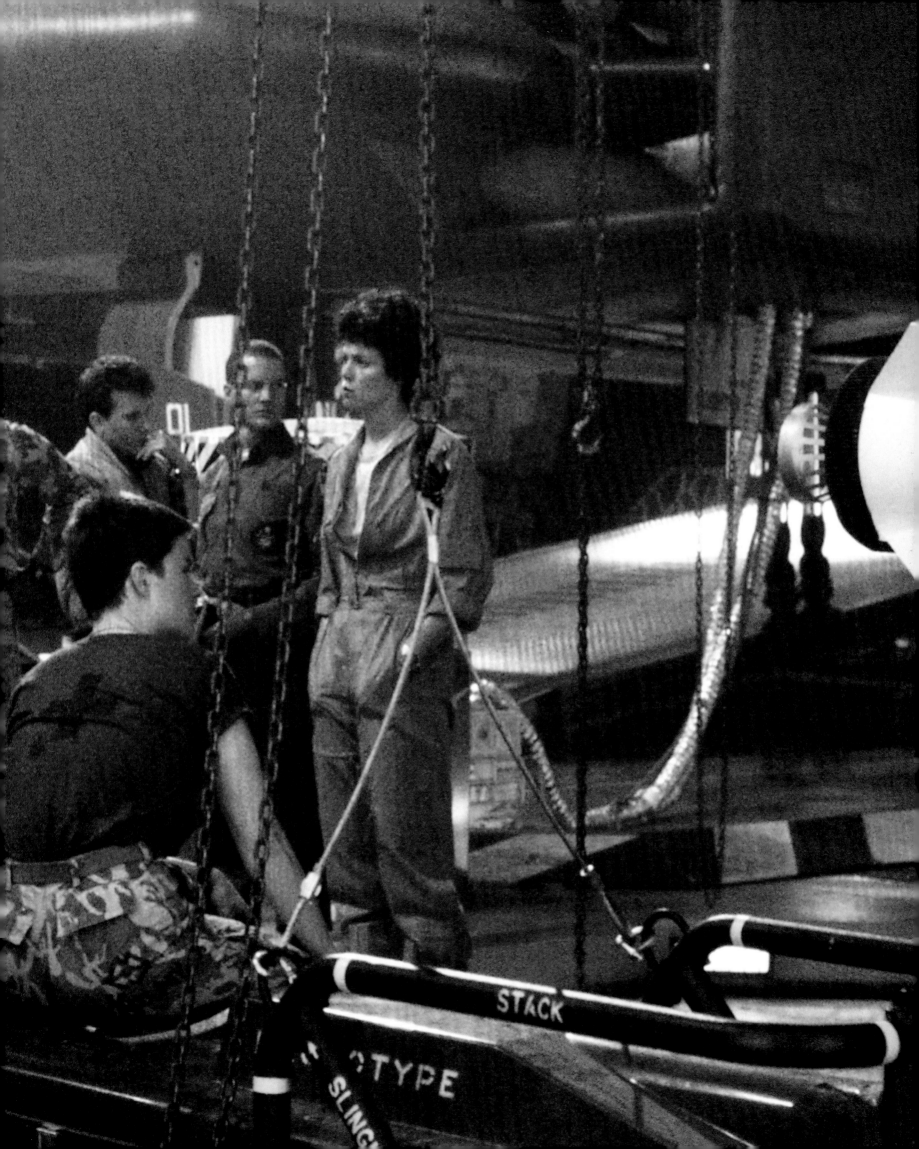

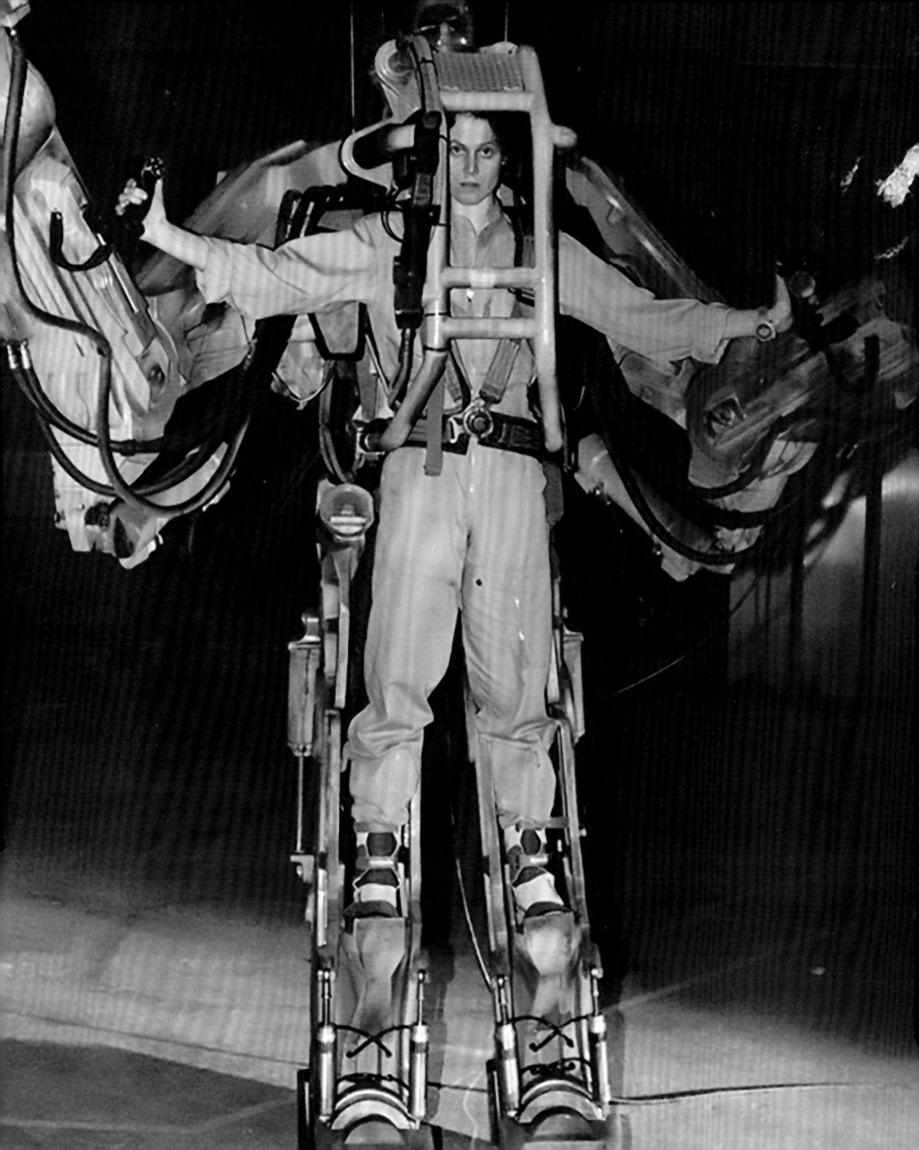

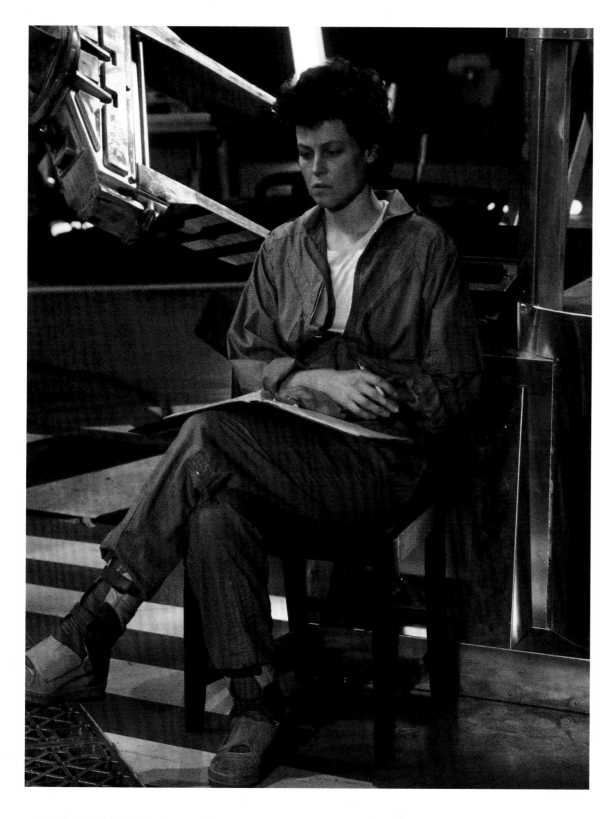

OPPOSITE: Weaver strapped into the full-scale model of the powerloader. On her wrist is the Giugiaro 7A28-7000 watch, created by car designer Giorgetto Giugiaro. Seiko re-issued the timepiece as a limited edition in 2015.

LEFT: Weaver studying lines between takes on the dropship bay set. Her trainers became a fan favorite item, nicknamed the 'Alien Stomper,' and sold sporadically since 1997.

BOTTOM LEFT: The powerloader was built from aluminum, PVC plastic and fiberglass. Hidden behind Weaver, inside the machine itself, was stuntman John Lees, who operated the prop.

BOTTOM RIGHT: "Since introduction, the powerloader has improved workplace safety by 300% in off-world applications. Its low-alloy steel exoskeleton is designed to withstand maximum compression stress, keeping the driver safe from external blows. Hydraulically stabilized legs give 3 tons of load-lifting ability." Weyland-Yutani Corporation

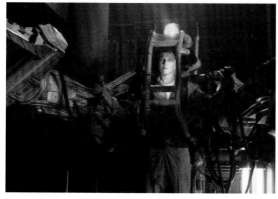

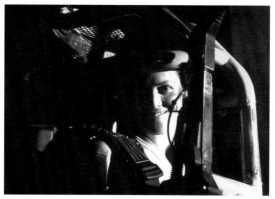

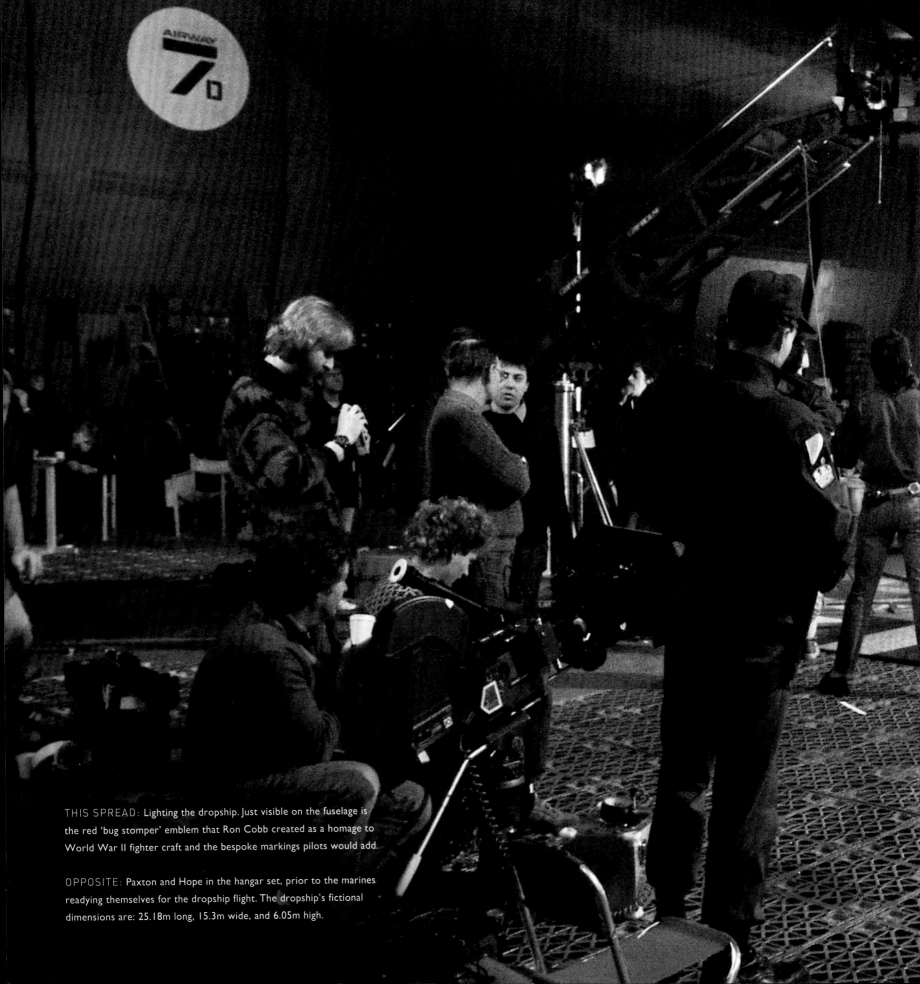

THIS SPREAD: Lighting the dropship. Just visible on the fuselage is the red 'bug stomper' emblem that Ron Cobb created as a homage to World War II fighter craft and the bespoke markings pilots would add.

OPPOSITE: Paxton and Hope in the hangar set, prior to the marines readying themselves for the dropship flight. The dropship's fictional dimensions are: 25.18m long, 15.3m wide, and 6.05m high.

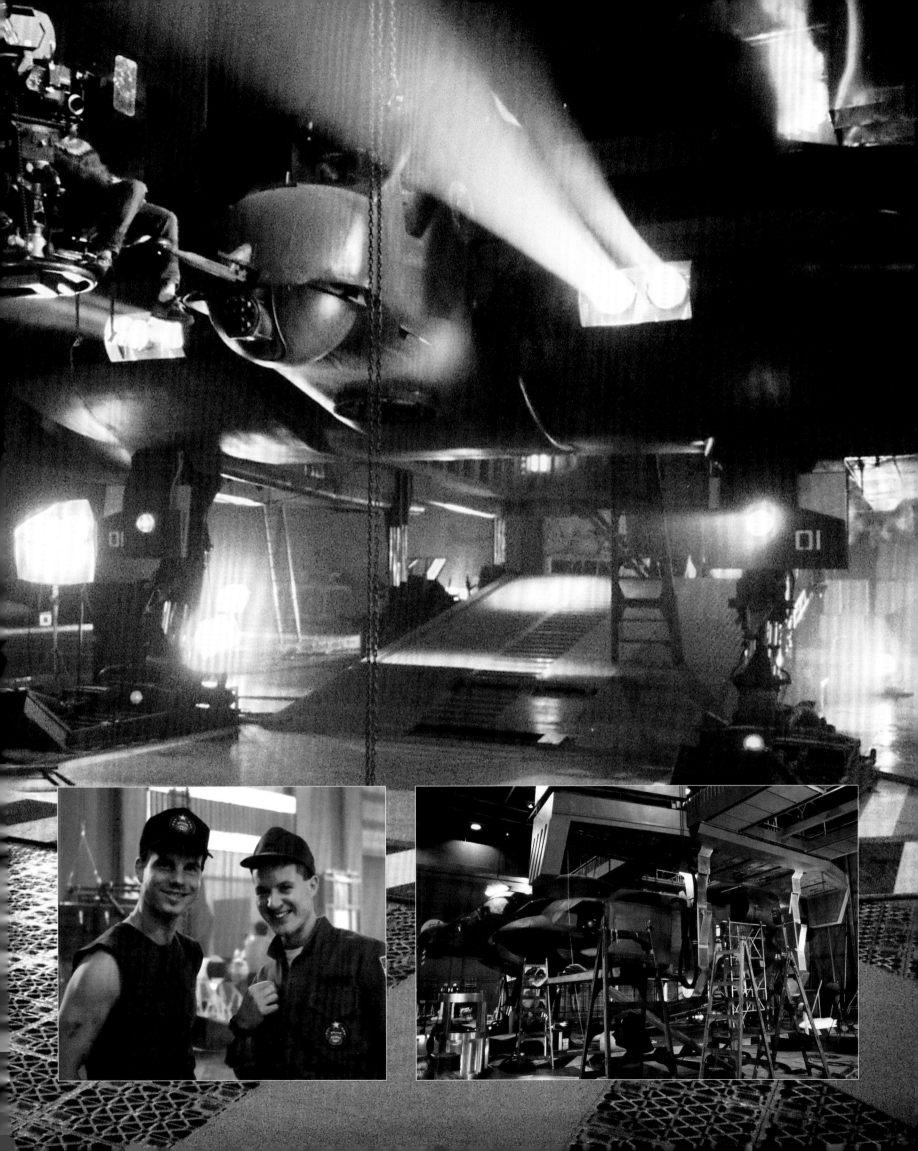

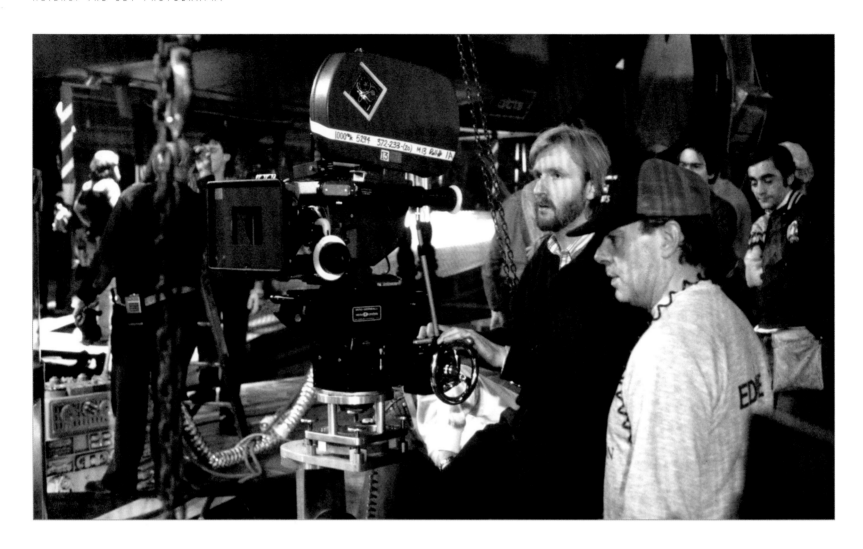

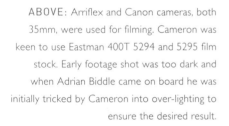

ABOVE: Arriflex and Canon cameras, both 35mm, were used for filming. Cameron was keen to use Eastman 400T 5294 and 5295 film stock. Early footage shot was too dark and when Adrian Biddle came on board he was initially tricked by Cameron into over-lighting to ensure the desired result.

RIGHT: *Aliens* was Cameron's fifth produced screenplay. He wrote the initial 42-page treatment in only four days.

OPPOSITE: Items in Hicks' locker include a punchbag, a boxing helmet and gloves, and pin-up photos on the inside of the door. Deeper inside the locker is a trenchcoat, which has been speculated to be a homage to Cameron and Biehn's previous film together, *The Terminator* (1984). All the marines cast were encouraged to personalize their armor and appearance. The front of Vasquez's breastplate reads 'EL RIESGO SIEMPRE VIVE,' which translates as 'The risk always lives.' It is taken from one of Goldstein's favourite poems.

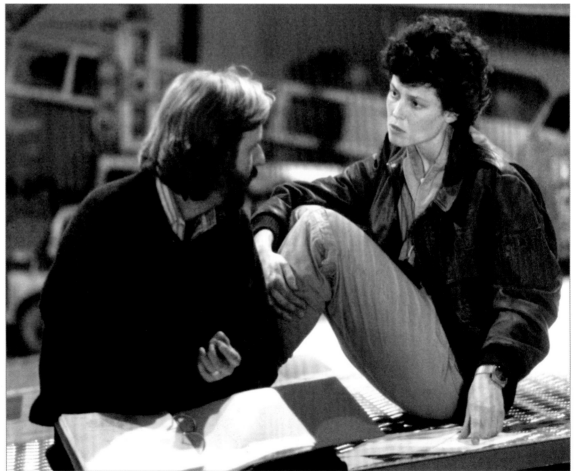

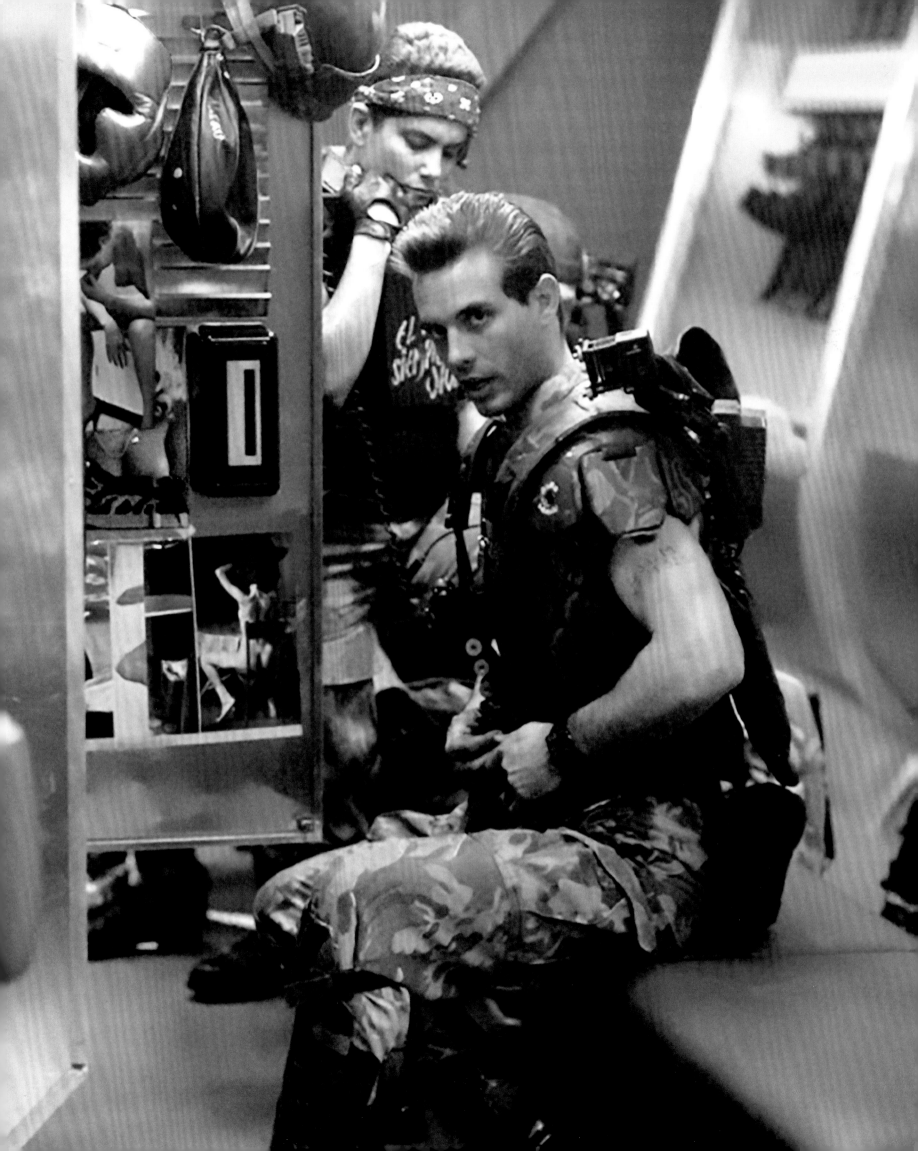

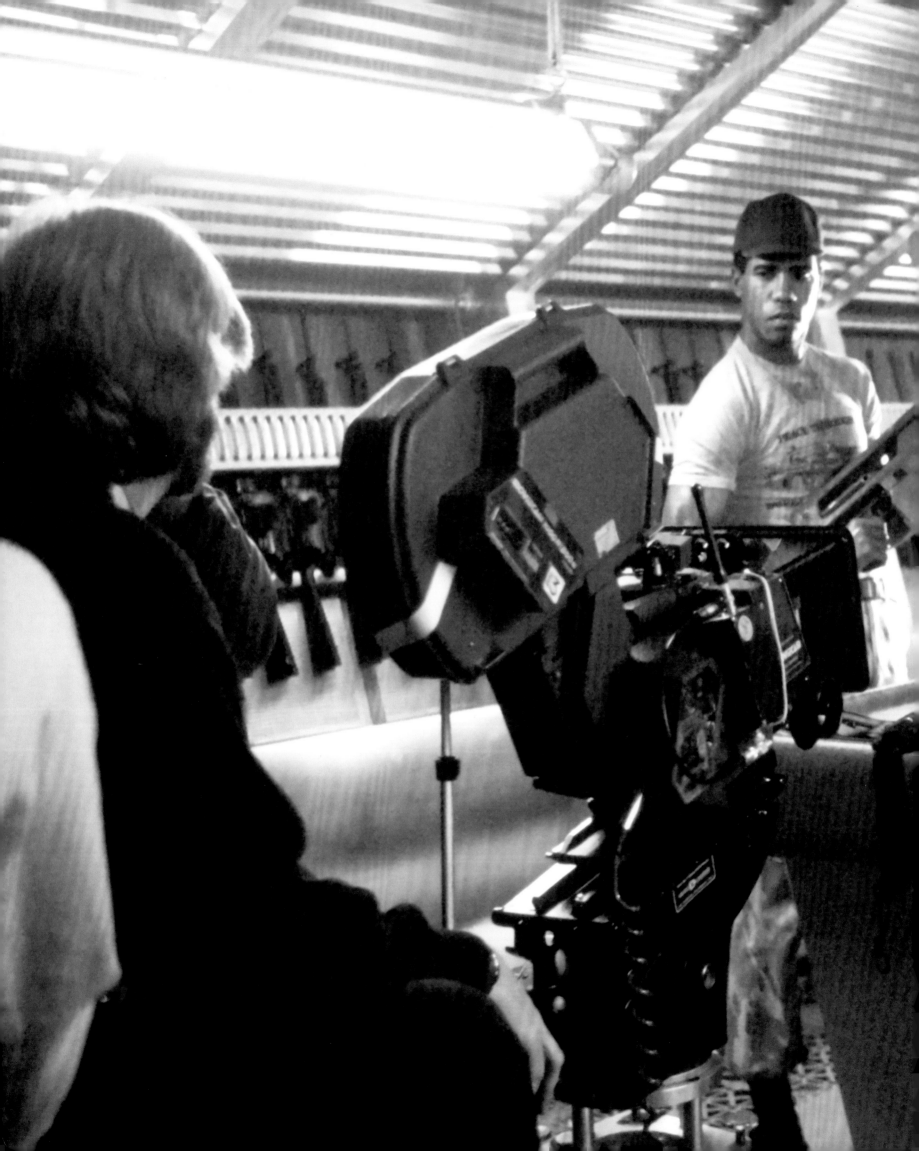

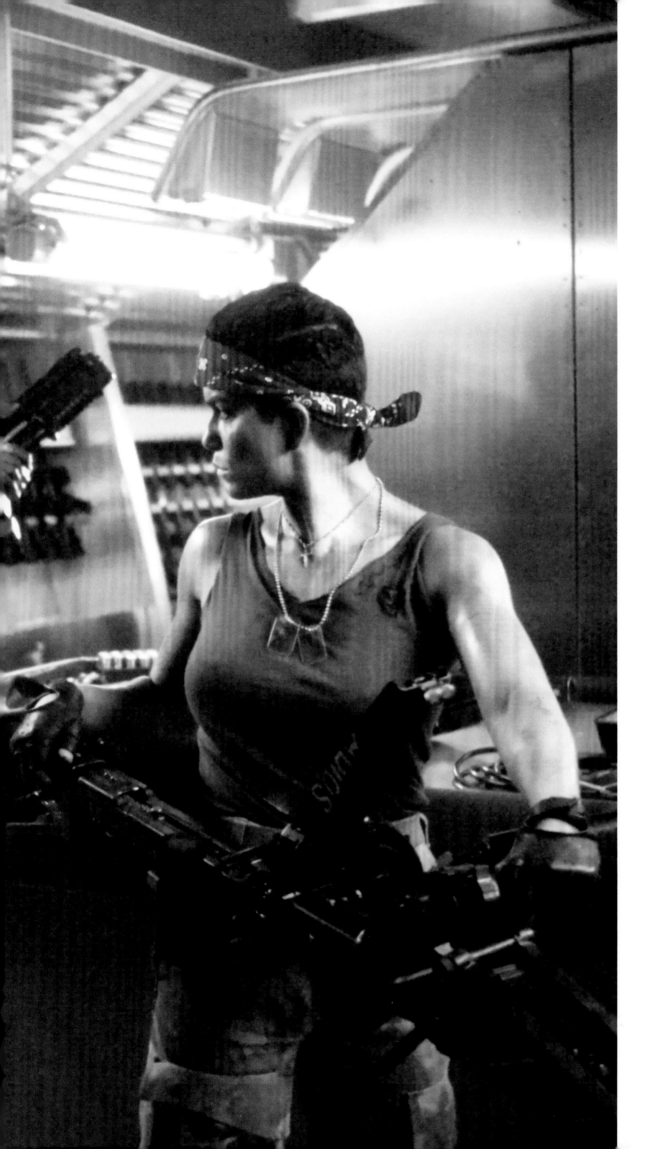

"JAMES PUT ALL OF US THROUGH SORT OF A BOOT CAMP AND WE WERE TRAINED IN SMALL ARMS, URBAN WARFARE AND WEAPON HANDLING, I'D NEVER HANDLED A WEAPON BEFORE, SO IT WAS REALLY GOOD AND WE GOT SO MUCH TIME TO GET TO KNOW EACH OTHER."

JENETTE GOLDSTEIN ON THE TRAINING THAT SOME OF THE ACTORS RECEIVED IN PREPARATION FOR PLAYING THE MARINES

LEFT: Jenette Goldstein personalized her look with the 'Adios' on her smartgun, a teardrop tattoo under her left eye, and a rough—then abandoned—sketch of a skull and crossbones on the shoulder of her tanktop.

41

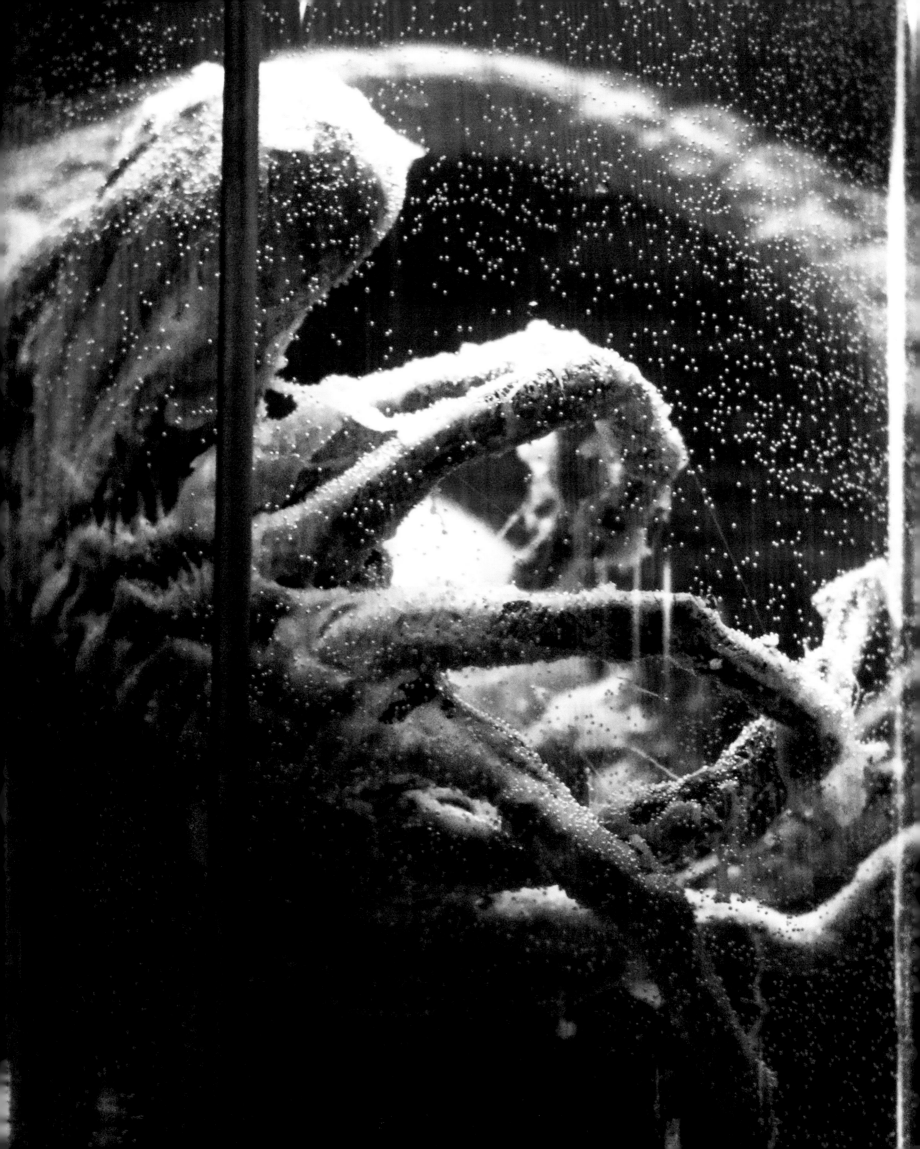

COLONY RECONNAISSANCE

THE DROPSHIP TAKES THE MARINES, RIPLEY, AND BURKE DOWN TO LV-426. FOR RIPLEY IT IS RETURNING TO WHAT SHE SPENT
HALF A CENTURY ESCAPING, BUT FOR THE "CHICKEN-SHIT OUTFIT" MARINES IT COULD JUST BE "ANOTHER BUG HUNT."

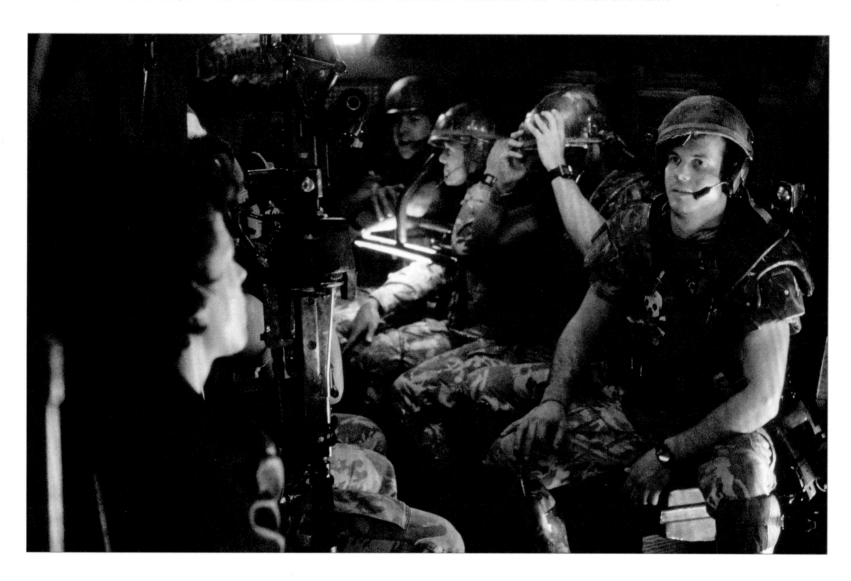

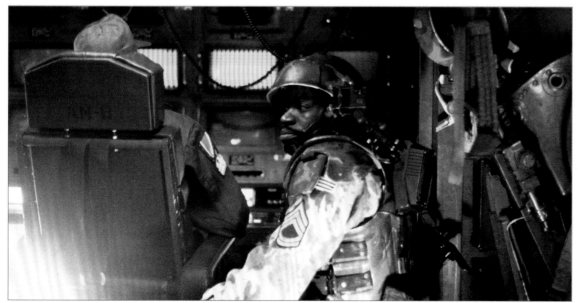

OPPOSITE: The facehugger was updated by
Stan Winston from the original. This version
featured legs more like fingers and a longer tail.

ABOVE: In a scene cut from the theatrical
edition, Hudson prepares to deliver a boastful
monologue to Ripley extolling the formidable
power of the marines and their arsenal.

LEFT: Sgt. Apone does not sport any
customization on his armor. Despite the
futuristic space setting of the story, the marines
wear camouflage fatigues, drawing further
comparisons to contemporary Earth-set warfare.
The color of the fatigues was also specifically
picked to complement the blue lighting on set.

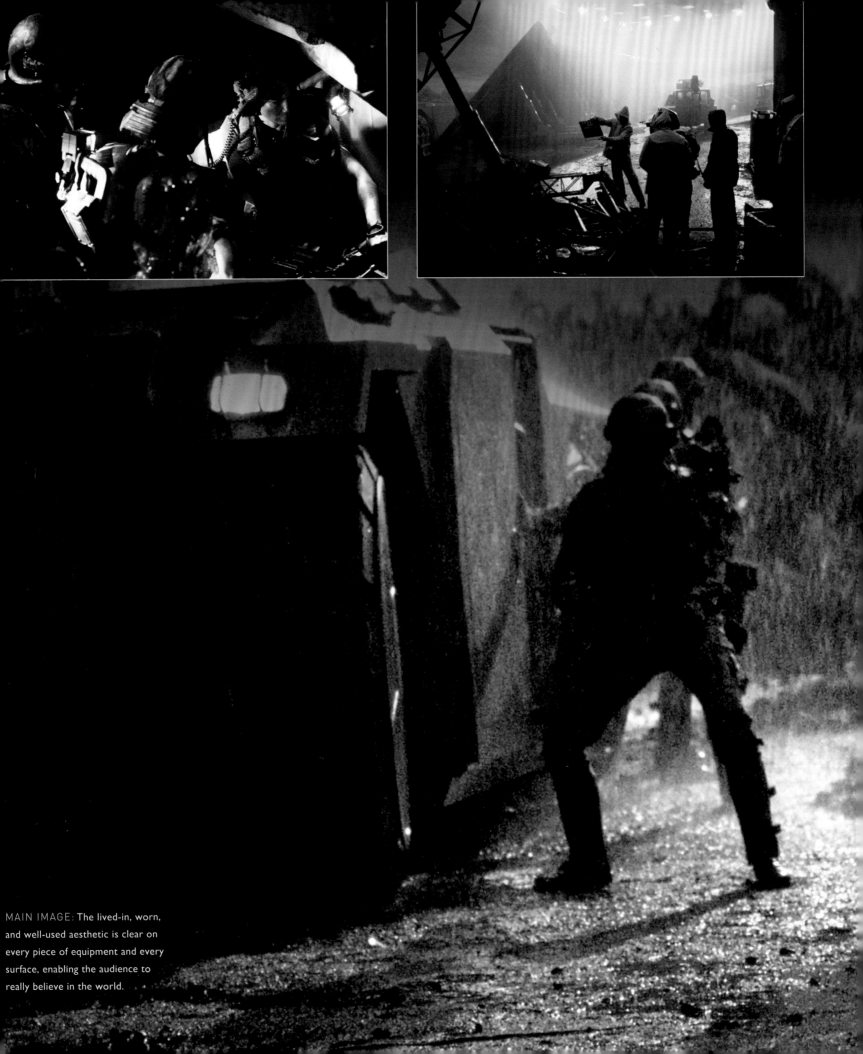

MAIN IMAGE: The lived-in, worn, and well-used aesthetic is clear on every piece of equipment and every surface, enabling the audience to really believe in the world.

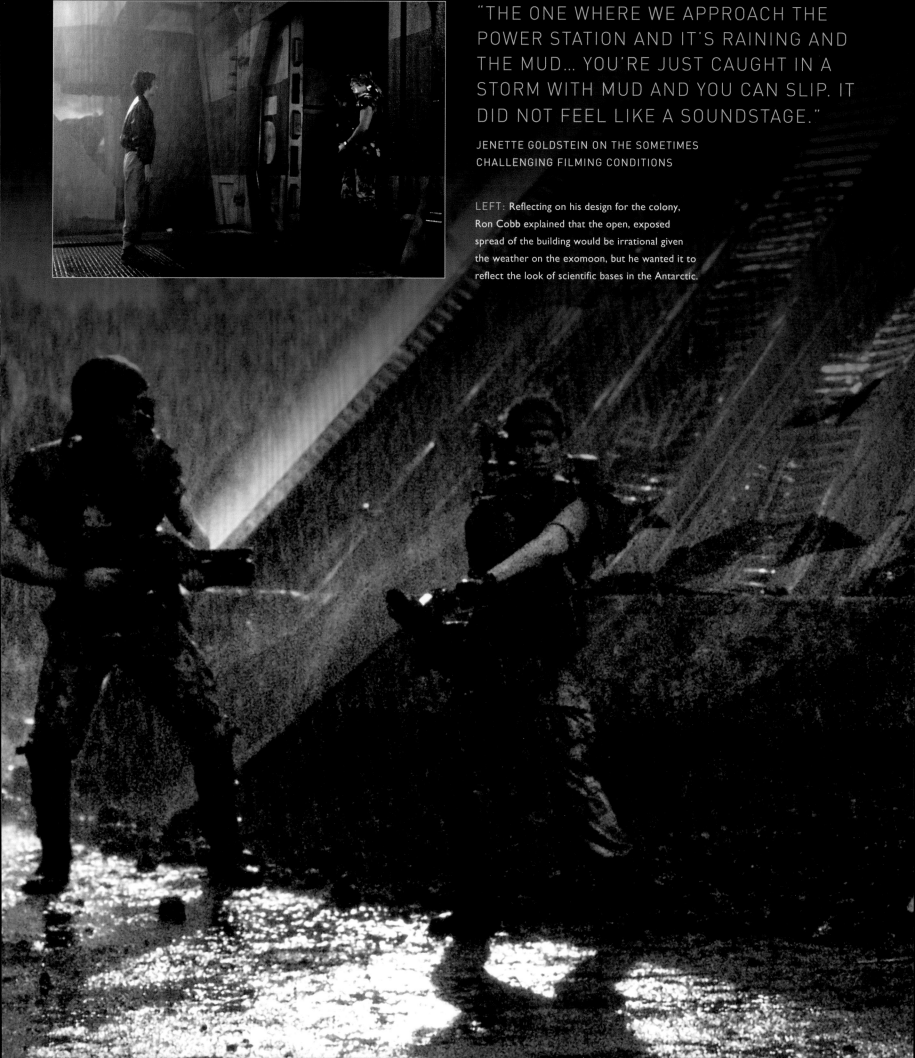

"THE ONE WHERE WE APPROACH THE POWER STATION AND IT'S RAINING AND THE MUD... YOU'RE JUST CAUGHT IN A STORM WITH MUD AND YOU CAN SLIP. IT DID NOT FEEL LIKE A SOUNDSTAGE."

JENETTE GOLDSTEIN ON THE SOMETIMES CHALLENGING FILMING CONDITIONS

LEFT: Reflecting on his design for the colony, Ron Cobb explained that the open, exposed spread of the building would be irrational given the weather on the exomoon, but he wanted it to reflect the look of scientific bases in the Antarctic.

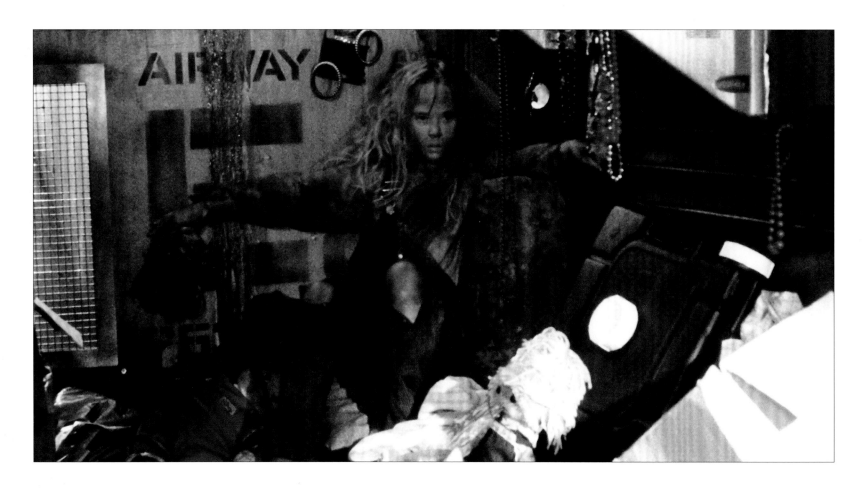

"I WAS SO UPSET WHEN I FIRST WENT INTO MY LITTLE NEST—I COULDN'T BELIEVE THAT ALL OF THESE AMAZING NEW TOYS HAD ALL BEEN DESTROYED!"

CARRIE HENN ON FILMING NEWT'S DISCOVERY BY THE MARINES

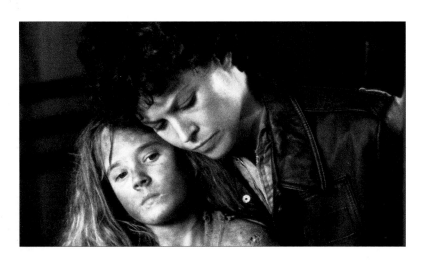

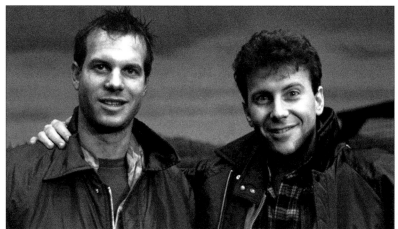

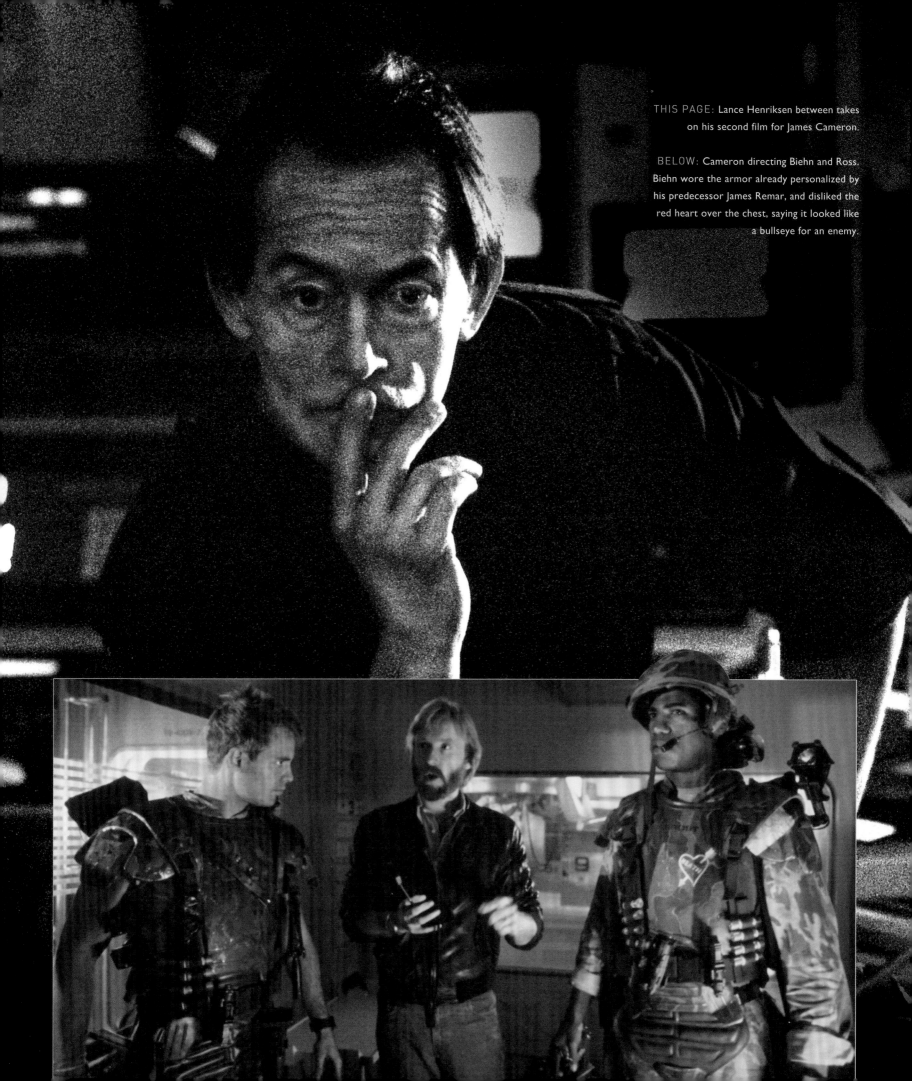

THIS PAGE: Lance Henriksen between takes on his second film for James Cameron.

BELOW: Cameron directing Biehn and Ross. Biehn wore the armor already personalized by his predecessor James Remar, and disliked the red heart over the chest, saying it looked like a bullseye for an enemy.

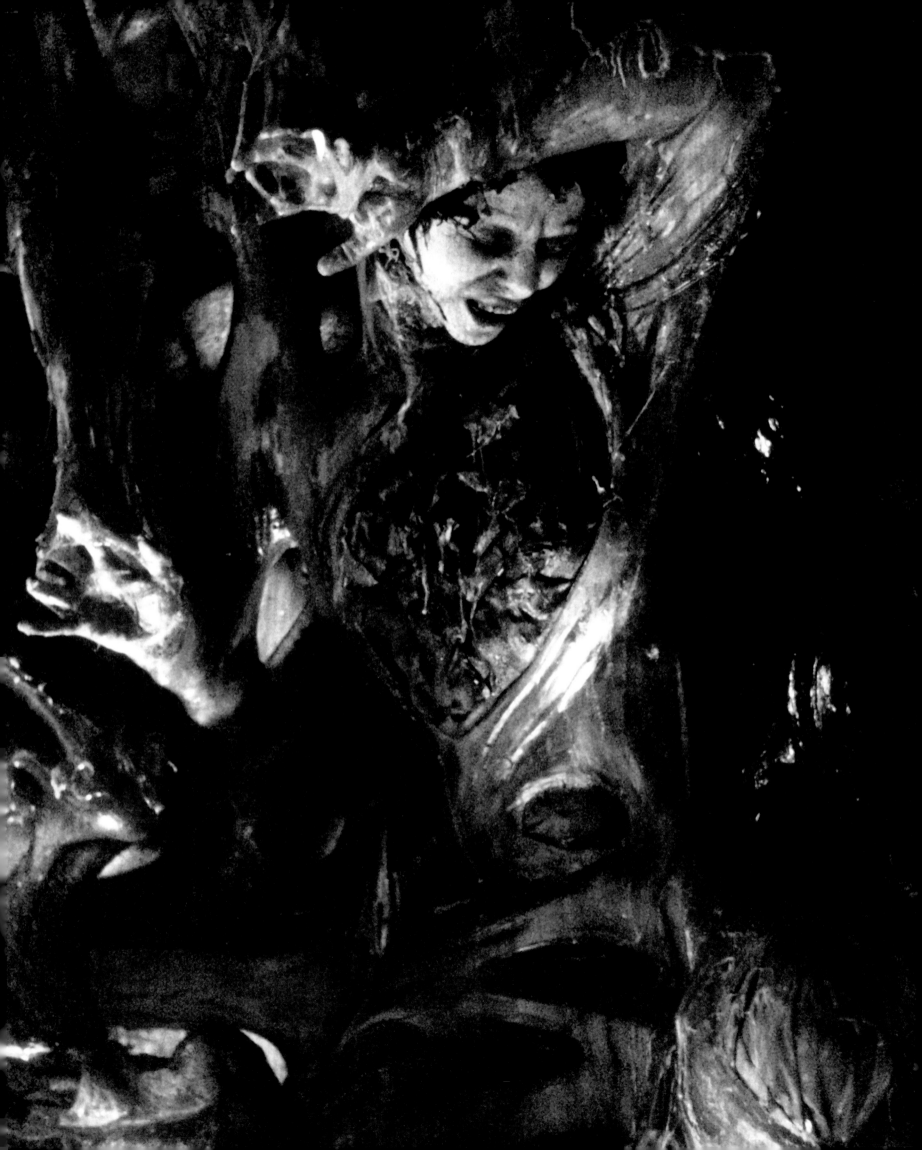

ALIEN AMBUSH

FINDING NO ONE BUT NEWT IN THE COLONY, THE MARINES MAKE
THEIR WAY OVER TO THE ATMOSPHERE PROCESSING STATION...

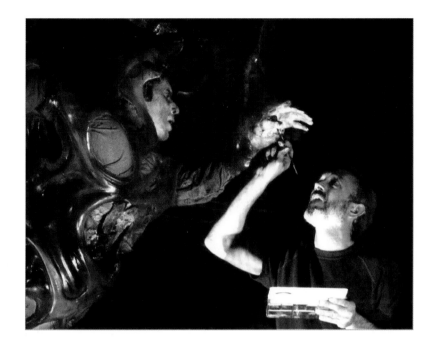

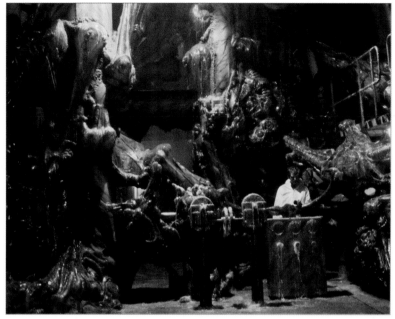

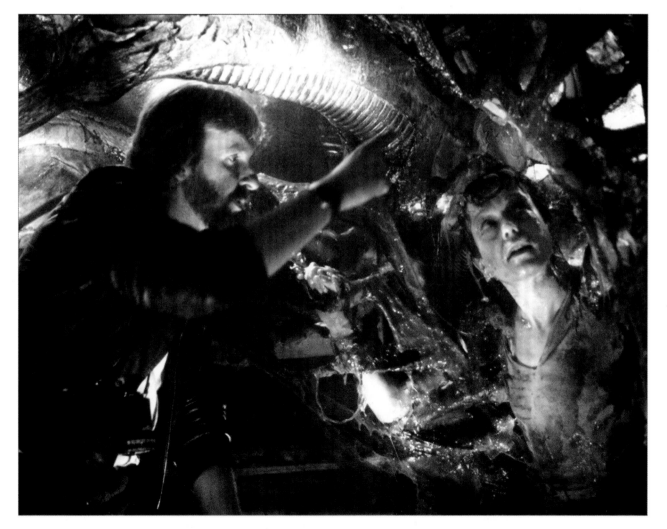

OPPOSITE: What survivors
there are are discovered on
sublevel three. The area has
been transformed by some sort
of 'secreted resin;' everything
is wet and organic-looking,
like delving into the body of
an alien itself. The remaining
members of the colony have
been cocooned by the aliens,
fused to the walls, and used for
impregnating.

LEFT: Barbara Coles played
the cocooned woman.

ABOVE LEFT: A chestburster
emerges from the woman. Stan
Winston slightly adapted the
look of the newborn creature,
adding a pair of arms to make it
look "quite alive."

ABOVE: The interior was a
single set at Pinewood's E stage.

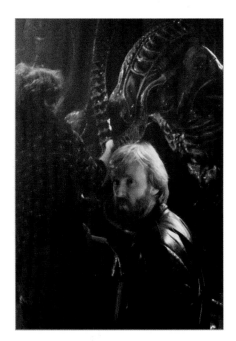

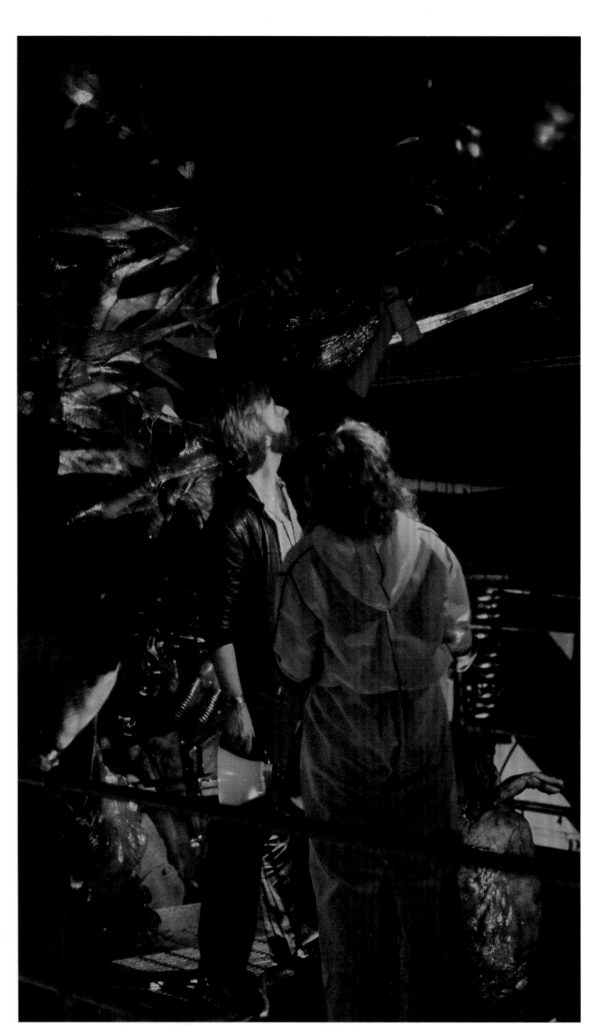

ABOVE: The walls become a real, living threat as perfectly-camouflaged aliens reveal themselves after the marines kill the chestburster.

RIGHT: For several scenes, including the cocooned colonists sequence and the queen's nest sequence, the crew filmed in a disused power station in Acton, London. Production designer Peter Lamont recalls they used "250 gallons of silver paint and we sprayed the whole lot silver."

OPPOSITE: Dietrich becomes the first victim of the alien ambush in the station.

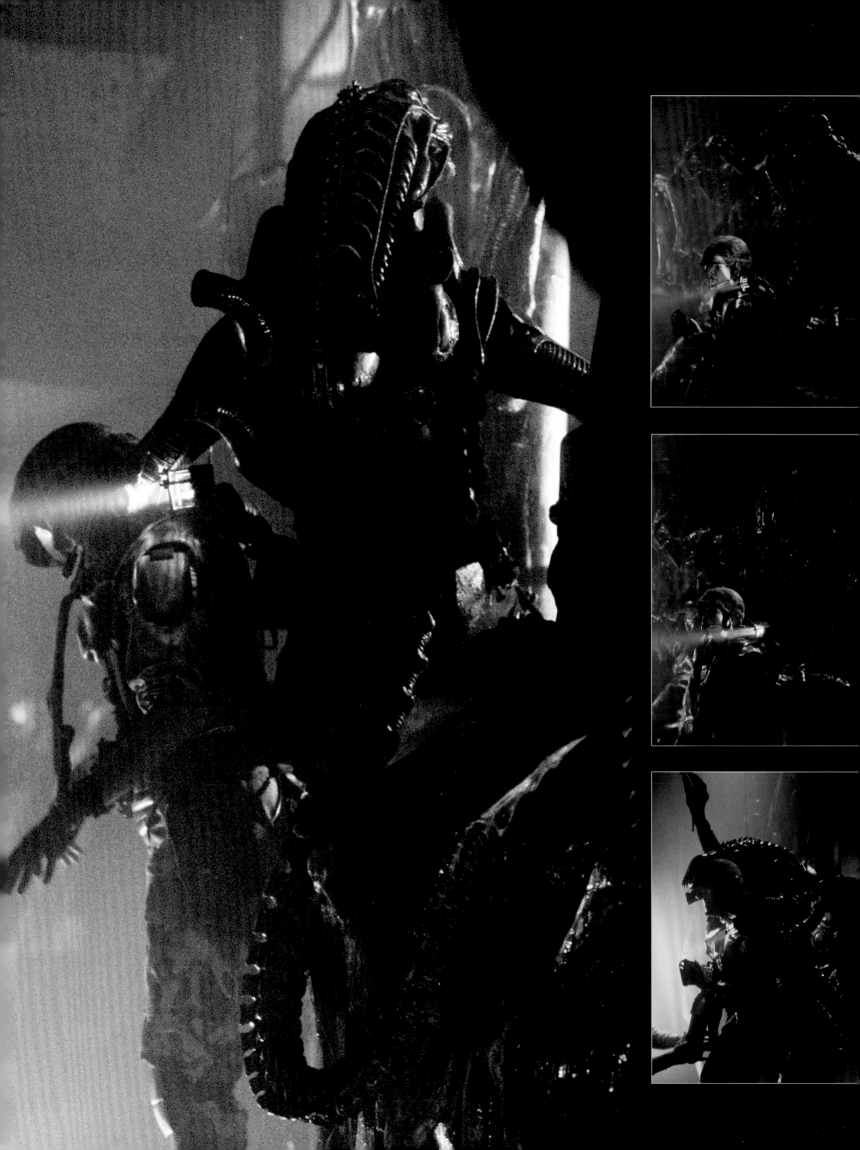

RIGHT: A shot not seen in the finished film; originally Ferro sees the alien, then the shot cuts and we see her blood spatter. This alien is a stowaway, foreshadowing the queen's surprise return on the second dropship at the film's climax.

BELOW: The color palette of the marines' outfits and weapons was chosen to complement the lighting and photography, thus the colors appear very different when seen on set.

MAIN IMAGE: The new creature design was much darker than the original and played on the light and shadows, with the monsters blending into the surrounding darkness.

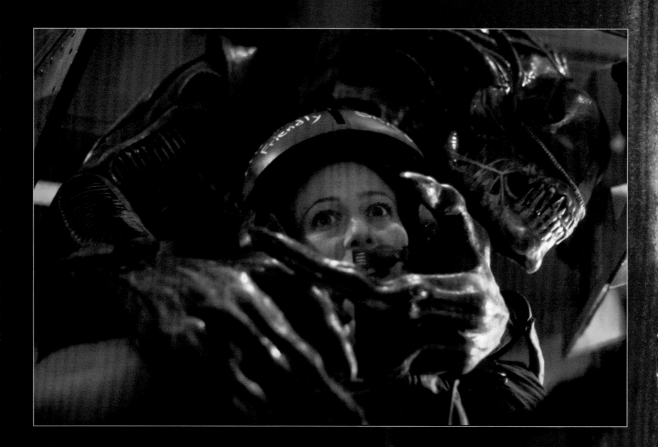

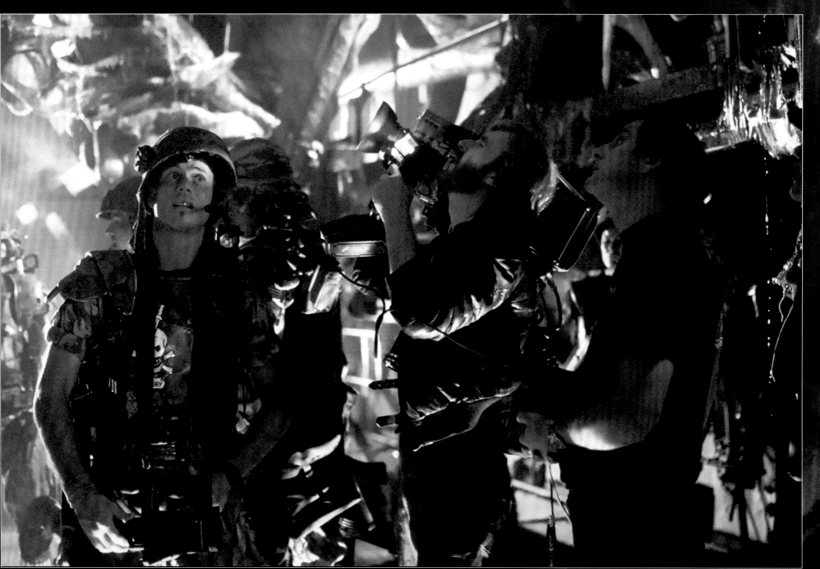

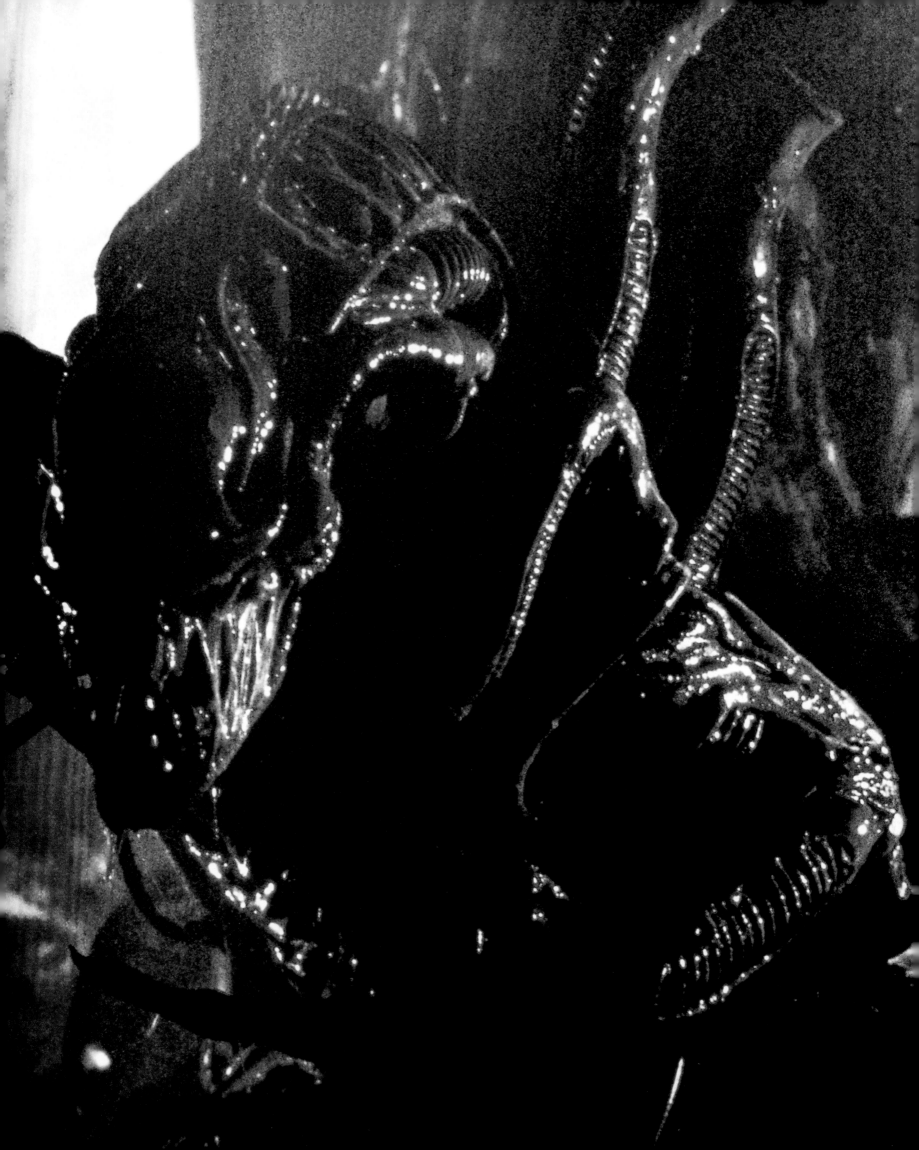

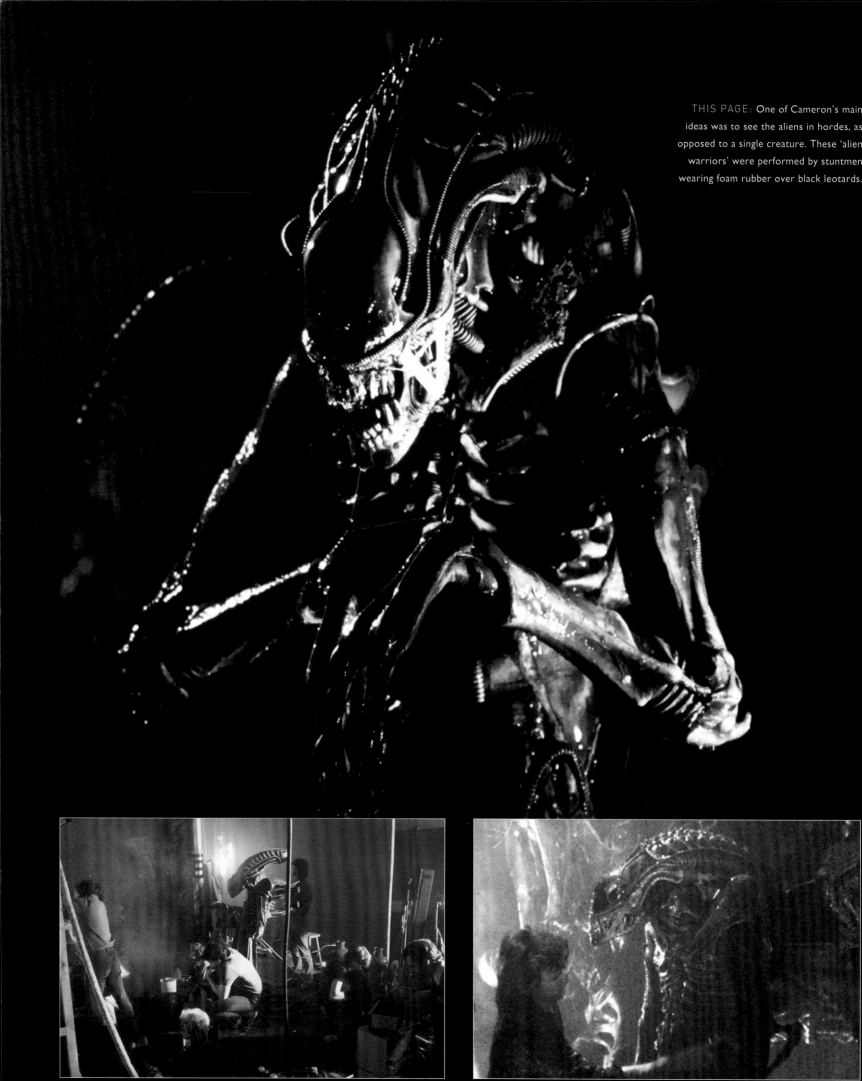

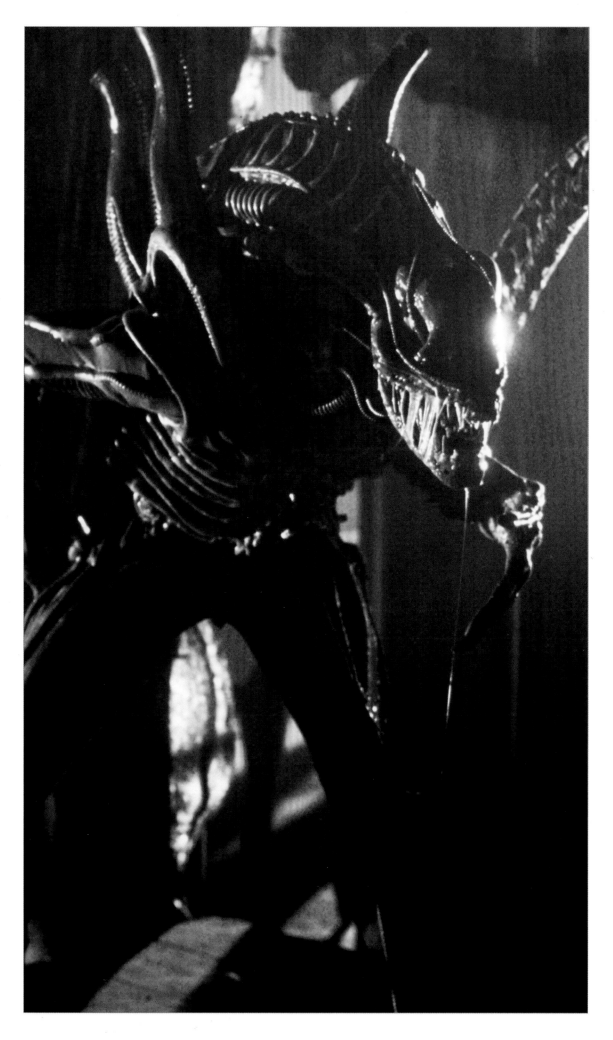

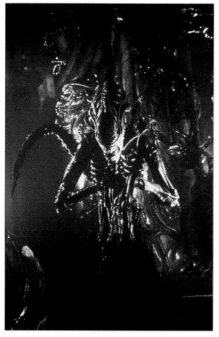

"WE BUILT VERY LOW RELIEF FORMS FOR ARMS AND LEGS AND EVEN THE CHEST SECTION WITH THE RIBS. WE BASICALLY BUILT THE HIGH POINT OF ALL THESE BONE STRUCTURES AND JUST BLENDED EVERYTHING OFF."

TOM WOODRUFF (CREATURE EFFECTS COORDINATOR)

THIS PAGE: So as not to give the impression of men in suits portraying the aliens, Cameron shot glimpses of the monsters and changed the film speed to give them the appearance of insects in a hive, protecting their queen.

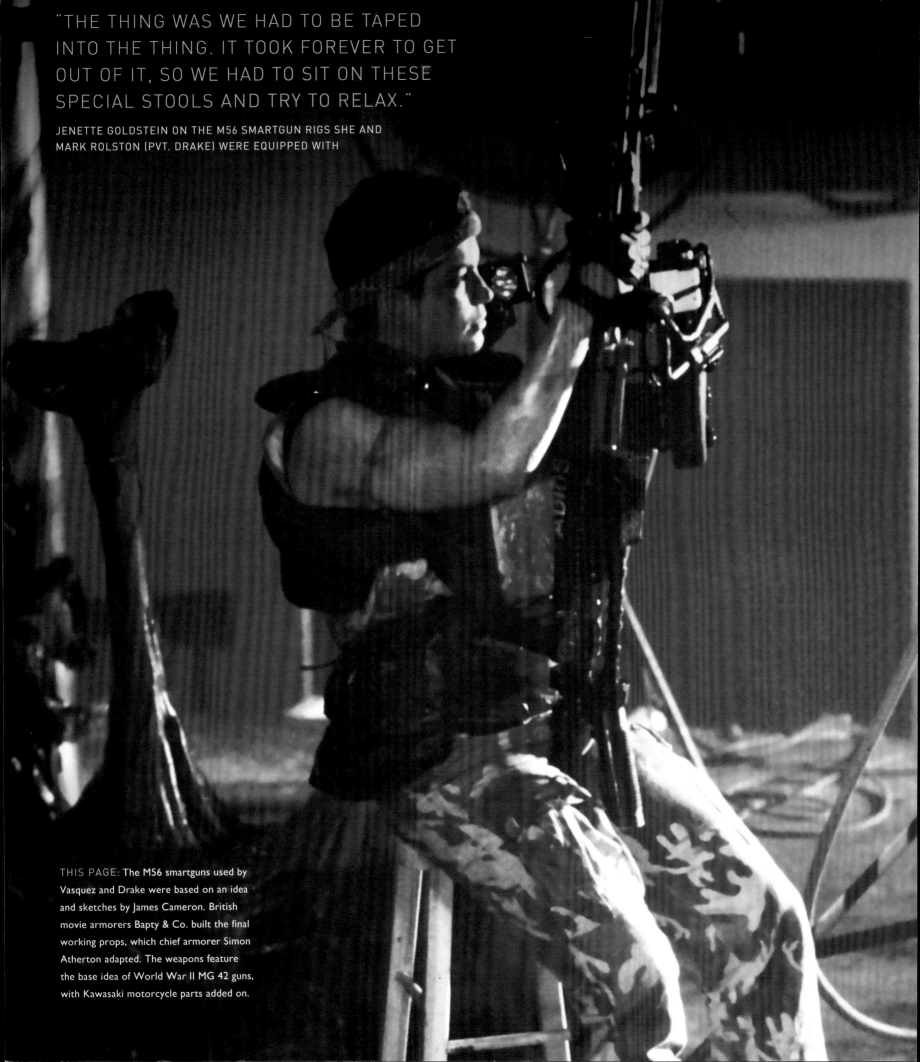

"THE THING WAS WE HAD TO BE TAPED INTO THE THING. IT TOOK FOREVER TO GET OUT OF IT, SO WE HAD TO SIT ON THESE SPECIAL STOOLS AND TRY TO RELAX."

JENETTE GOLDSTEIN ON THE M56 SMARTGUN RIGS SHE AND
MARK ROLSTON (PVT. DRAKE) WERE EQUIPPED WITH

THIS PAGE: The M56 smartguns used by
Vasquez and Drake were based on an idea
and sketches by James Cameron. British
movie armorers Bapty & Co. built the final
working props, which chief armorer Simon
Atherton adapted. The weapons feature
the base idea of World War II MG 42 guns,
with Kawasaki motorcycle parts added on.

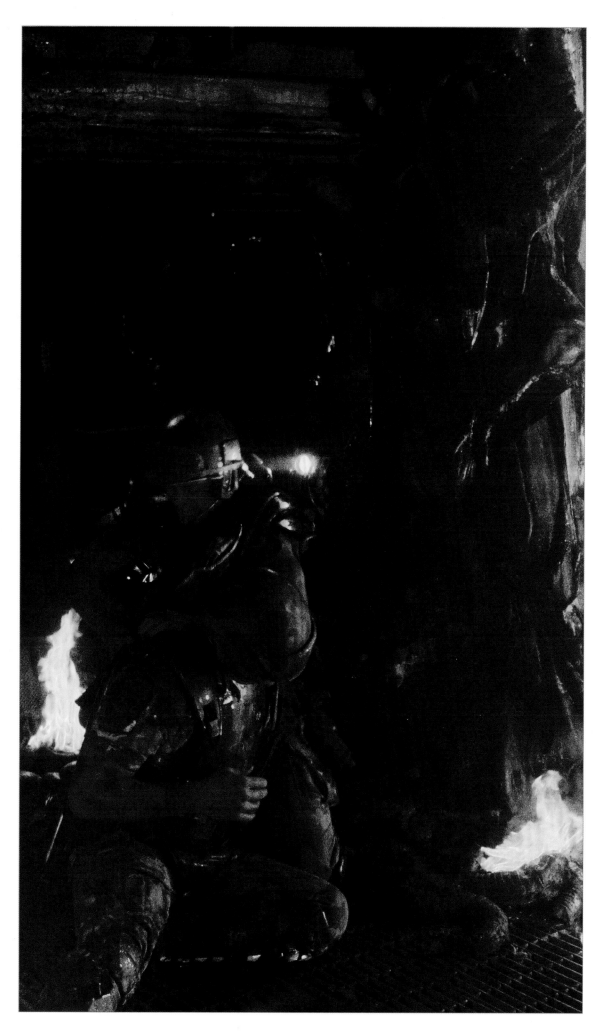

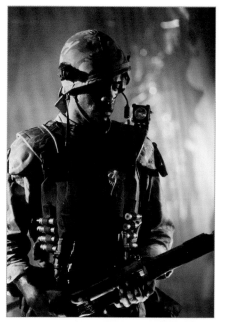

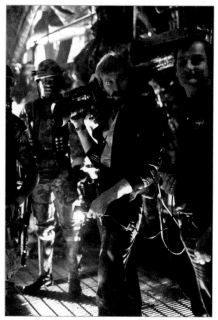

TOP: Pvt. Frost about to be caught in the line of fire of Dietrich's flamethrower. Ricco Ross has a heart with a Cupid arrow shot through it drawn onto his breastplate. The name inside the heart reads 'Heath,' short for Ross's girlfriend Heather.

ABOVE: In a deleted scene, Hudson claims the rifles are "phase-plasma." This is incorrect (it is a kinetic plasma) but is a reference to a weapon namechecked in Cameron's previous film.

LEFT: Ordered not to fire live ammunition, some of the marines take no notice, while others use flamethrowers. As a result, all hell breaks loose as Hicks (Michael Biehn) and Wierzbowski (Trevor Steedman) take cover.

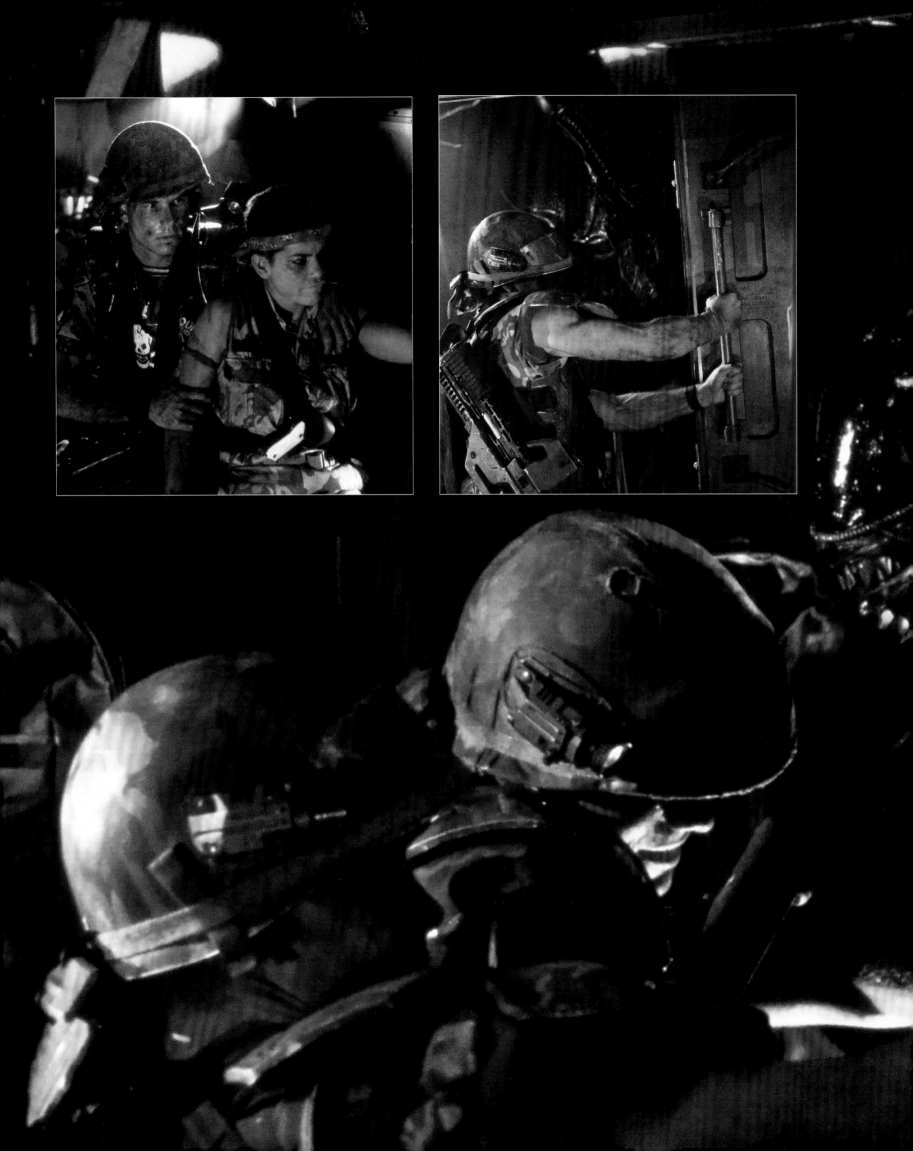

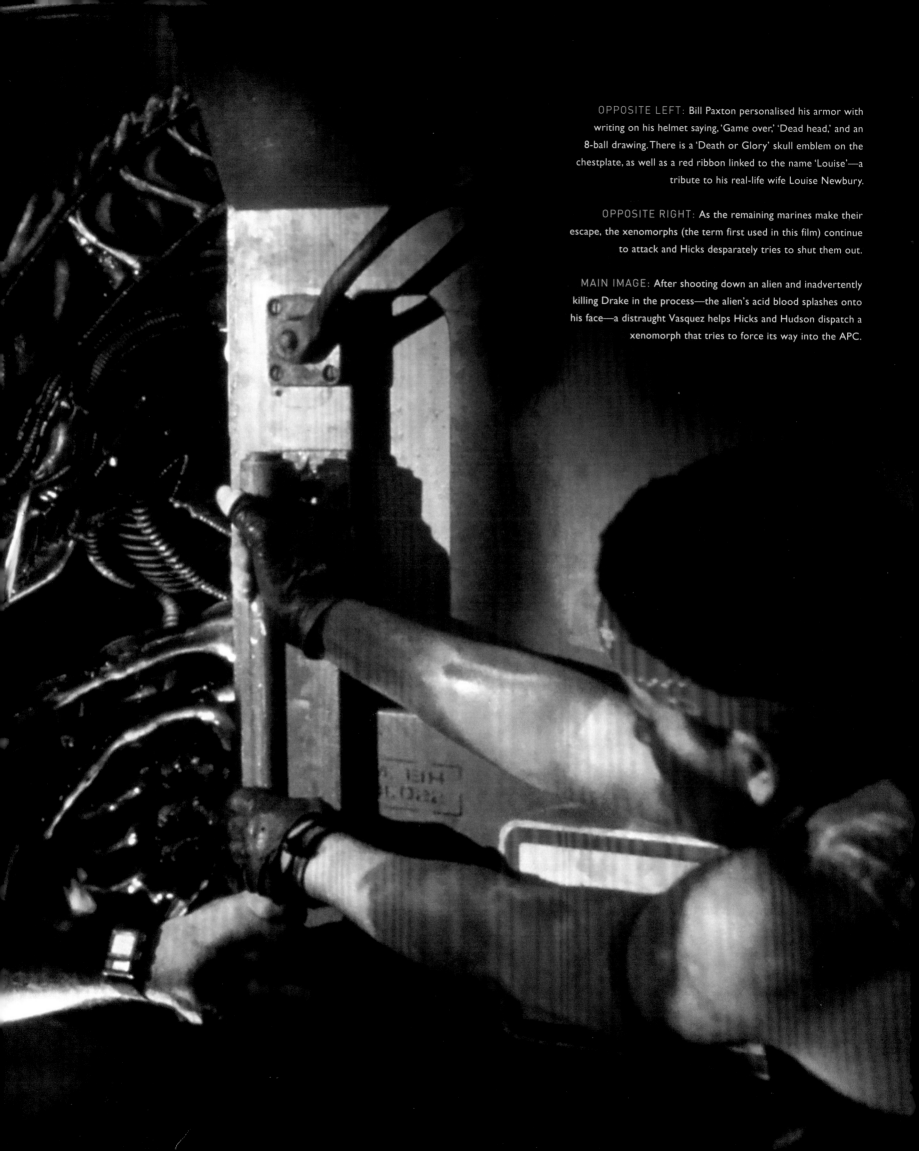

OPPOSITE LEFT: Bill Paxton personalised his armor with writing on his helmet saying, 'Game over,' 'Dead head,' and an 8-ball drawing. There is a 'Death or Glory' skull emblem on the chestplate, as well as a red ribbon linked to the name 'Louise'—a tribute to his real-life wife Louise Newbury.

OPPOSITE RIGHT: As the remaining marines make their escape, the xenomorphs (the term first used in this film) continue to attack and Hicks desparately tries to shut them out.

MAIN IMAGE: After shooting down an alien and inadvertently killing Drake in the process—the alien's acid blood splashes onto his face—a distraught Vasquez helps Hicks and Hudson dispatch a xenomorph that tries to force its way into the APC.

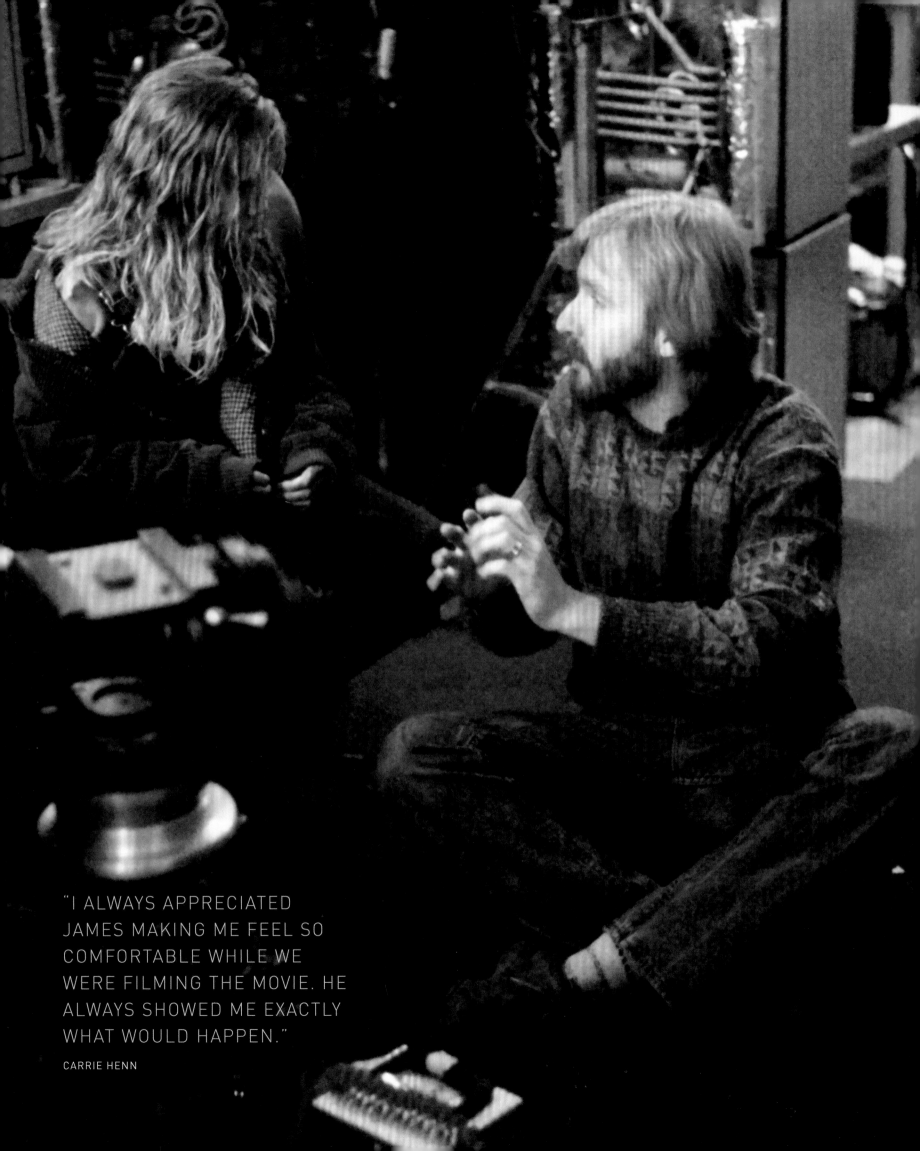

"I ALWAYS APPRECIATED
JAMES MAKING ME FEEL SO
COMFORTABLE WHILE WE
WERE FILMING THE MOVIE. HE
ALWAYS SHOWED ME EXACTLY
WHAT WOULD HAPPEN."

CARRIE HENN

BARRICADED IN

AFTER THE DROPSHIP CRASHES BECAUSE OF A ROGUE ALIEN, THE SURVIVORS RETREAT INTO THE COLONY, HEEDING NEWT'S WARNING: "WE'D BETTER GET BACK BECAUSE IT'LL BE DARK SOON AND THEY MOSTLY COME AT NIGHT. MOSTLY."

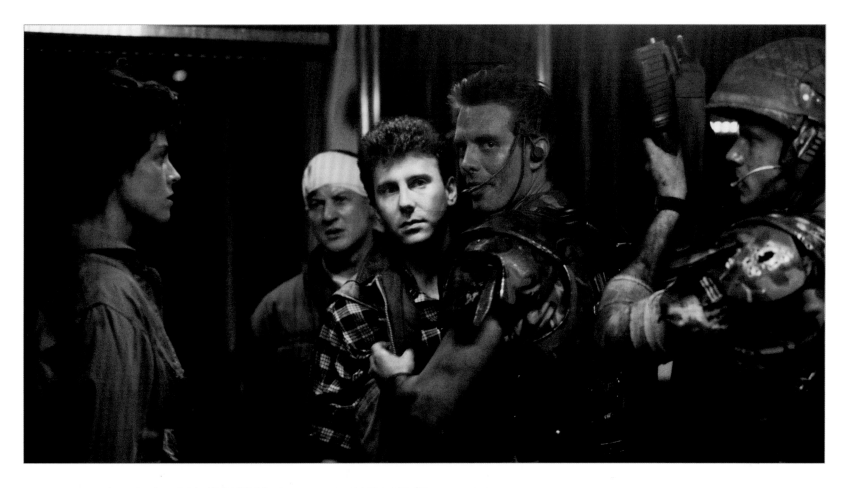

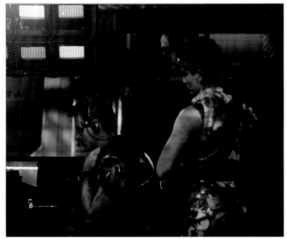

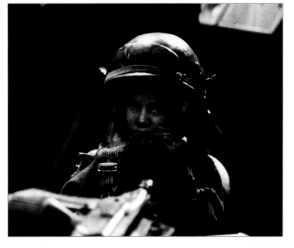

FAR LEFT: In a sequence cut from the original theatrical edition, Ripley and the marines set up remote sentry weapons to keep the alien hordes at bay, and watch the attack from a terminal inside their base.

LEFT: CH: "I loved wearing the helmet. I felt like I was part of the marines!"

ABOVE: After Burke sets the facehuggers on Ripley and Newt, the marines unanimously decide to remove him. As Hudson observes, "You're dog meat, pal."

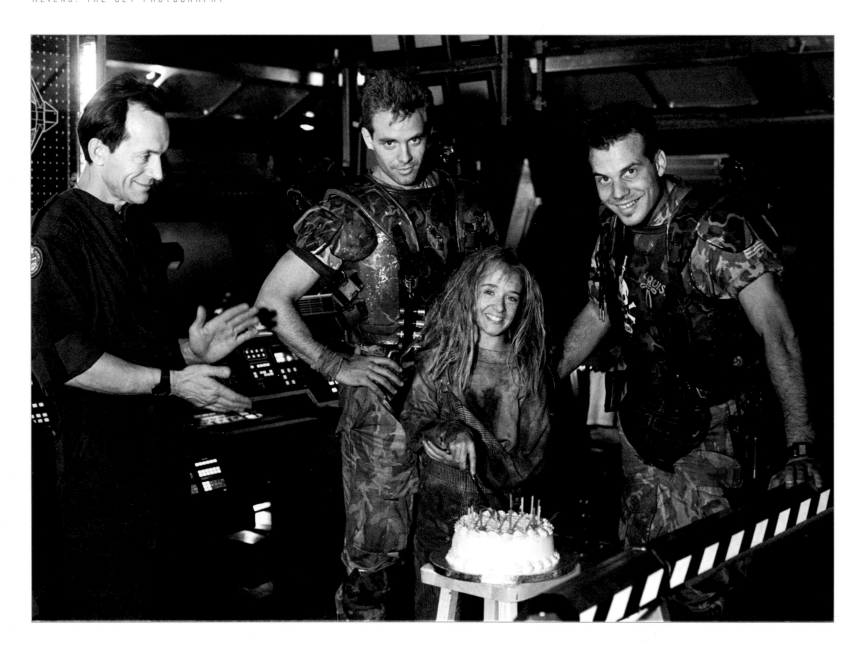

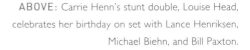

ABOVE: Carrie Henn's stunt double, Louise Head, celebrates her birthday on set with Lance Henriksen, Michael Biehn, and Bill Paxton.

RIGHT: Cameron with the actors between takes of the 'sentry guns versus the aliens' sequence. As with most of the weapons in the film, the sentry guns were adapted from pre-existing firearms, in this case World War II MG42 machine guns.

OPPOSITE TOP LEFT: Ripley cares for Newt and eventually manages to coax her into speaking. CH:"The hot chocolate they gave me was freezing cold—I was so disappointed!"

OPPOSITE TOP RIGHT: Hicks' bond with Ripley continues to grow as he introduces her to his M41 Mark 2 Plasma Pulse Rifle, "a personal friend."

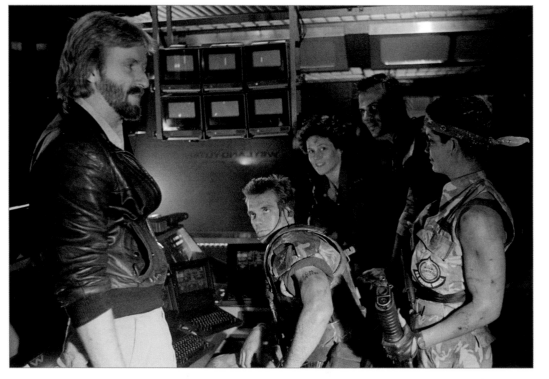

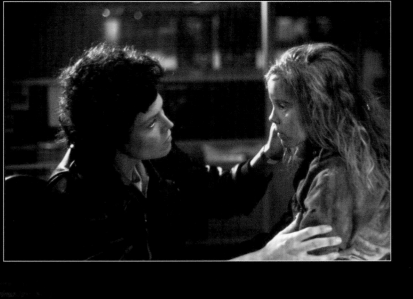
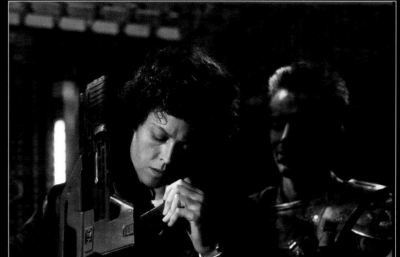

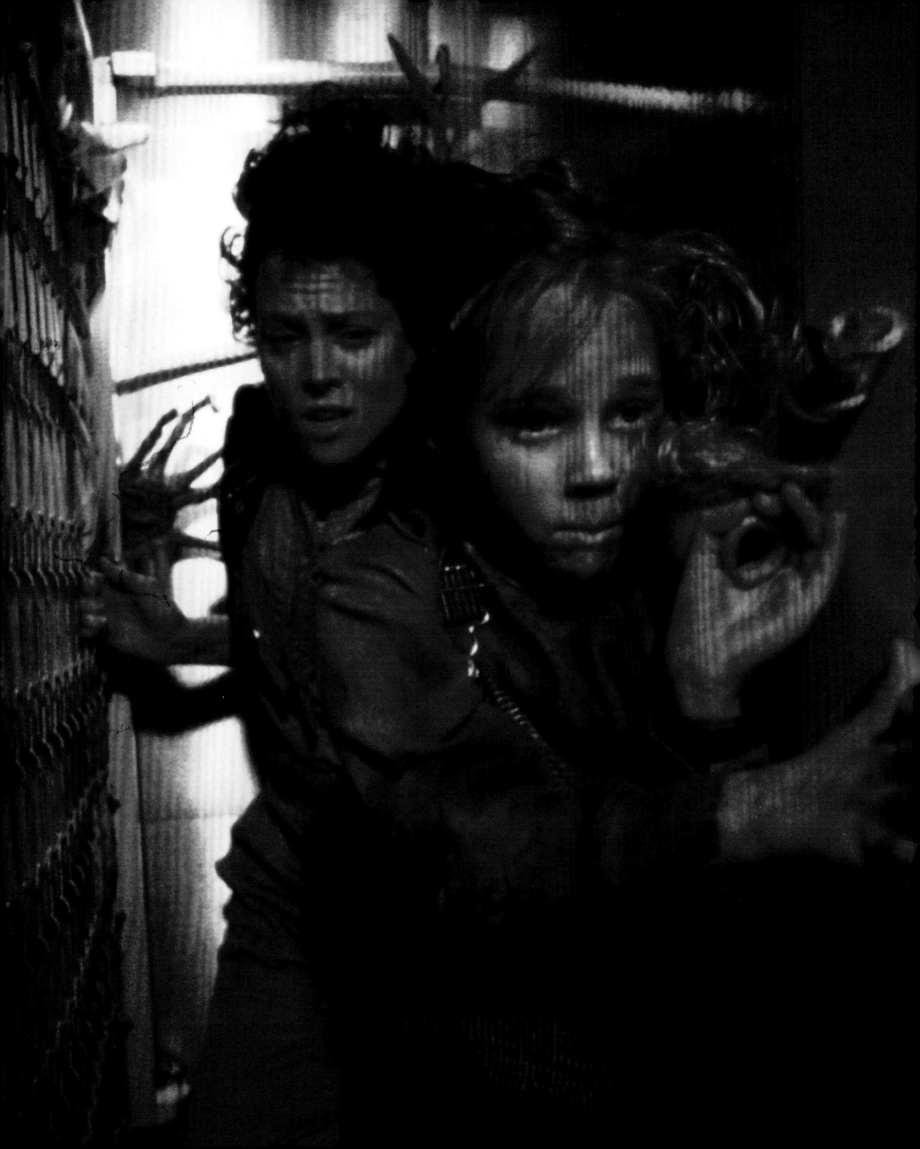

MEDICAL LAB

RIPLEY AND NEWT REST IN THE MEDICAL LAB, BUT BURKE SETS THE FACEHUGGERS
LOOSE ON THEM IN AN ATTEMPT TO SMUGGLE AN ALIEN OUT OF THE COLONY.

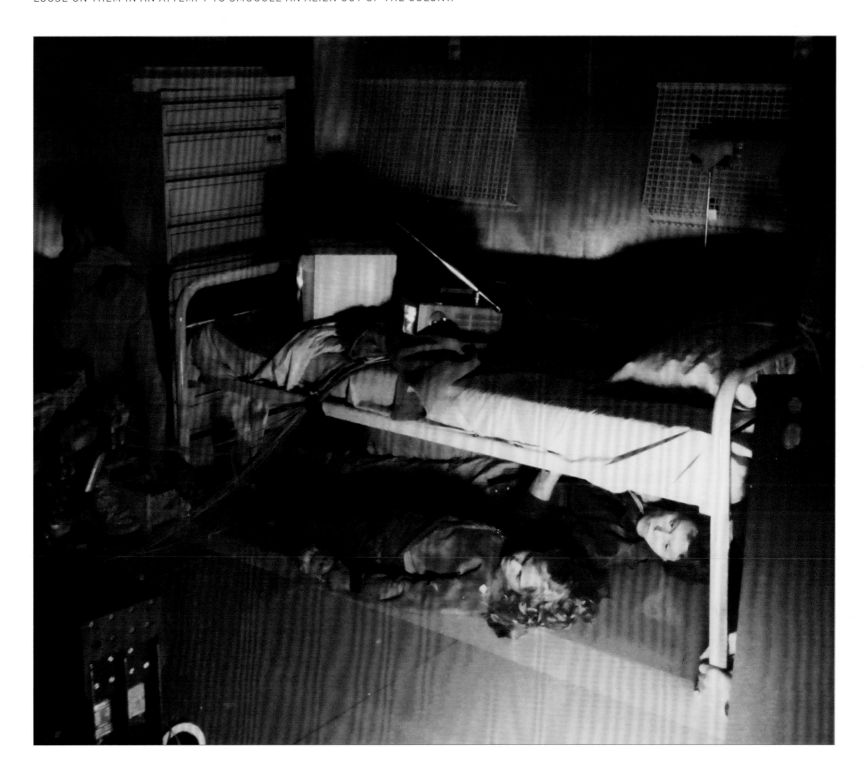

ABOVE: Newt reverts to her survival instinct and sleeps under the bed—
an act which saves her and Ripley's life when the facehuggers appear.

LEFT: Newt clutches her Casey doll head, as always. The new version of
the facehuggers were more mobile and active than in the original film, as
Stan Winston explains, "we had facehuggers running all over the place."

"THIS WAS A FUN SCENE TO FILM, ROLLING
AROUND ON THE FLOOR. WE WOULD SING
SONGS WHILE WAITING UNDER THE BED."

CARRIE HENN ON THE MEDICAL LAB SCENE (ABOVE)

RIGHT: The actors keeping warm on set following the sprinklers being set off by Ripley in the med lab scene. William Hope keeps hold of the facehugger prop.

OPPOSITE: Sigourney Weaver and Bill Paxton enjoy a warming drink between takes of the med lab scene. CH: "I loved the foil blankets, I wanted to keep doing the scene so we could keep using them!"

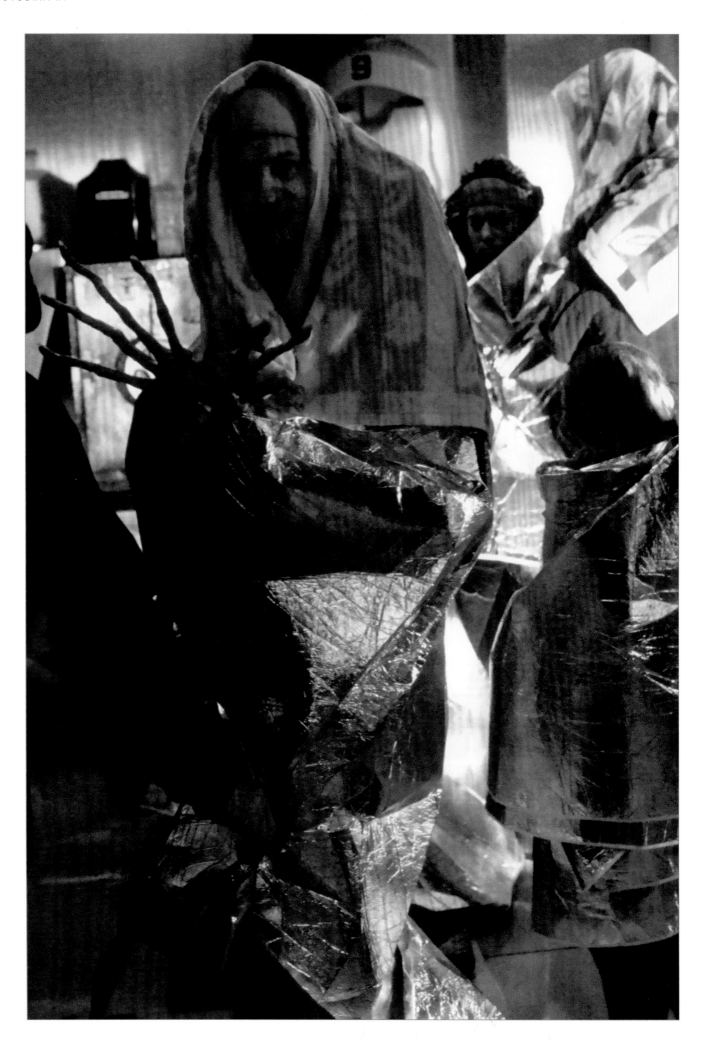

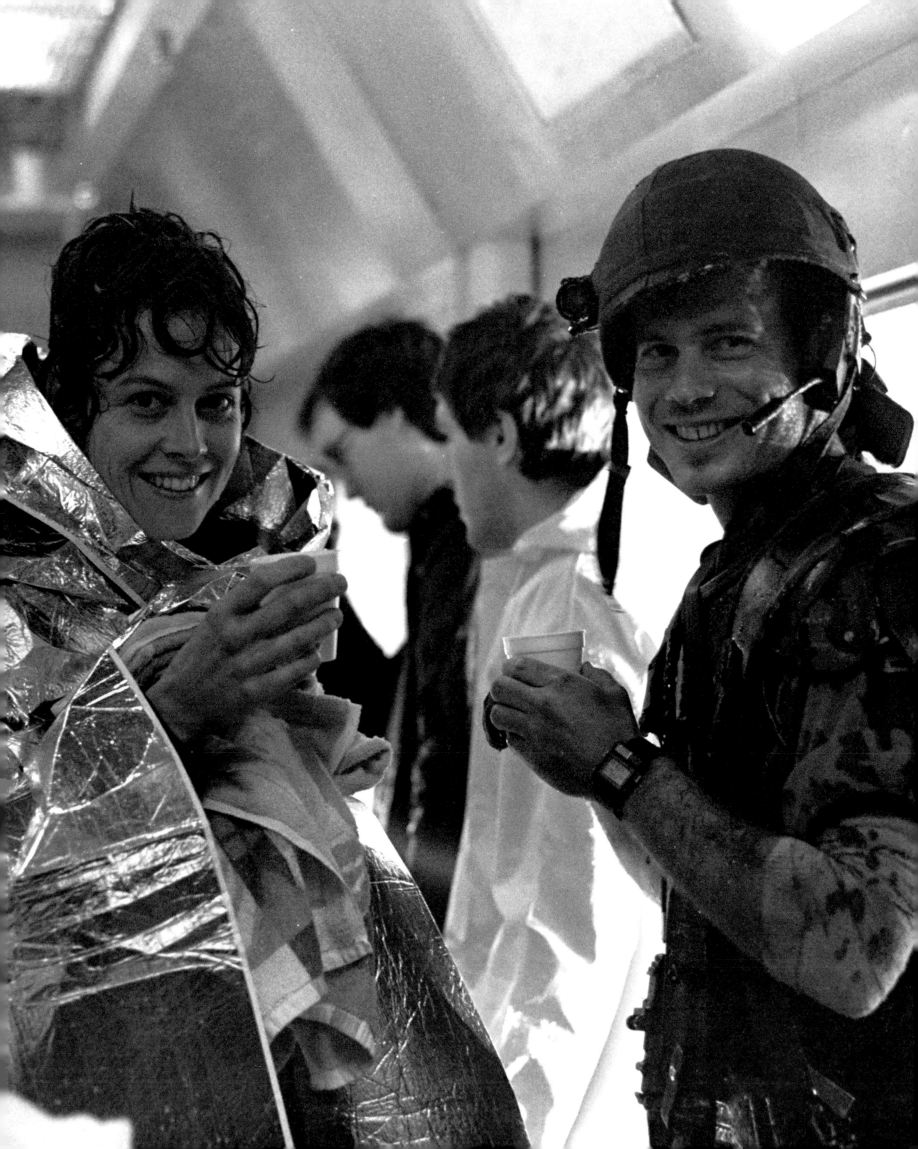

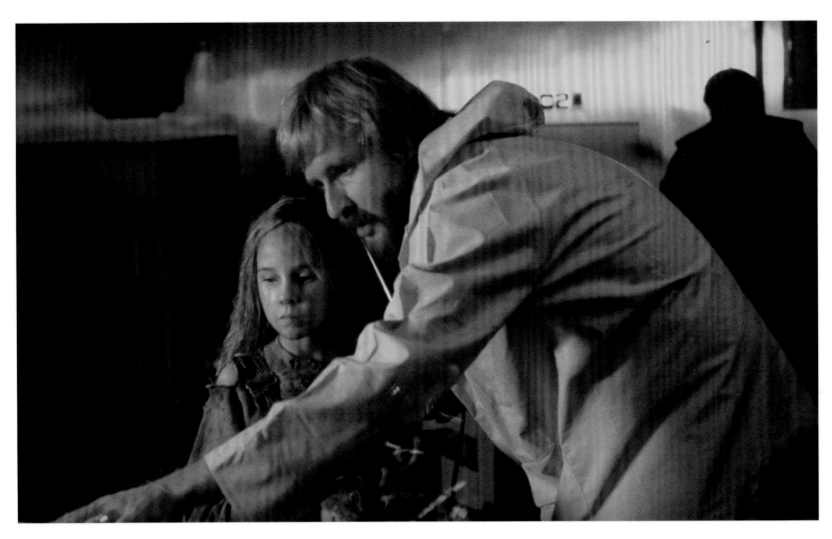

ABOVE: CH: "Jim would make me laugh and used to always try and scare me. So he used to throw stuff at me and try different things."

RIGHT: CH: "Sigourney and I did a lot on set. It always makes me laugh when people see me at conventions because they'll often find a picture of Sigourney holding me, and they'll actually say to me, 'Did you ever meet her?' I just smile politely and say, 'Yes, I did.'"

OPPOSITE: The facehugger attacks Ripley, wrapping its tail around her throat. Cameron wanted the creature to be able to do exactly as he wanted and two working props were built.

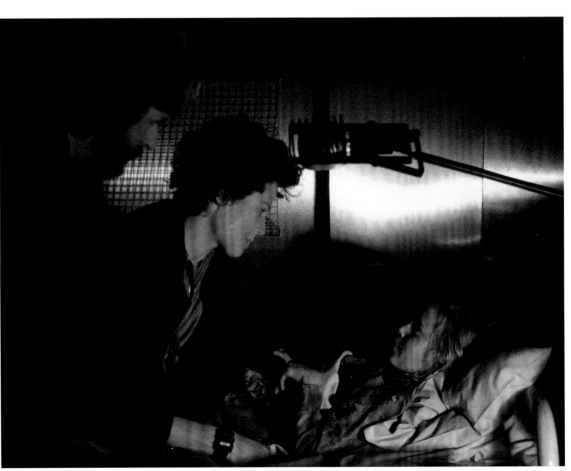

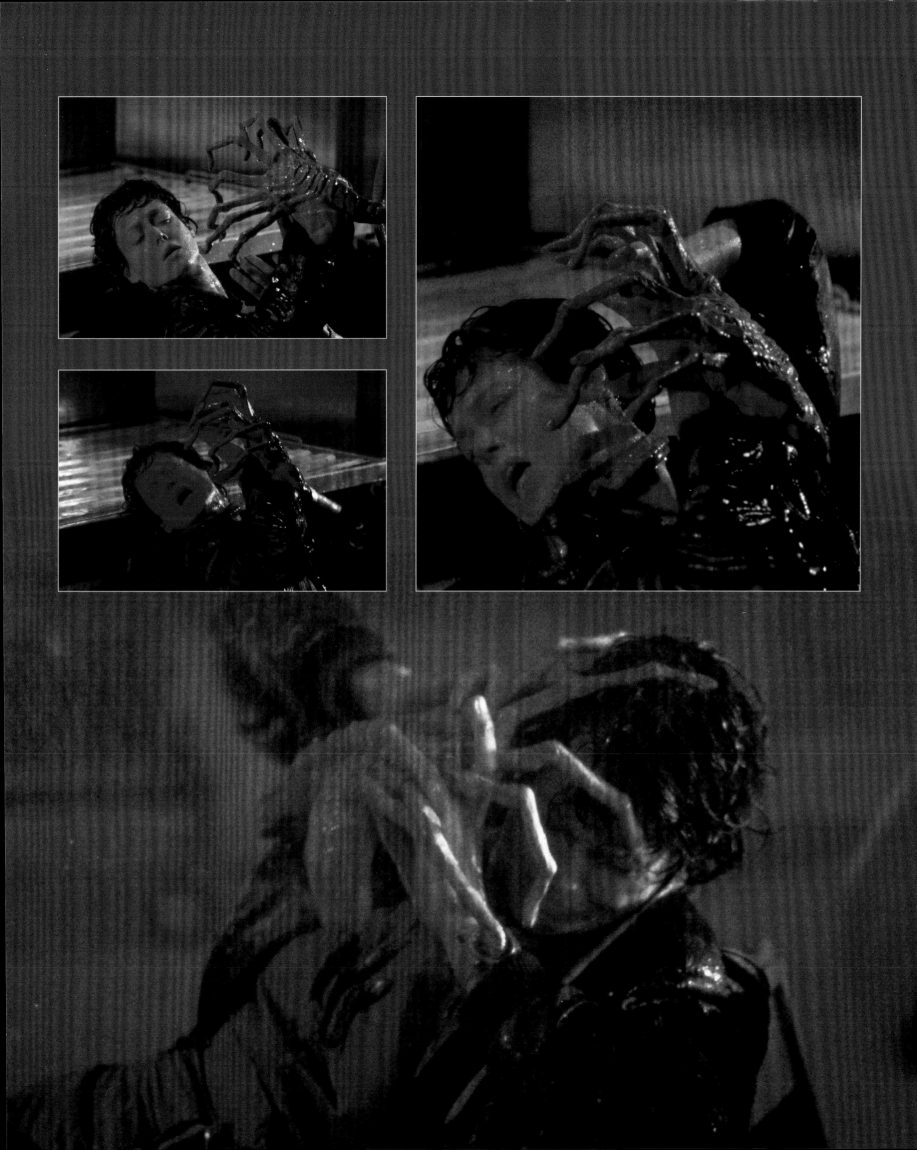

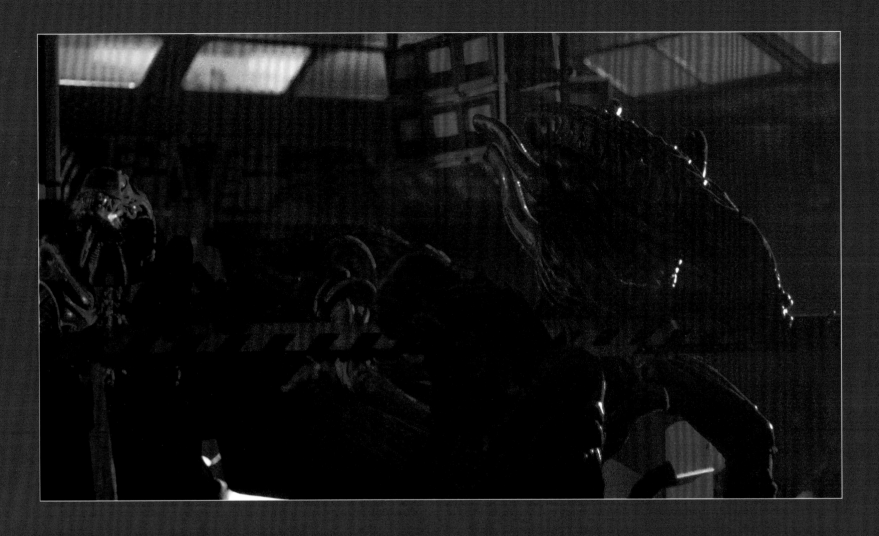

OPPOSITE TOP: Using Cameron's filmmaking savvy (framing, reverse shots), lighting, and the work of the stuntmen in the costumes, the aliens emerge and behave, according to Stan Winston, "like insects."

OPPOSITE BOTTOM: Goldstein discussed with Cameron how she visualised her character, specifying two important visual points: "bandana; teardrop tattoo, which represents years in prison."

THIS PAGE: The original creature suit worn by Bolaji Badejo was latex and heavy. For the sequel, Stan Winston's team used much lighter foam pieces.

THE ESCAPE

WHEN THE ALIENS INVADE THE OPERATIONS ROOM IN THE COLONY, ONLY RIPLEY, NEWT, AND HICKS MAKE IT OUT ALIVE BY CRAWLING THROUGH THE AIR VENTS. BUT RIPLEY AND NEWT SOON BECOME SEPARATED.

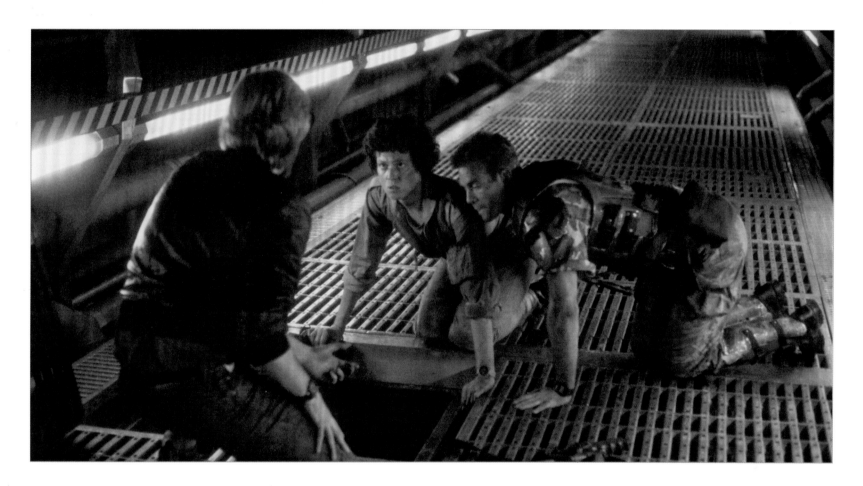

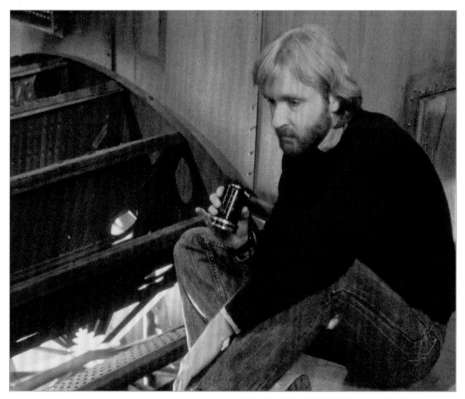

"[JAMES CAMERON IS] ACTUALLY A VERY SHY KIND OF GEEKY TECH GUY AND HE'S ALL-CONSUMED BY THE WORK HE'S DOING AT THE TIME."

JENETTE GOLDSTEIN ON HER DIRECTOR'S PRESENCE ON SET (LEFT)

ABOVE: The family unit is the core and overt theme running through the film. Ripley and Hicks are brought together purely by circumstance, but their closeness and affection for Newt gives all of them a second chance at family: replacing Ripley's daughter, Newt's parents and brother, and even Hicks' comrades in the marine corps.

OPPOSITE: Hicks (Michael Biehn) prepares to follow Newt and Ripley out of the medical lab. Fans have pointed out that it is counter-intuitive for the LED ammo count on the plasma rifles to be on the side of the weapon, making it harder to easily see when in use—but possibly easier for viewers to keep track of.

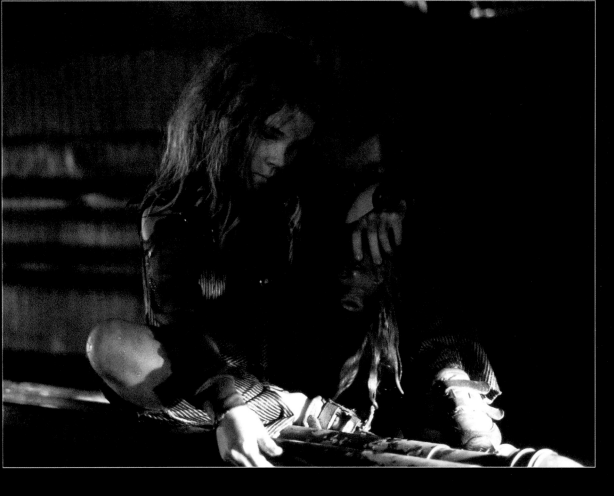

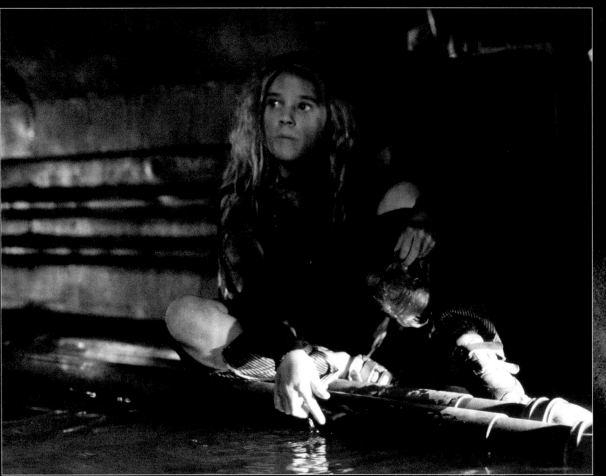

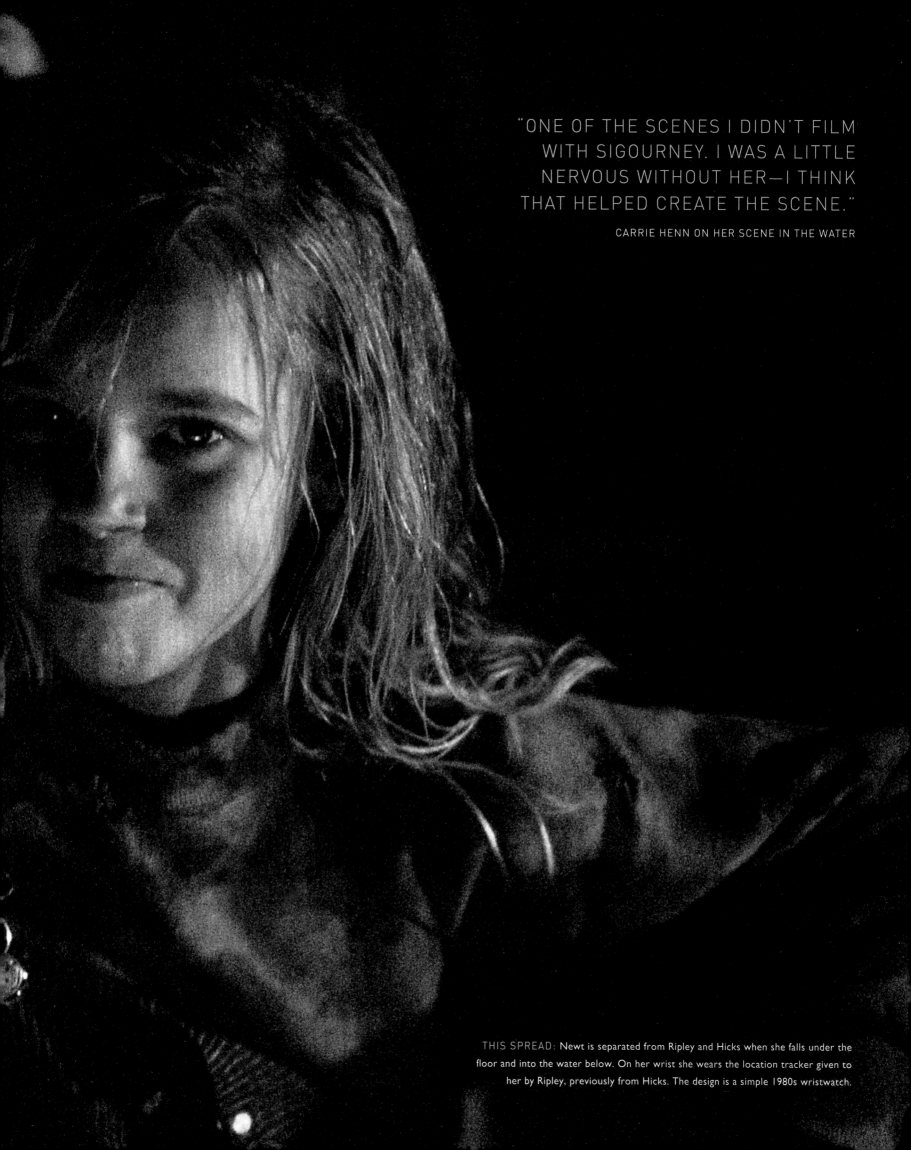

"ONE OF THE SCENES I DIDN'T FILM WITH SIGOURNEY. I WAS A LITTLE NERVOUS WITHOUT HER—I THINK THAT HELPED CREATE THE SCENE."

CARRIE HENN ON HER SCENE IN THE WATER

THIS SPREAD: Newt is separated from Ripley and Hicks when she falls under the floor and into the water below. On her wrist she wears the location tracker given to her by Ripley, previously from Hicks. The design is a simple 1980s wristwatch.

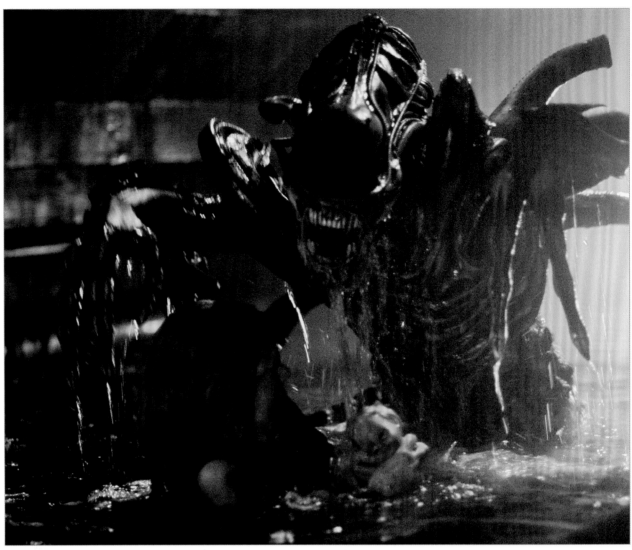
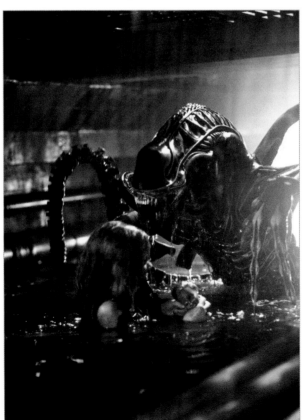
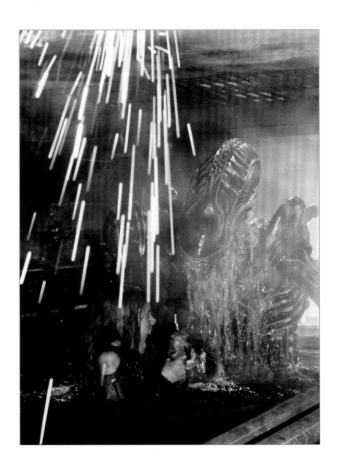

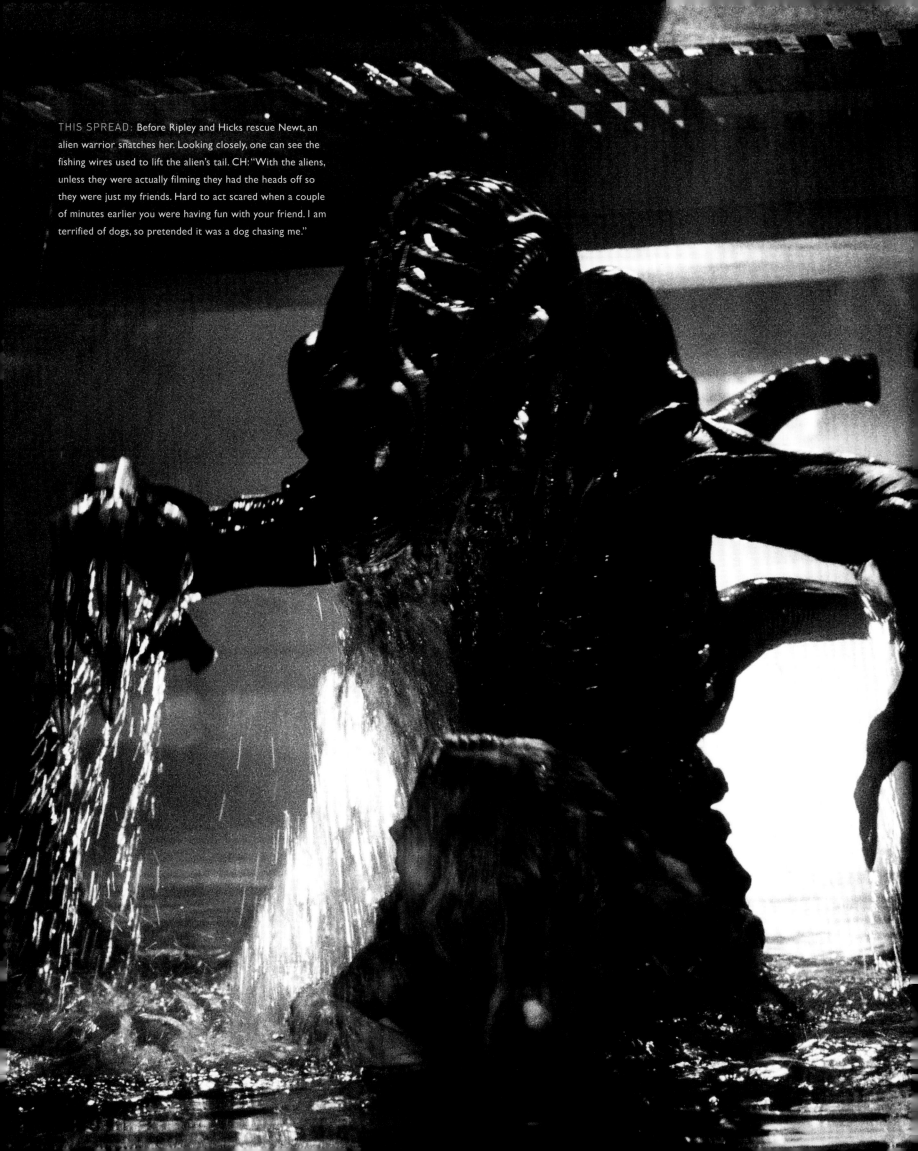

THIS SPREAD: Before Ripley and Hicks rescue Newt, an alien warrior snatches her. Looking closely, one can see the fishing wires used to lift the alien's tail. CH: "With the aliens, unless they were actually filming they had the heads off so they were just my friends. Hard to act scared when a couple of minutes earlier you were having fun with your friend. I am terrified of dogs, so pretended it was a dog chasing me."

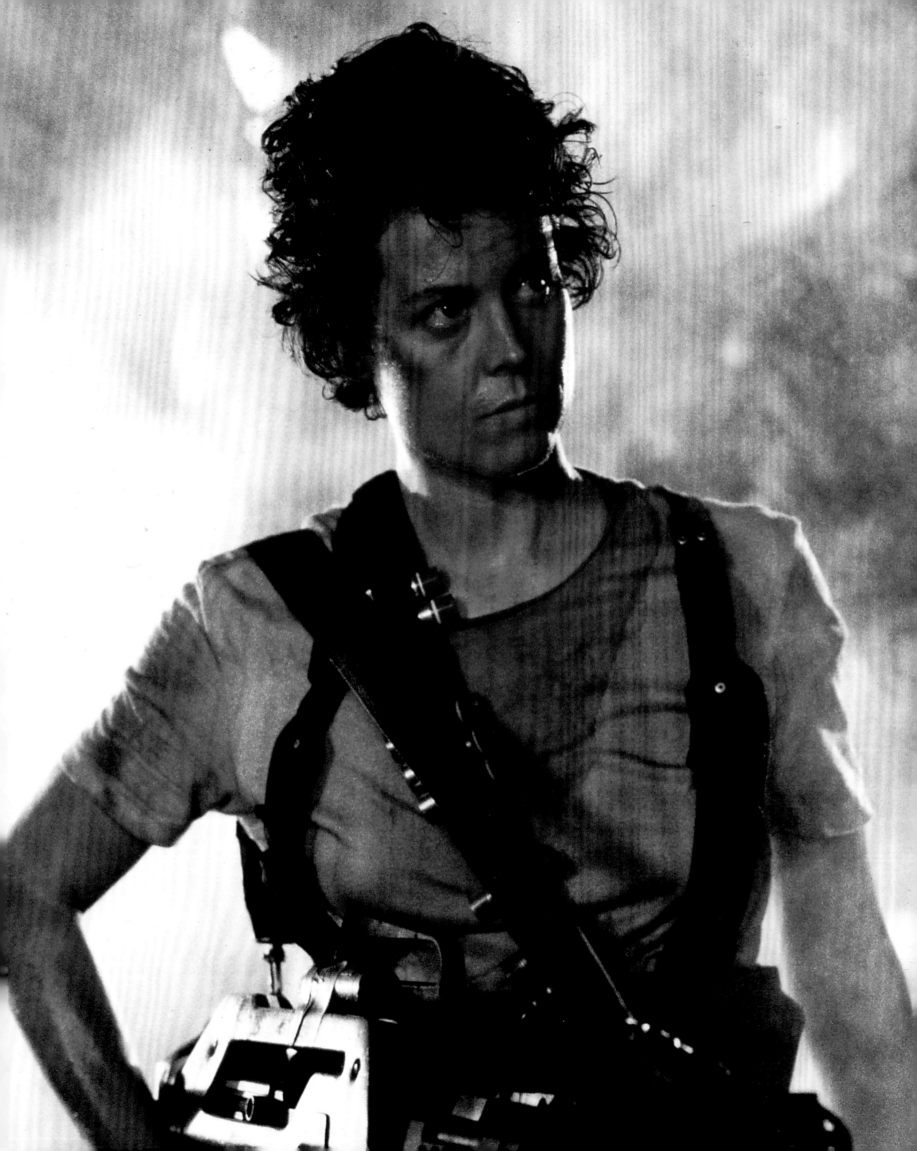

RESCUING NEWT

WHEN HICKS IS INJURED BY THE XENOMORPH'S ACID BLOOD, RIPLEY ARMS HERSELF AND GOES IN SEARCH OF NEWT. DESPITE HER INITIAL
RELUCTANCE TO RETURN TO THE PLANET AND DESPITE ALL THE EFFORTS OF THE MARINES, RIPLEY MUST FACE THE ALIENS ALONE—AGAIN.

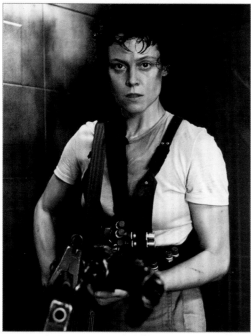

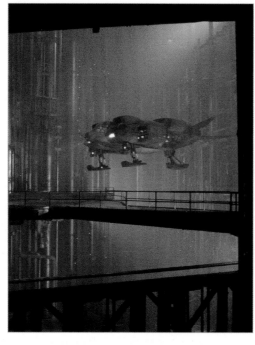

OPPOSITE: Sigourney Weaver compared Ripley to
Shakespeare's Henry V or women warriors in Chinese
classical literature. She nicknamed her character
'Rambolina,' after Sylvester Stallone's iconic hero and
again in keeping with the Vietnam fallout overtones.

ABOVE: CH: "It's one of the few movies where the
female is the hero. That's an important aspect."

FAR LEFT: Highly resourceful, Ripley duct-tapes an
M240 Incinerator Unit to the left-hand side of a pulse
rifle. She attaches the wristwatch locator to the top, and
goes in search of Newt. For the live fire produced from
the weapon, the production used liquid fuel as opposed
to gas-powered because it was a safer and more
common option.

LEFT: Bishop remotely pilots the remaining dropship
out of the colony.

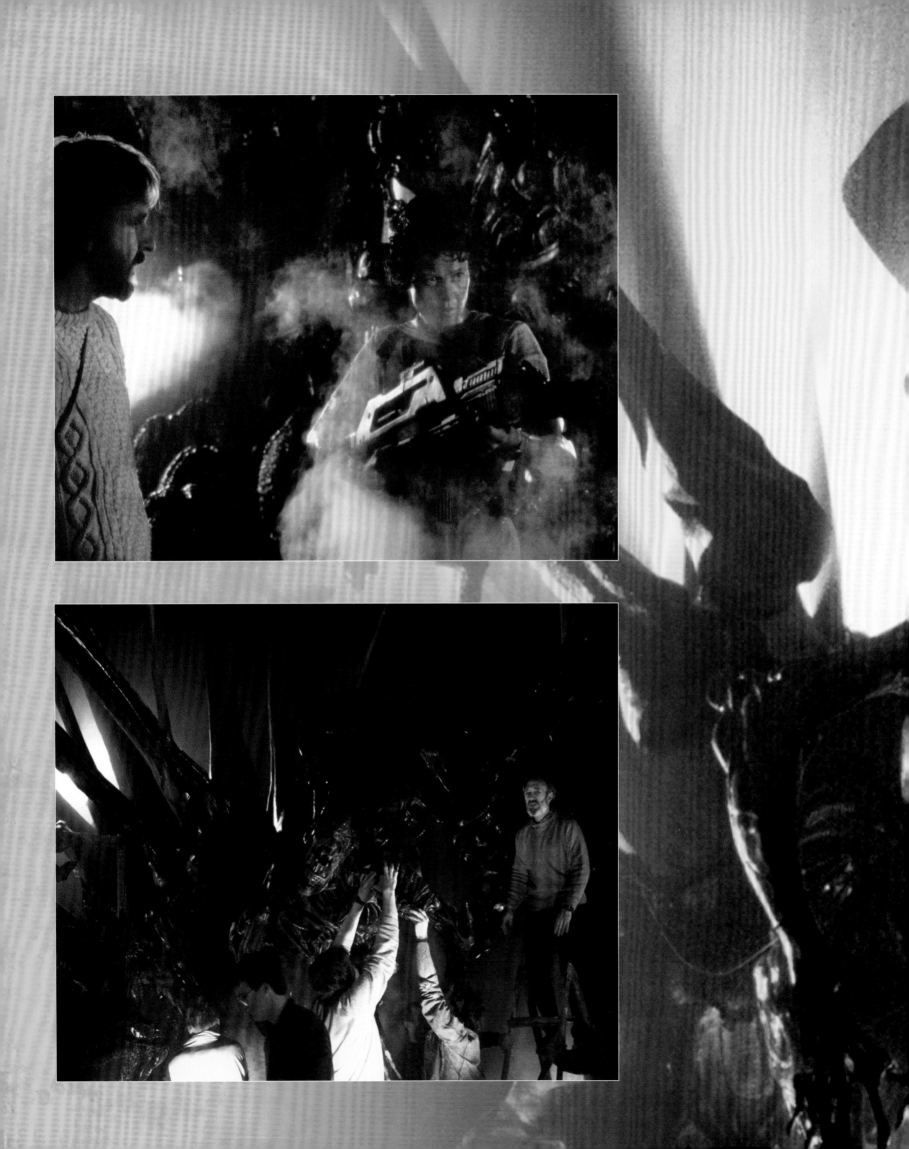

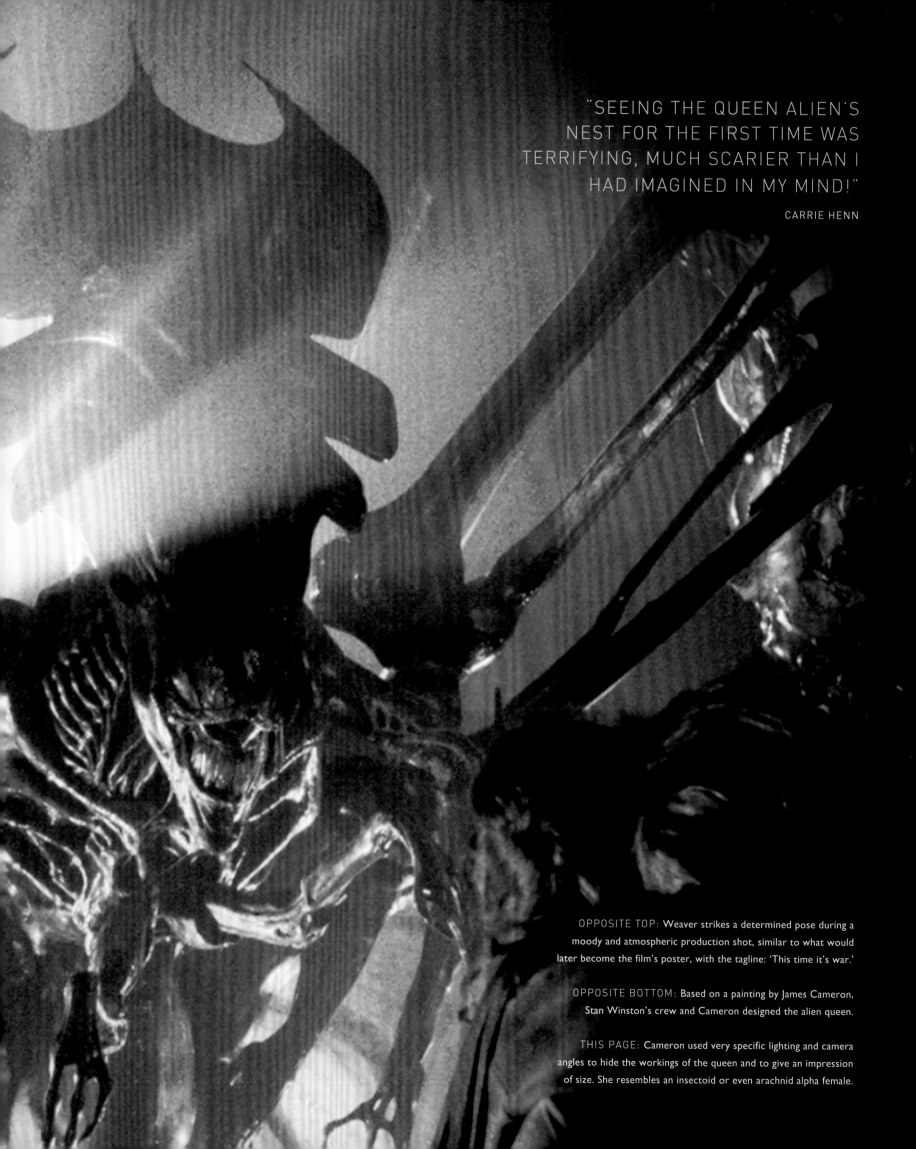

"SEEING THE QUEEN ALIEN'S NEST FOR THE FIRST TIME WAS TERRIFYING, MUCH SCARIER THAN I HAD IMAGINED IN MY MIND!"

CARRIE HENN

OPPOSITE TOP: Weaver strikes a determined pose during a moody and atmospheric production shot, similar to what would later become the film's poster, with the tagline: 'This time it's war.'

OPPOSITE BOTTOM: Based on a painting by James Cameron, Stan Winston's crew and Cameron designed the alien queen.

THIS PAGE: Cameron used very specific lighting and camera angles to hide the workings of the queen and to give an impression of size. She resembles an insectoid or even arachnid alpha female.

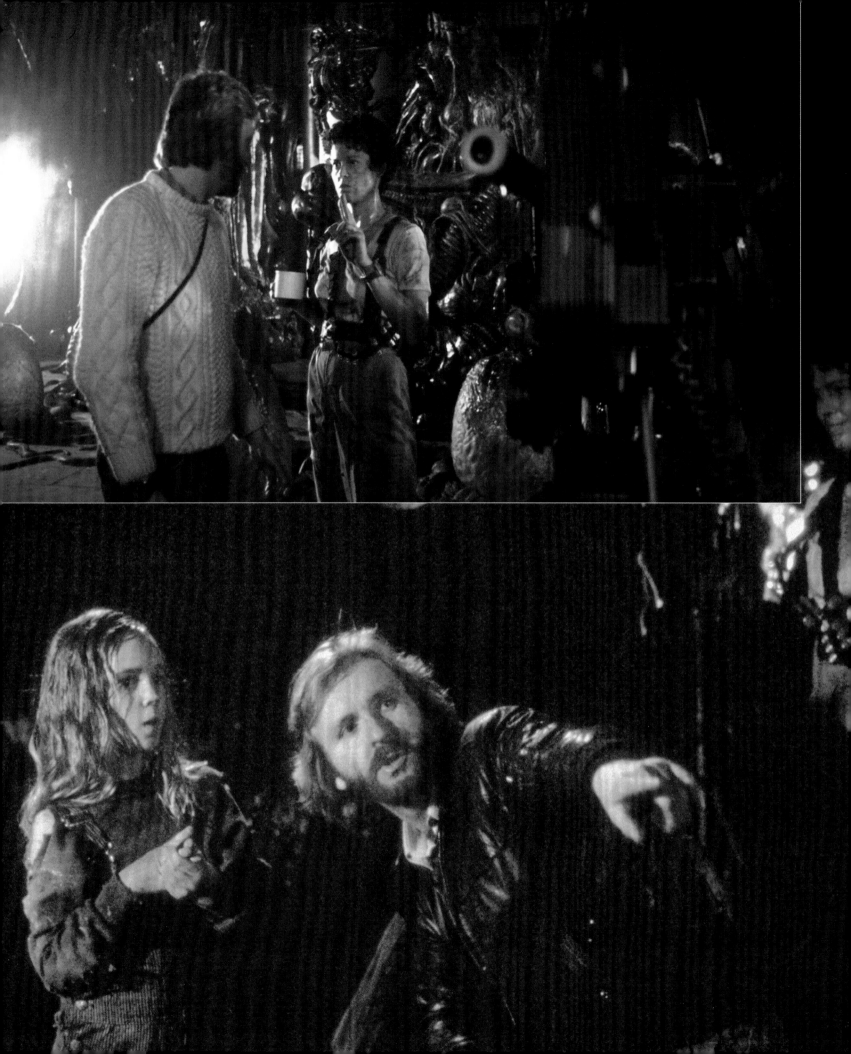

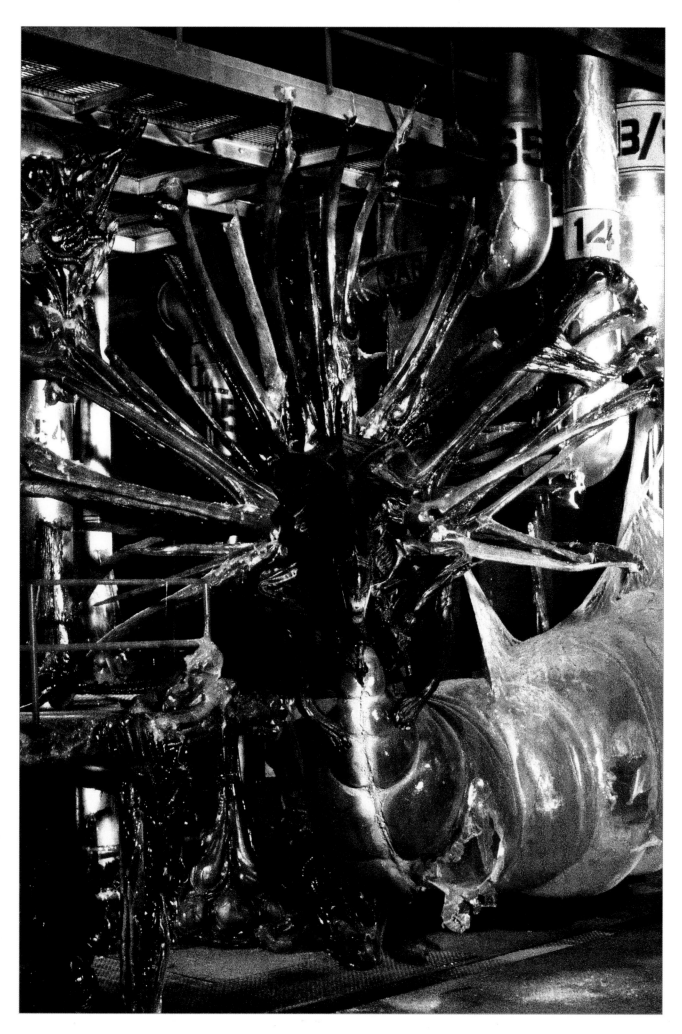

OPPOSITE TOP: Weaver and Cameron discuss the nest sequence. From the beginning of their relationship on the film, the actress and the director collaborated closely, with Cameron welcoming Weaver's notes on how her character would react in certain situations.

OPPOSITE BOTTOM: CH: "Because of all the smoke, guns and flames, I had to know exactly where to go and what to do. James was very specific with what I was to do. I must have been a worry for all of them during this scene. Sigourney was really concerned about me with that gun and the flamethrower. And you can see her in the film, pushing me behind her. Part of that was her character but part of that was her— that's just who she is."

LEFT: The queen attached to her ovipositor—her sac-like organ that lays and deposits the eggs. It is based on an early design of Cameron's.

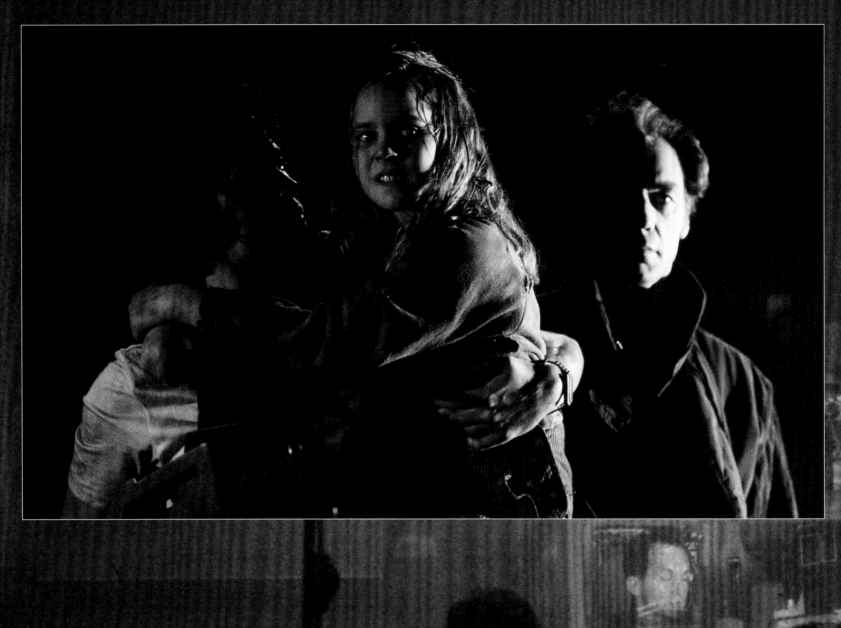

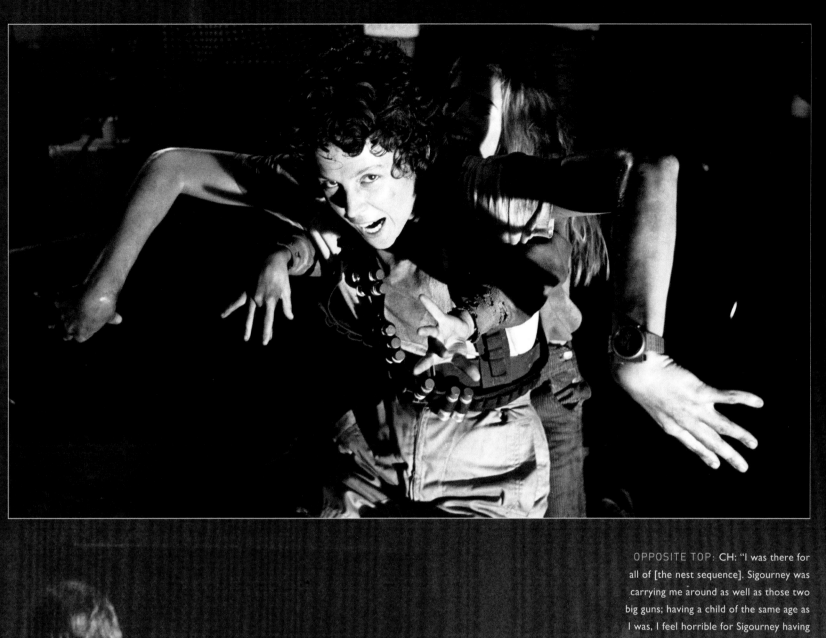

OPPOSITE TOP: CH: "I was there for all of [the nest sequence]. Sigourney was carrying me around as well as those two big guns; having a child of the same age as I was, I feel horrible for Sigourney having to carry me around so much!"

ABOVE: Weaver does her own alien queen impression with Carrie Henn's stunt double Louise Head.

MAIN IMAGE: Preparing the dropship for Bishop's rescue flight.

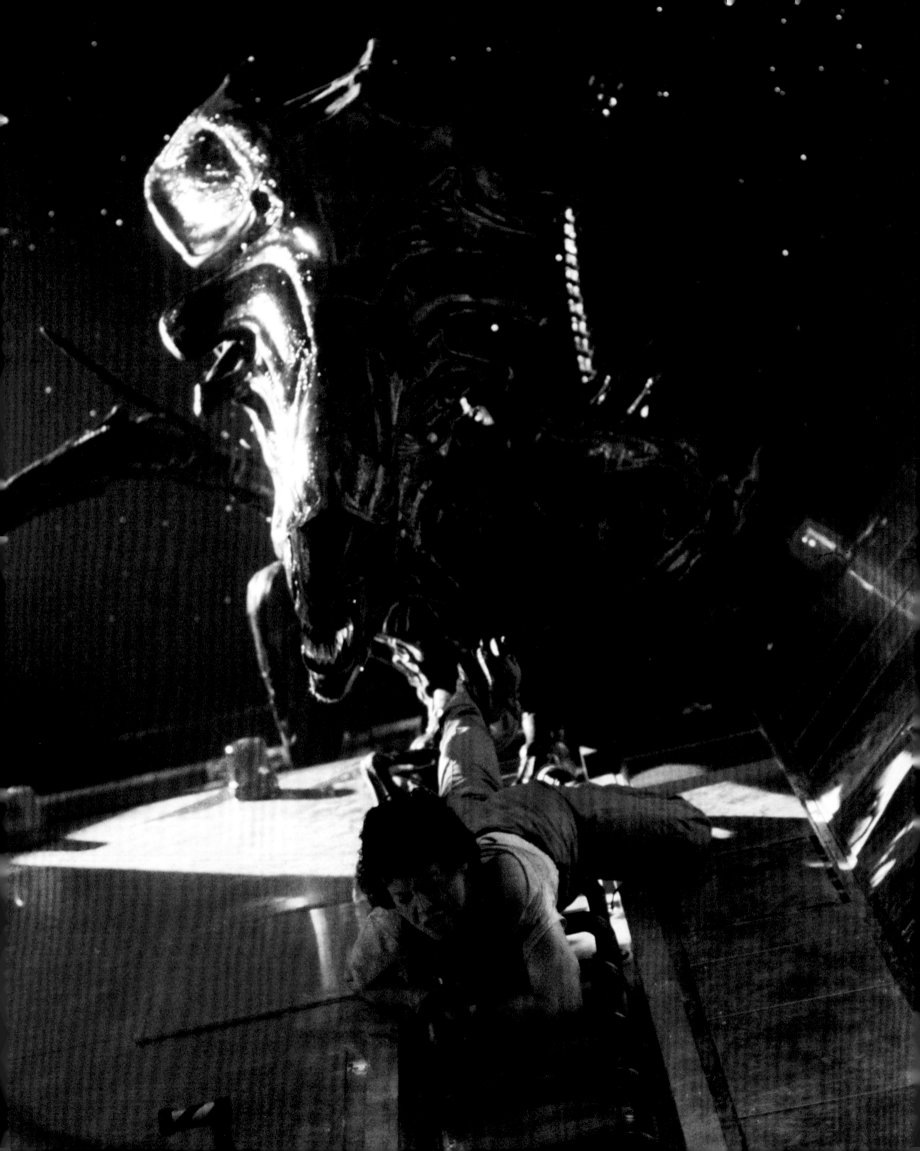

THE FINAL BATTLE

AFTER RESCUING NEWT AND DESTROYING THE QUEEN'S NEST, RIPLEY, NEWT, AND HICKS ESCAPE THE
COLONY IN THE DROPSHIP, PILOTED BY BISHOP. THEY MAKE IT BACK TO THE *SULACO*—WITH A STOWAWAY.

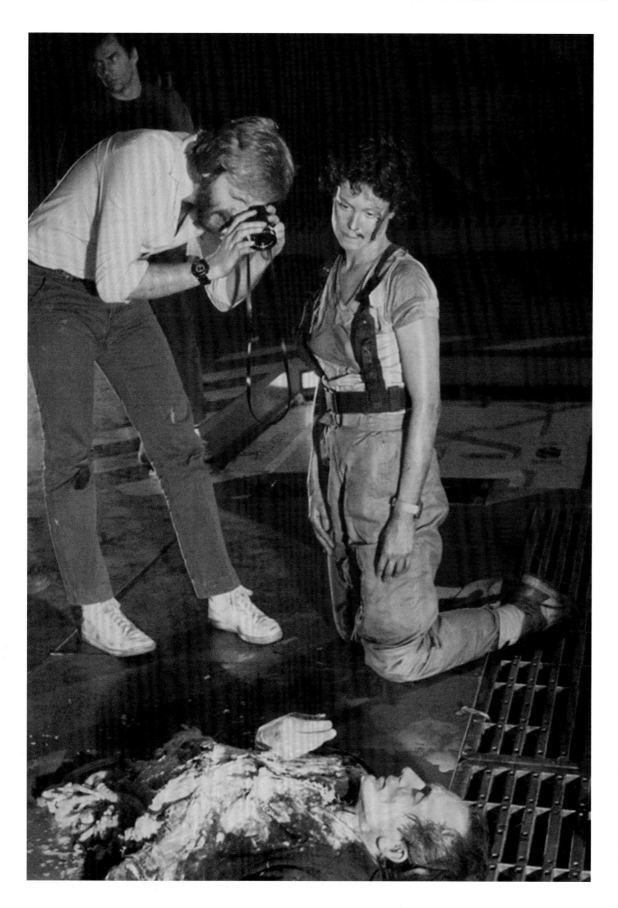

"[JAMES CAMERON] IS JUST FOCUSSED ON EVERYTHING HE DOES, 110%. AND HE EXPECTS THAT FROM EVERYONE WORKING WITH HIM, AS HE SHOULD."

JENETTE GOLDSTEIN

OPPOSITE: A wire holds the tip of the queen's tail in place. Stuntmen controlled the tail's side-to-side movement, while hydraulics served for the vertical.

LEFT: CH: "The final battle was very draining to film. I felt bad for Lance having to lay like that for so long—and the milk he had to spit out of his mouth was sour!"

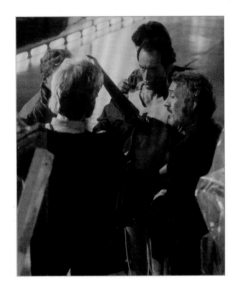

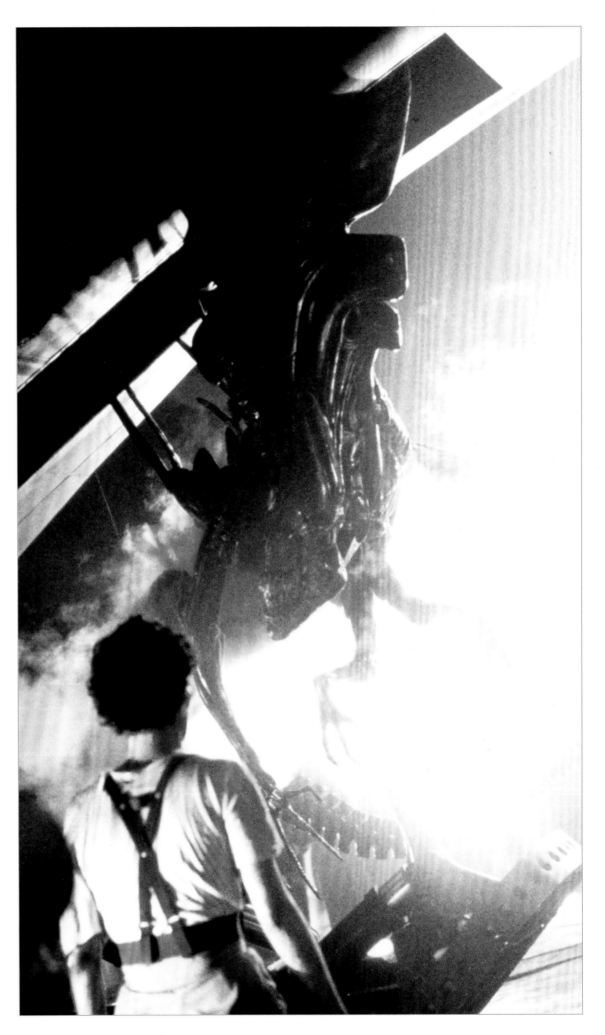

THIS PAGE: The queen reveals herself and impales Bishop with her knife-like tail. She rips him apart in an incredibly brutal moment that may have been a step toward 'splatter horror' if it wasn't for Bishop being an android. CH: "It was amazing to watch Lance be cut in half. It took a long time to get it just right."

OPPOSITE TOP: CH: "As tiring as the scene was, it was fun to be pulled across the ground on a string. The harness I was attached to was the same harness used to fly. Stunt coordinator, Paul Weston, let me fly like Peter Pan on another set. He then told me I was ready to be a stunt girl—which I thought was very cool at the time!"

OPPOSITE BOTTOM: CH: "I was walking along and I saw this big hole in the ground. I said, 'What's that for?' and they said, 'Oh, Lance.' And I couldn't figure it out. Then I realised that the body needed to be in it."

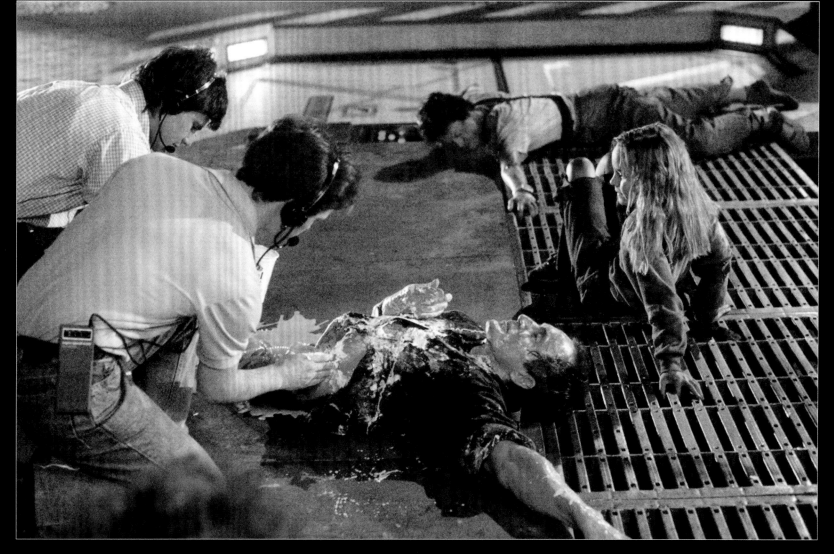
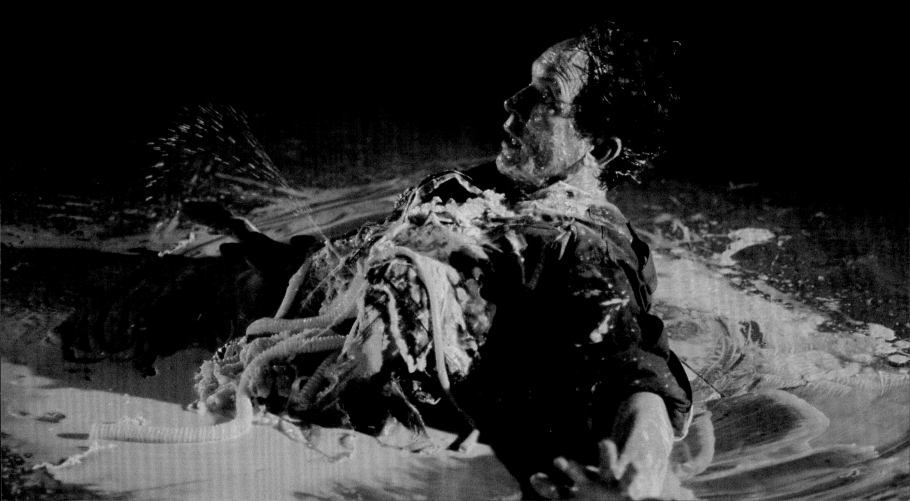

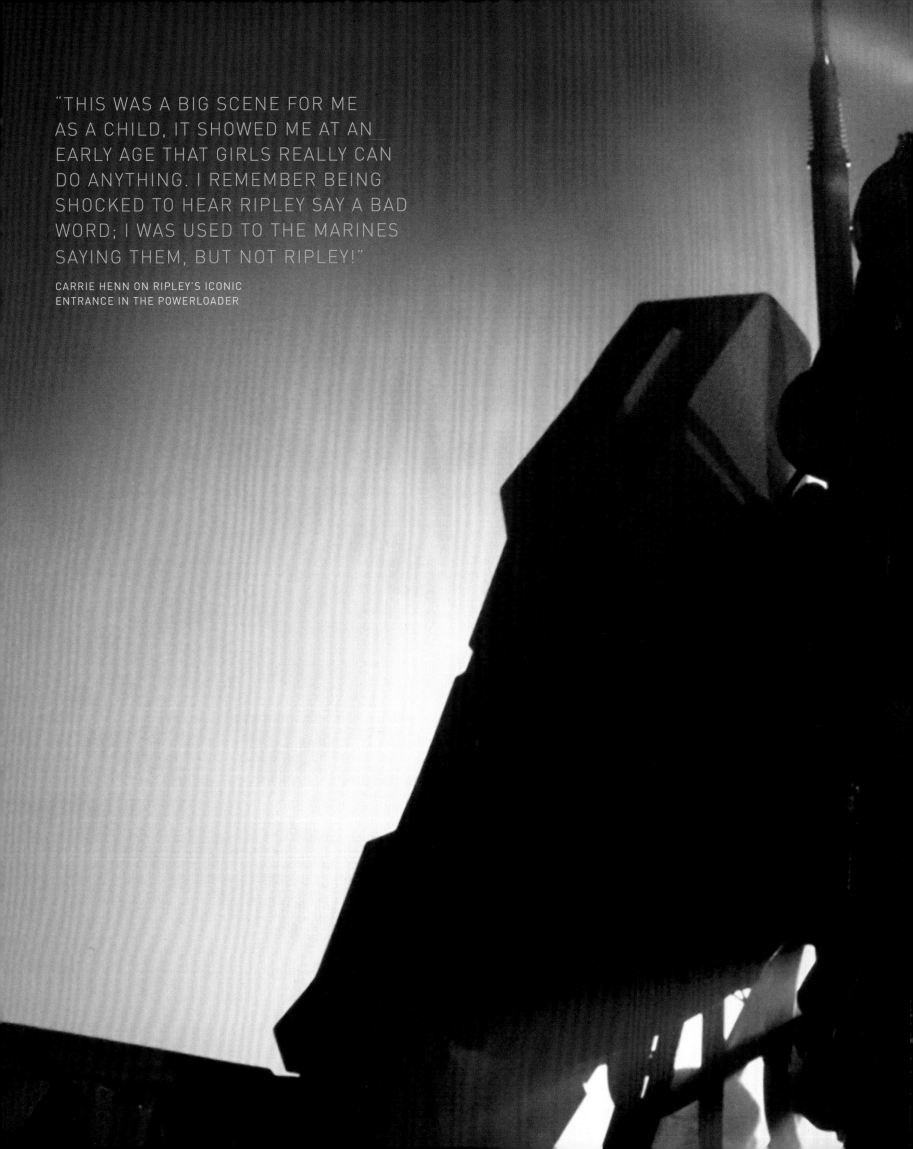

"THIS WAS A BIG SCENE FOR ME AS A CHILD, IT SHOWED ME AT AN EARLY AGE THAT GIRLS REALLY CAN DO ANYTHING. I REMEMBER BEING SHOCKED TO HEAR RIPLEY SAY A BAD WORD; I WAS USED TO THE MARINES SAYING THEM, BUT NOT RIPLEY!"

CARRIE HENN ON RIPLEY'S ICONIC
ENTRANCE IN THE POWERLOADER

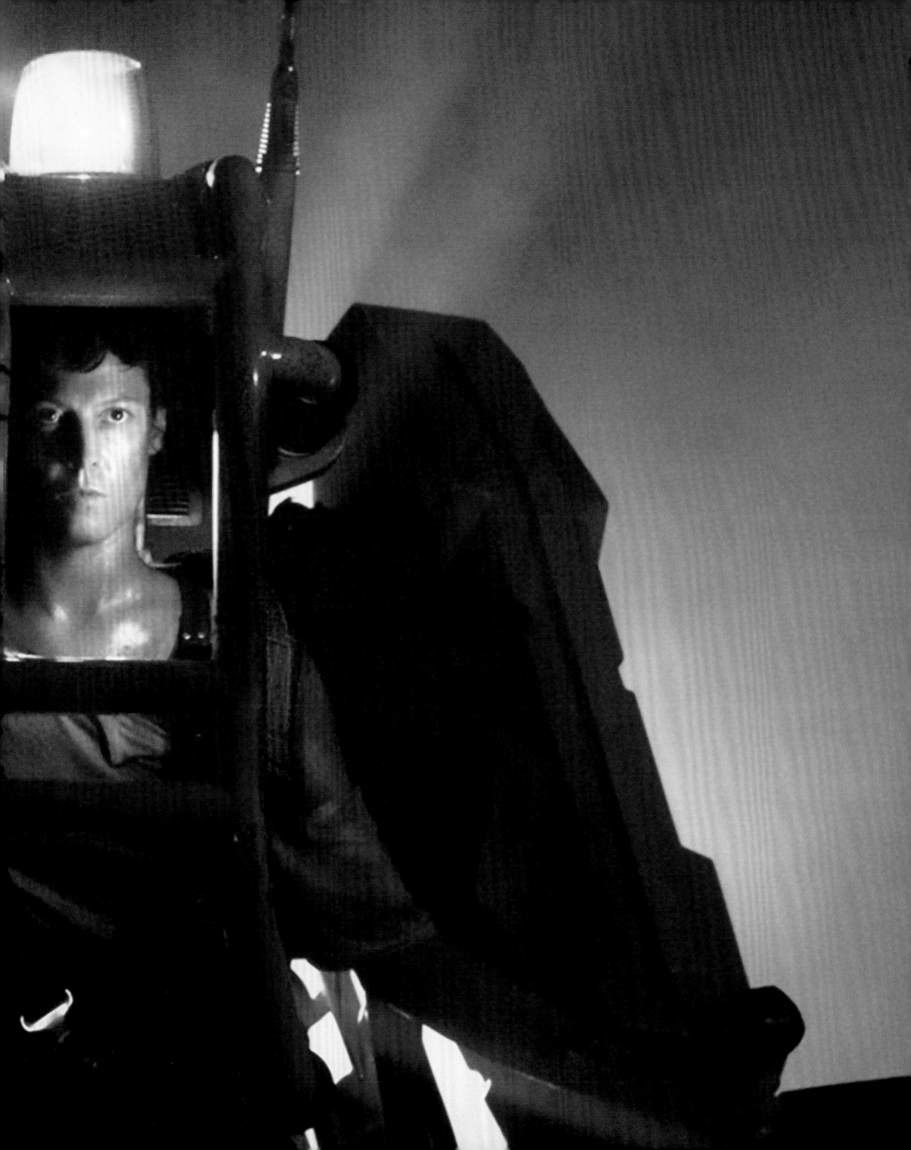

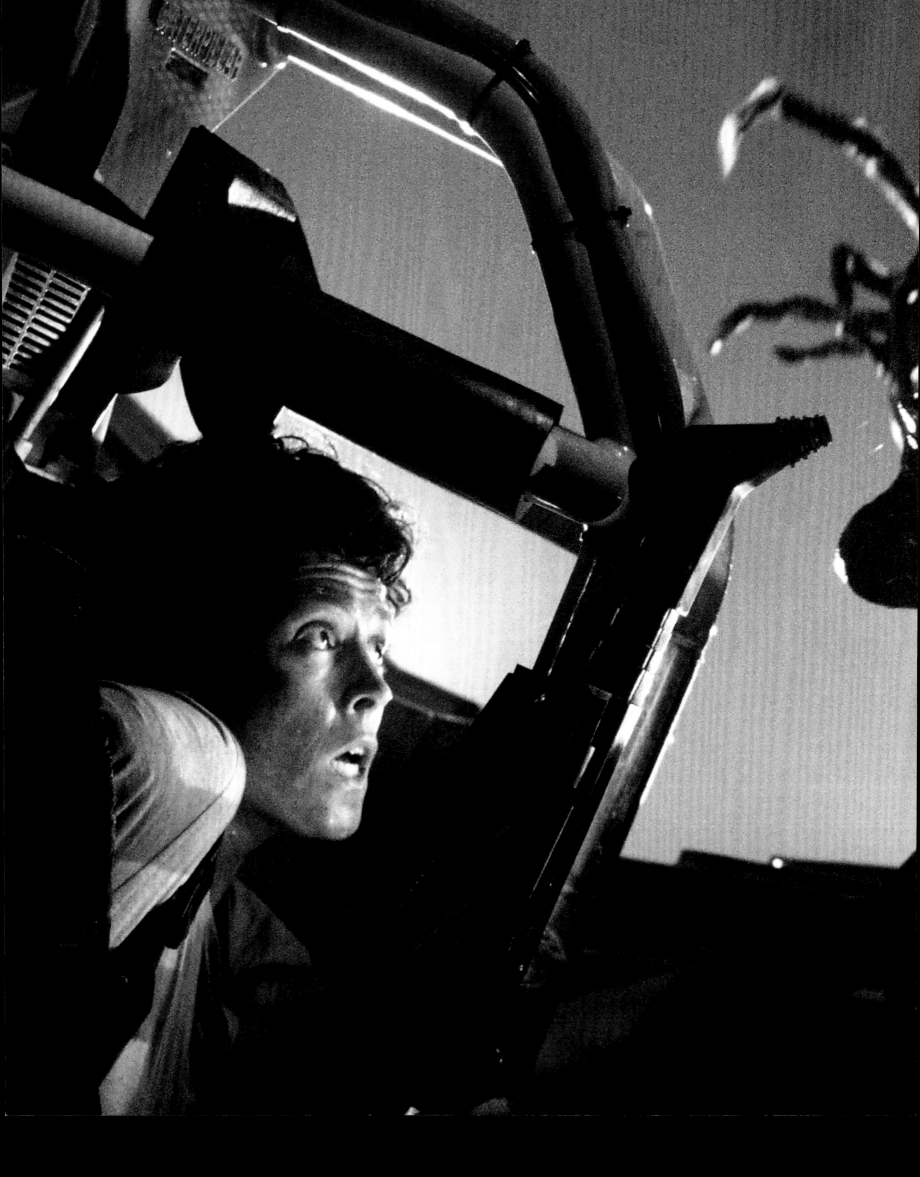

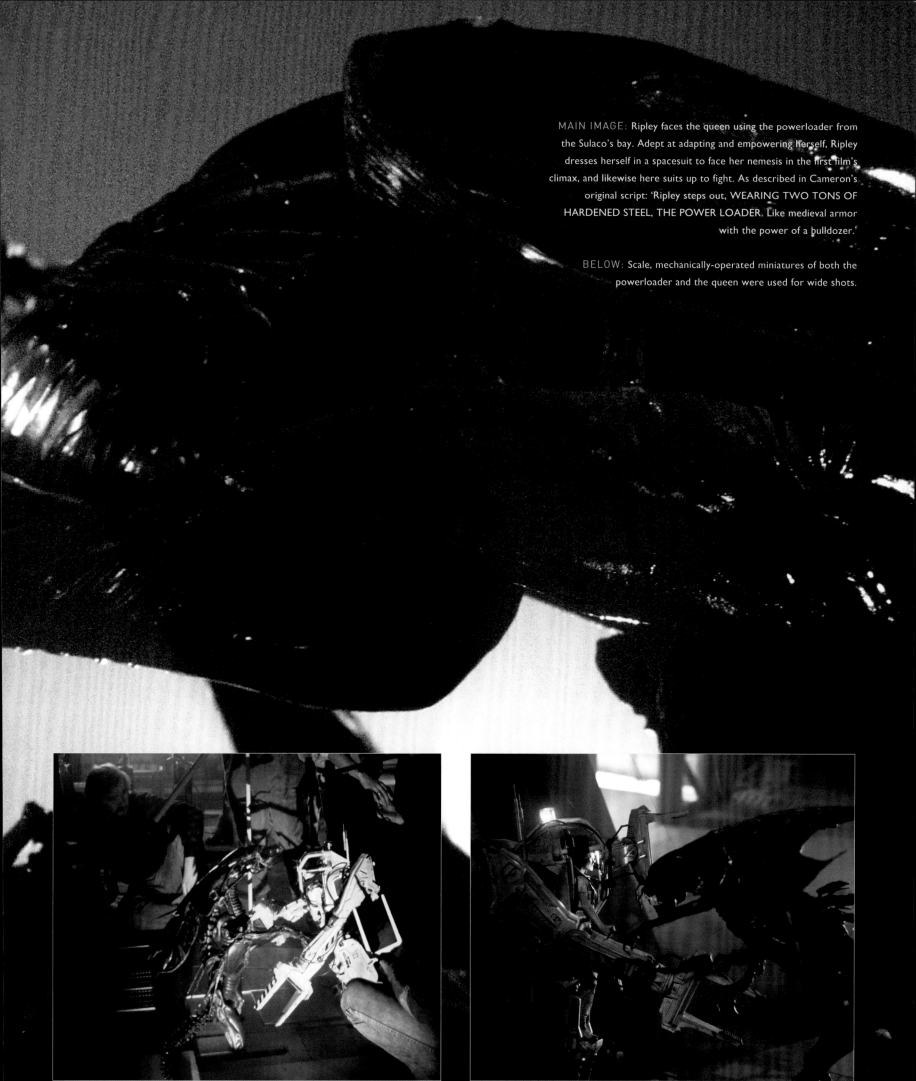

MAIN IMAGE: Ripley faces the queen using the powerloader from the Sulaco's bay. Adept at adapting and empowering herself, Ripley dresses herself in a spacesuit to face her nemesis in the first film's climax, and likewise here suits up to fight. As described in Cameron's original script: 'Ripley steps out, WEARING TWO TONS OF HARDENED STEEL, THE POWER LOADER. Like medieval armor with the power of a bulldozer.'

BELOW: Scale, mechanically-operated miniatures of both the powerloader and the queen were used for wide shots.

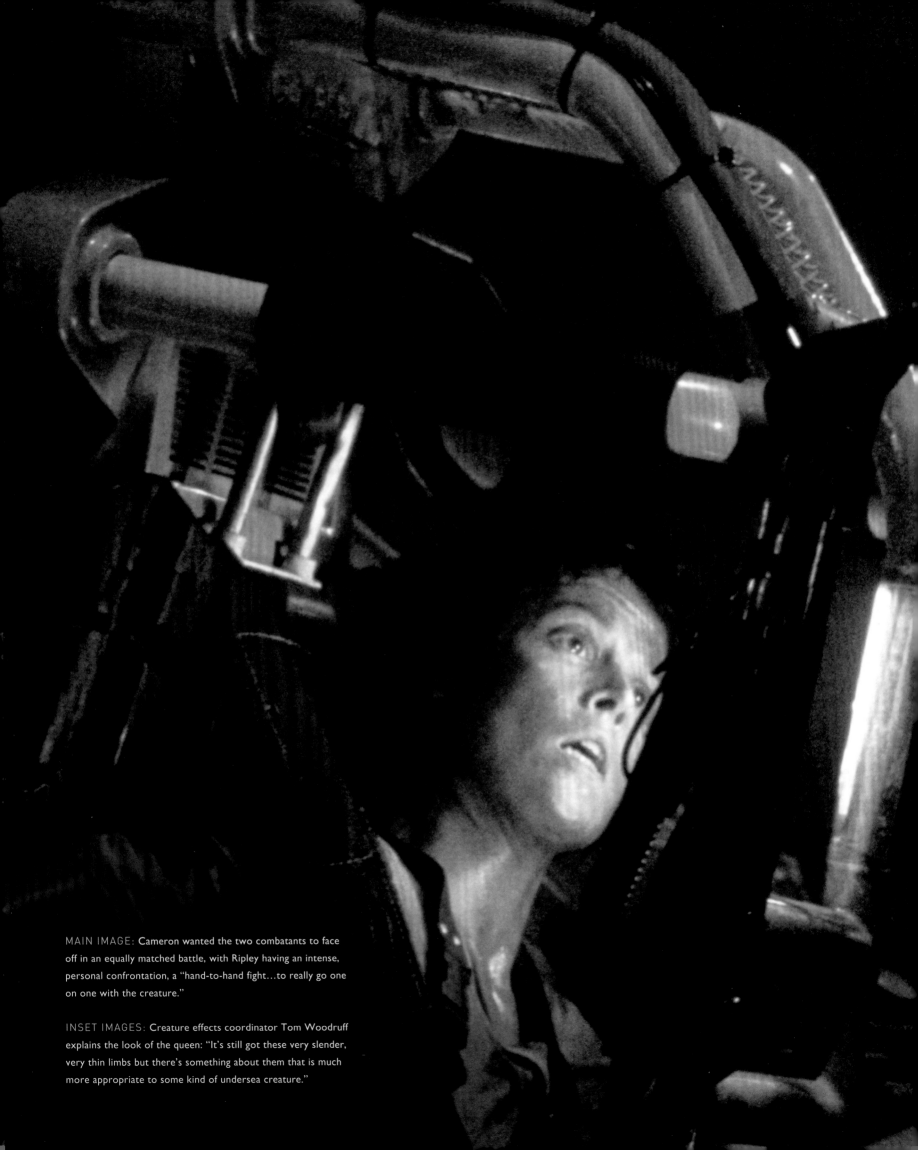

MAIN IMAGE: Cameron wanted the two combatants to face off in an equally matched battle, with Ripley having an intense, personal confrontation, a "hand-to-hand fight...to really go one on one with the creature."

INSET IMAGES: Creature effects coordinator Tom Woodruff explains the look of the queen: "It's still got these very slender, very thin limbs but there's something about them that is much more appropriate to some kind of undersea creature."

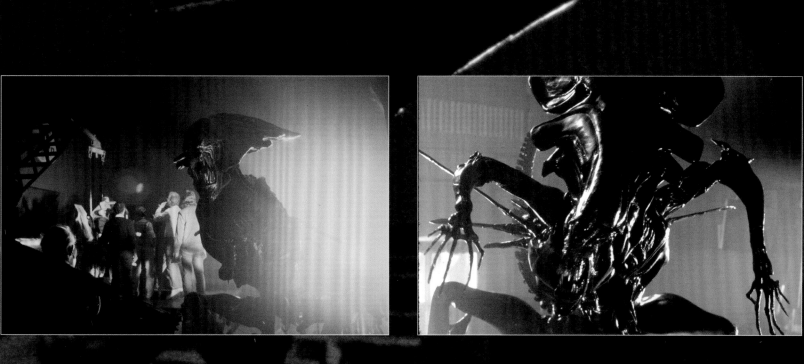

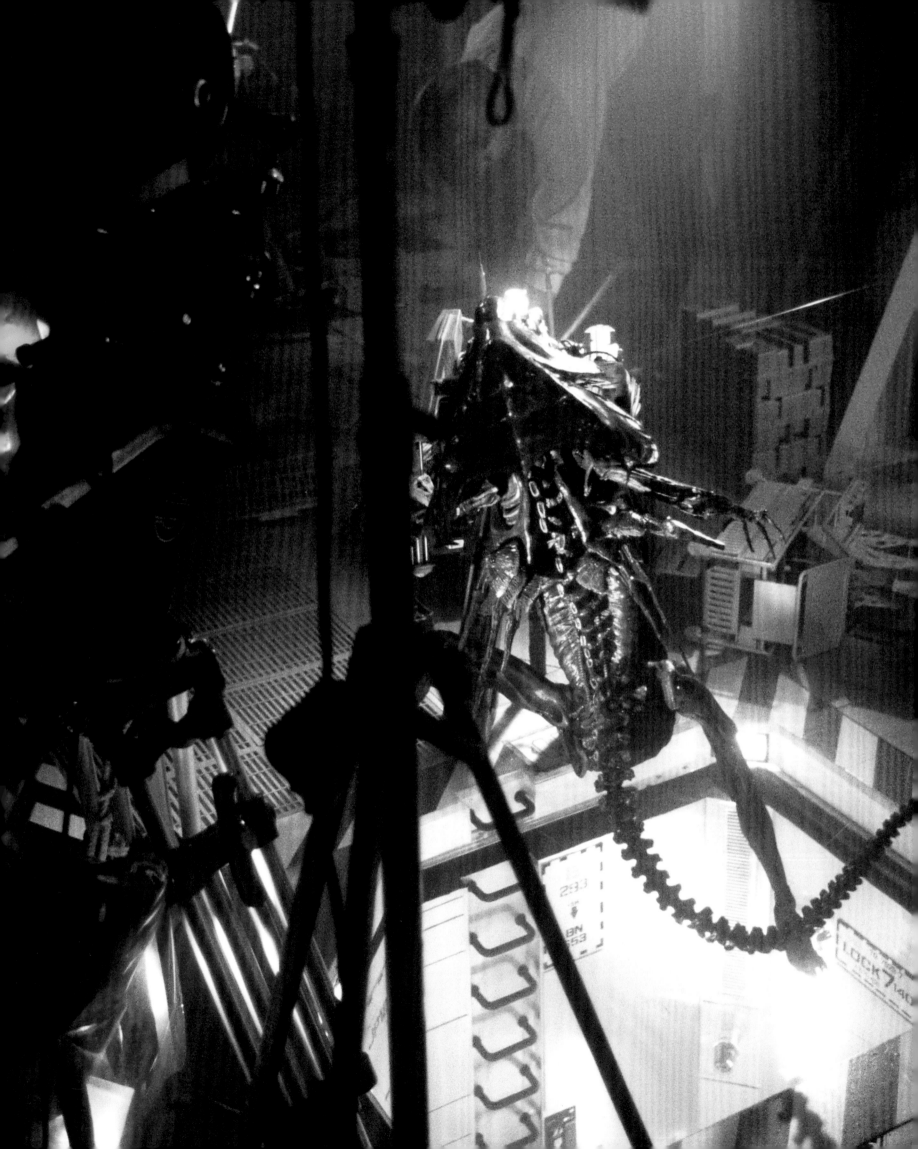

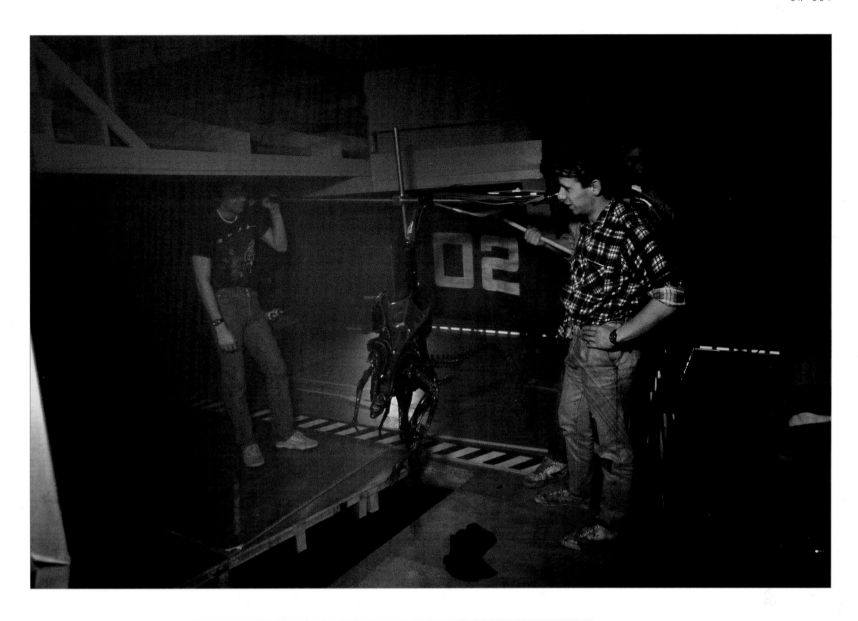

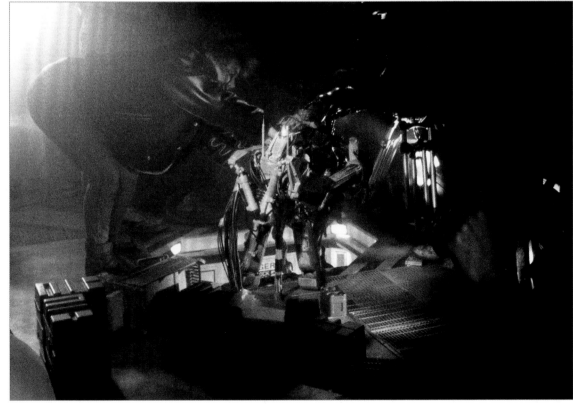

OPPOSITE: The miniature powerloader's legs were manipulated by rods inserted below the deck set, the arms operated by cables.

ABOVE: The final battle, both full-scale and miniature, was filmed at Pinewood. John Richardson worked on the powerloader designs with James Cameron, and Phil Notaro and Doug Beswick built both the powerloader and queen miniatures.

LEFT: Early designs for the powerloader showed a larger machine with the human more of a pilot than the exo-skeleton idea, somewhat reminiscent of the Mitsubishi MK-6 Amplified Mobility Platform in James Cameron's *Avatar* (2009).

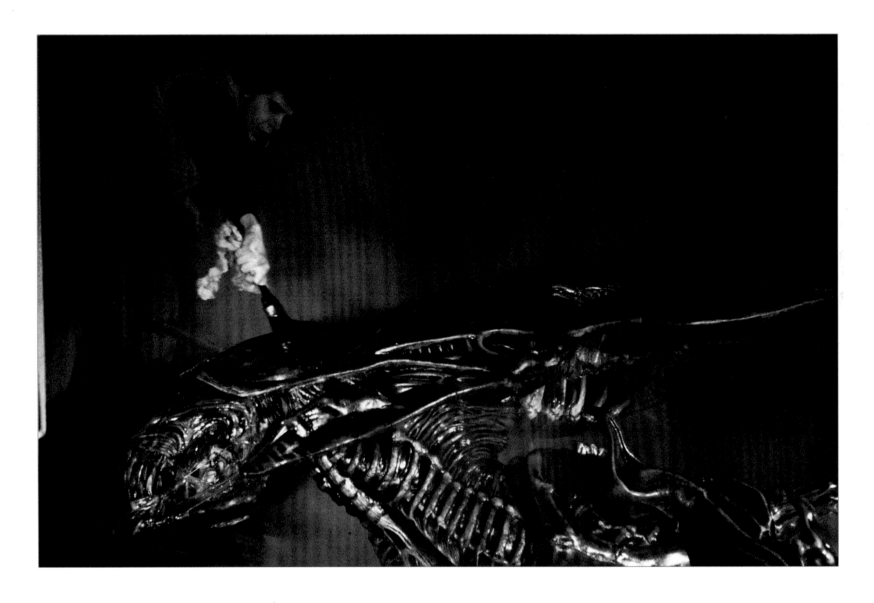

"I THINK GIGER'S MONSTER, IN OUR DREAMS, PRESENT US [WITH] THIS MYTHIC CREATURE AND [AN] ODD PSYCHOSEXUAL TERROR."

JENETTE GOLDSTEIN ON THE PSYCHOLOGICAL IMPACT OF THE ALIENS

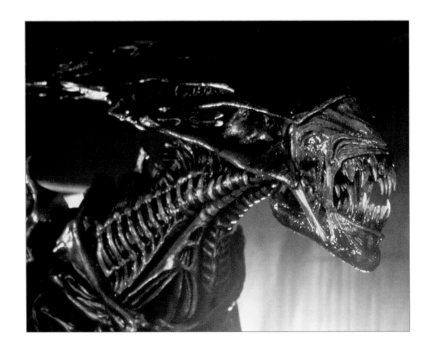

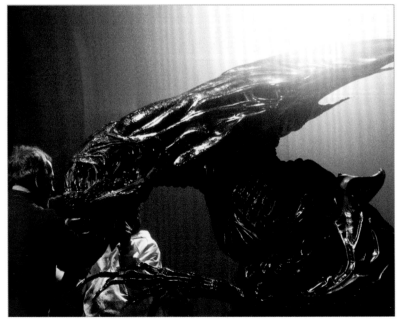

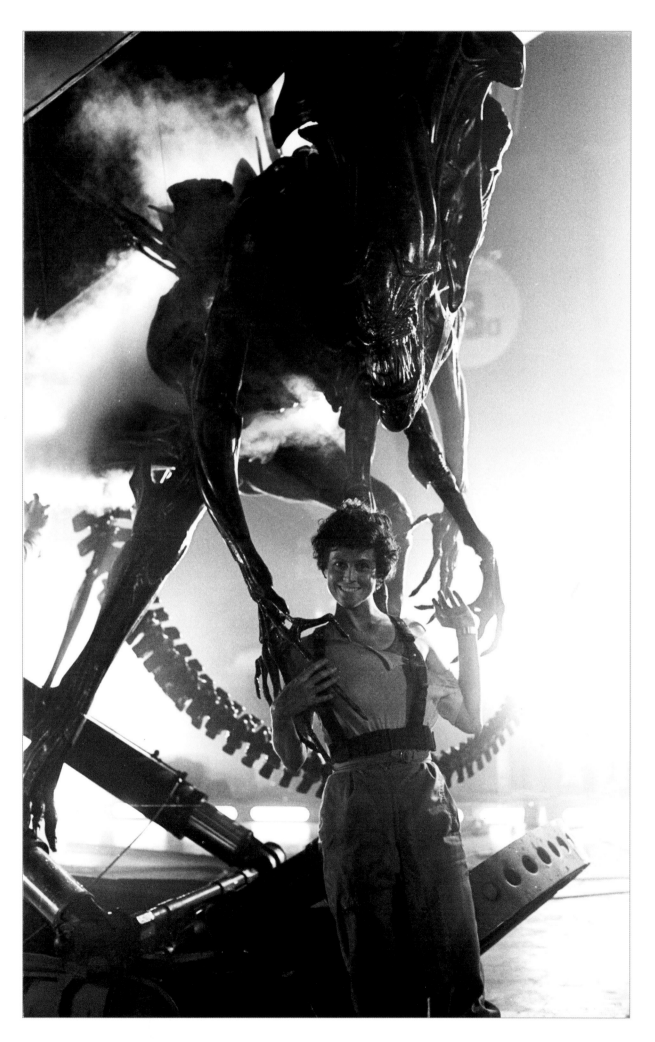

OPPOSITE TOP: Tom Woodruff putting finishing touches to the queen's polyfoam headpiece.

OPPOSITE BOTTOM: Stan Winston working on the head mechanism, which featured a working tongue and the ability to tilt. The full-size queen puppet needed two people hidden inside to operate, as well as additional puppeteers outside, while hydraulics enabled up and down movement.

LEFT: The queen is 14 feet tall, far larger than her drones. Cameron wanted her to be "hideous and beautiful at the same time, like a black widow spider."

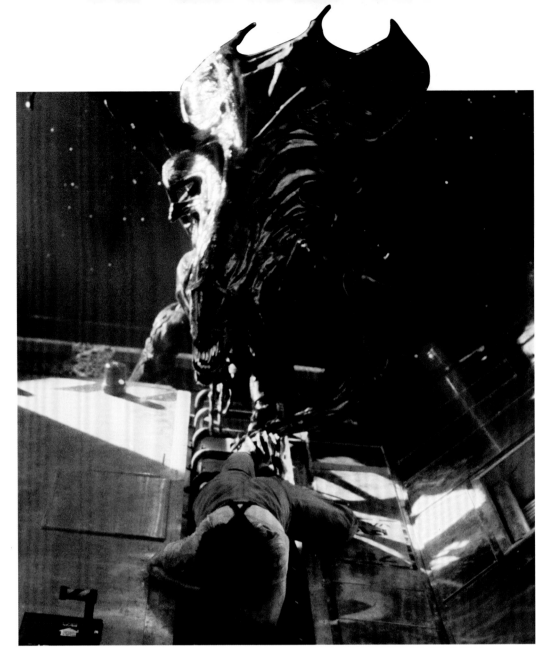

"I DIDN'T REALLY UNDERSTAND IT ALL AT THE TIME, BUT IT WAS A VERY DETAILED PROCESS. IT WAS AMAZING TO SEE HOW EVERYTHING HAPPENED."

CARRIE HENN ON THE MOVIE'S CLIMACTIC SCENE (RIGHT)

THIS PAGE: The queen drags Ripley down into an airlock, where Ripley manages to eject it into space. The film won an Academy Award® for visual effects.

OPPOSITE: Weighing 600lbs, supported by a pole through the back or with counterweights, the powerloader featured radio-controlled wrists and grabbers operated by cables. The visible hydraulics were, however, purely decorative.

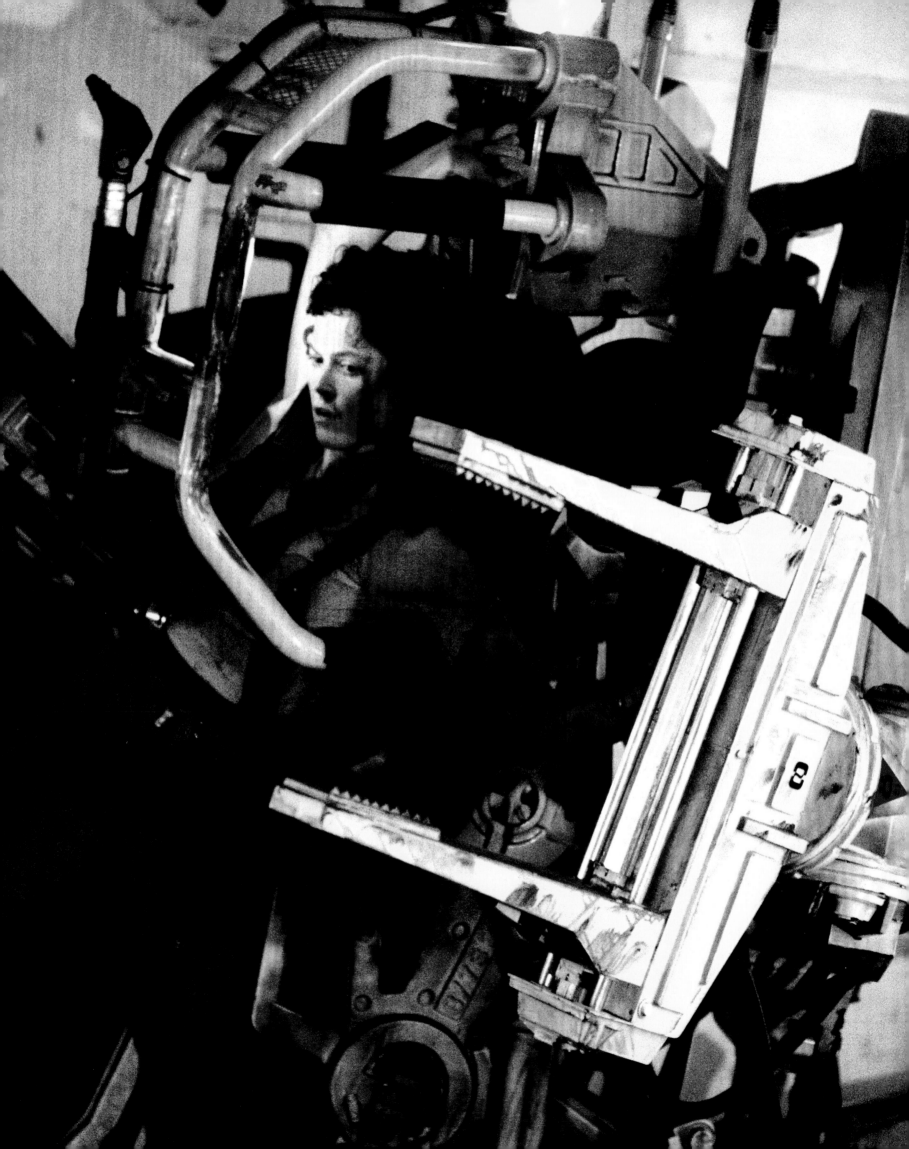

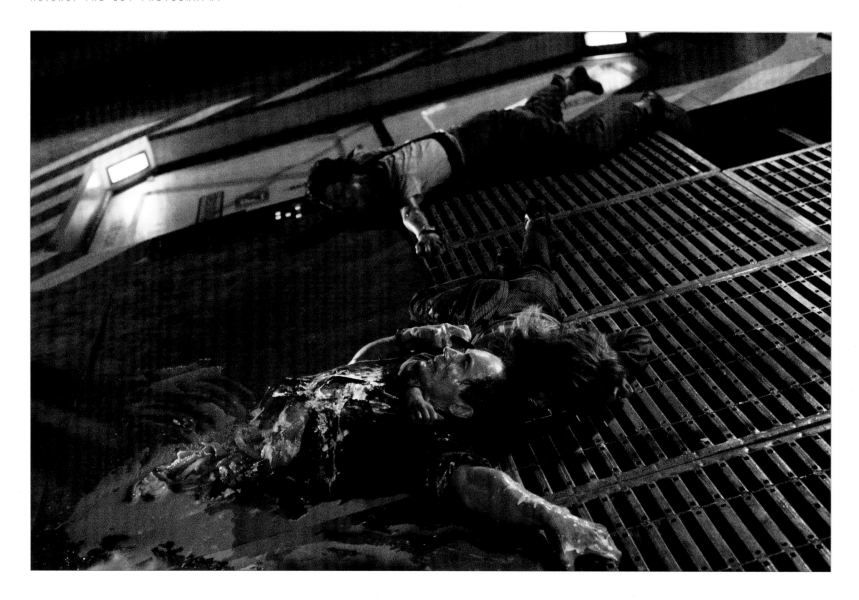

ABOVE: CH: "When I get pulled across the ground, that secure set was massive and it was pretty tiring constantly being dragged along. It doesn't sound like it would be, but it was mentally exhausting."

RIGHT: CH: "One of my most favorite scenes. When Sigourney comes up and I give her a hug... it was a long emotional few days of filming and a bittersweet feeling knowing it was over. The hug and tears were very genuine between Ripley and Newt."

OPPOSITE: James Cameron films the airlock scene. In the final film, when the queen and powerloader are shown being released into space, the miniatures were used— they were dropped through the hole and caught in a safety net.

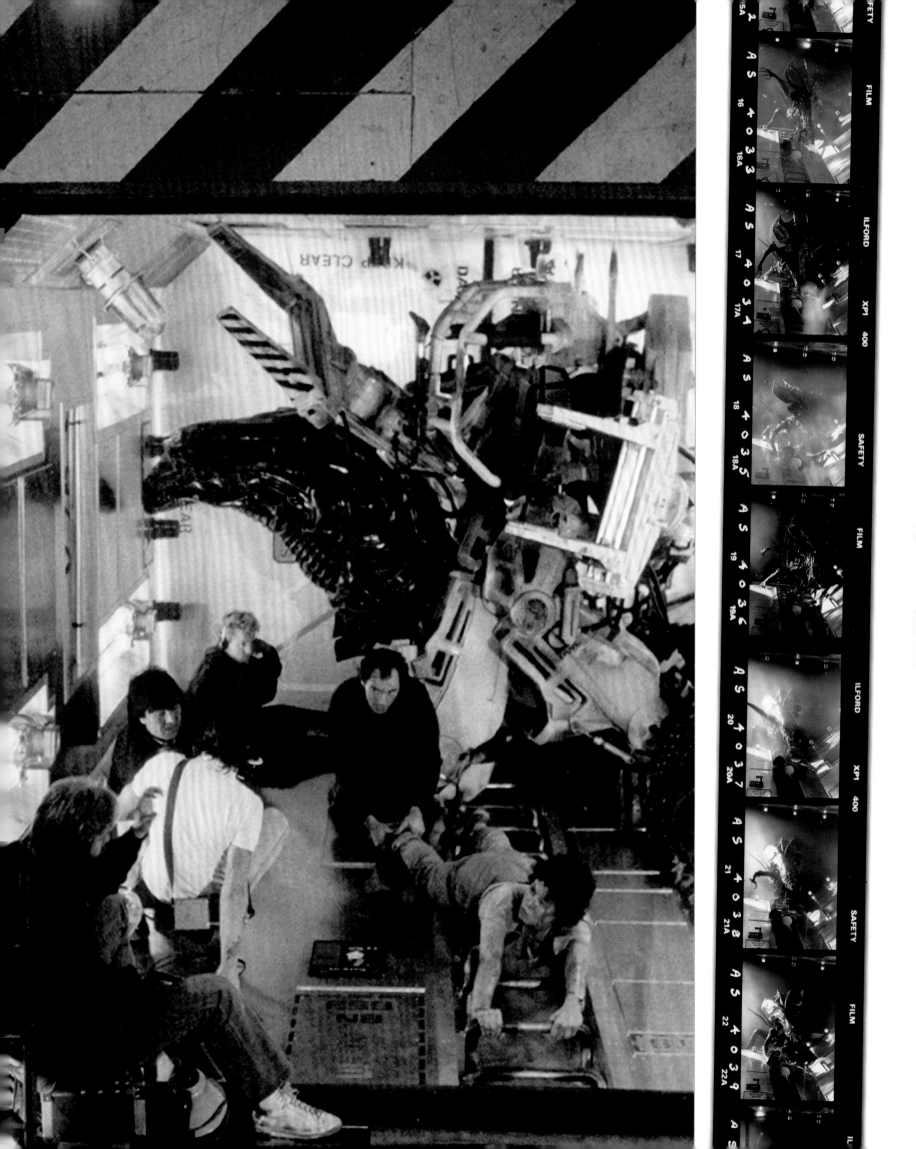

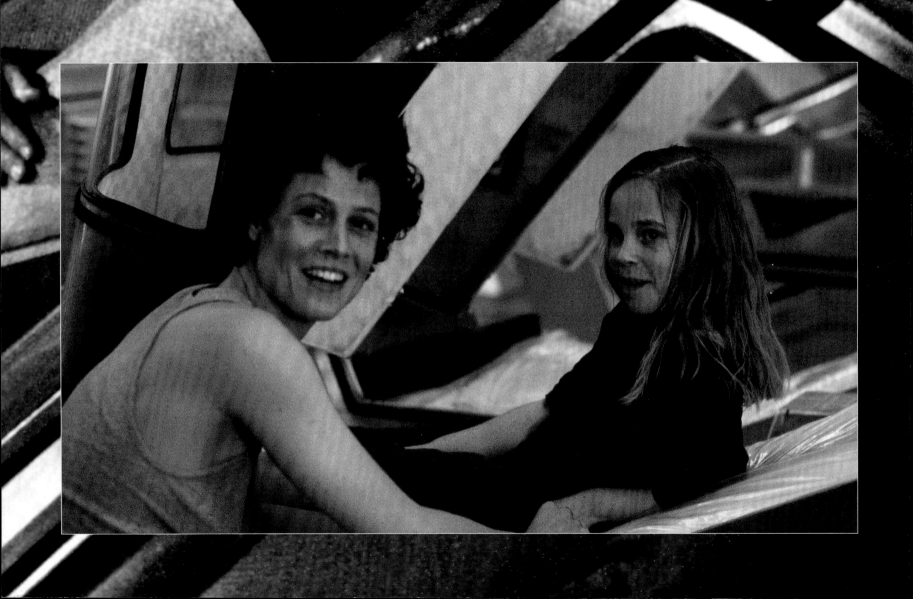

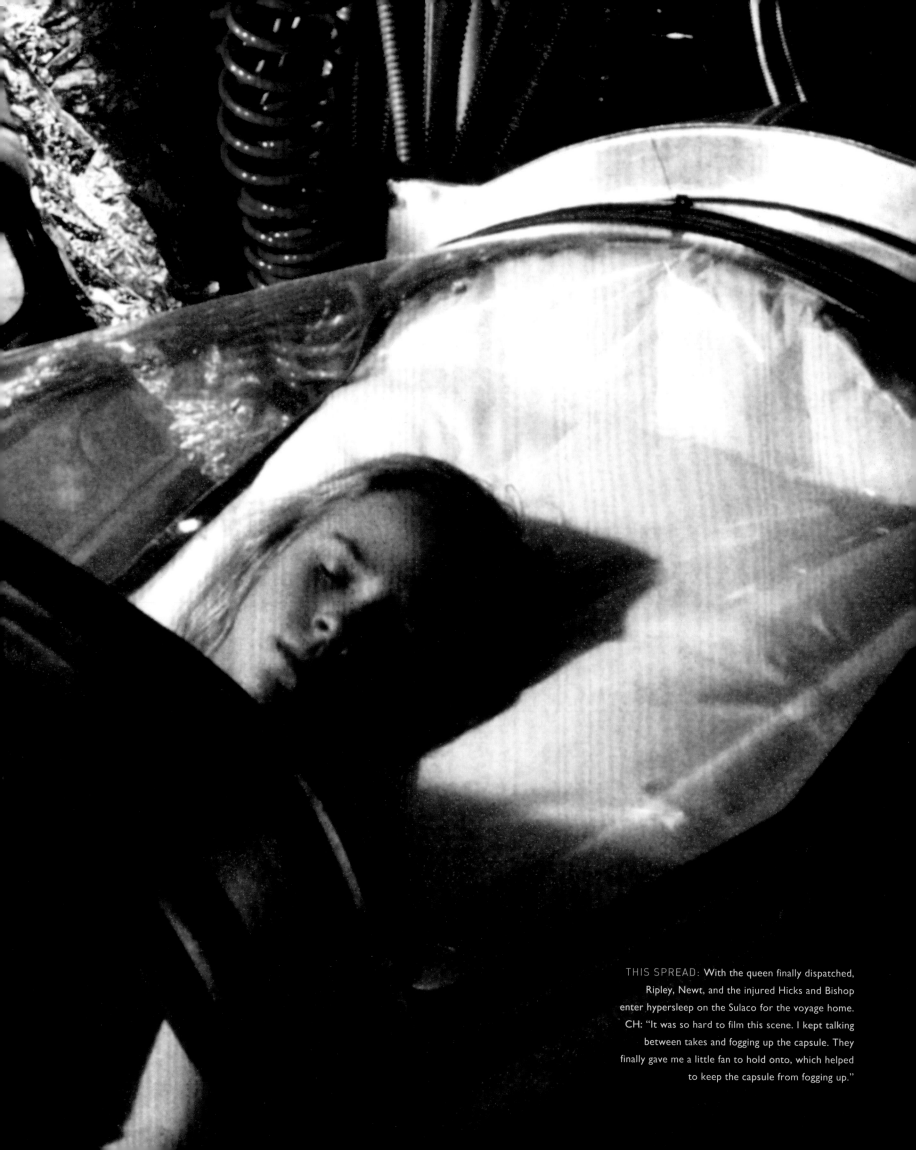

THIS SPREAD: With the queen finally dispatched, Ripley, Newt, and the injured Hicks and Bishop enter hypersleep on the Sulaco for the voyage home. CH: "It was so hard to film this scene. I kept talking between takes and fogging up the capsule. They finally gave me a little fan to hold onto, which helped to keep the capsule from fogging up."

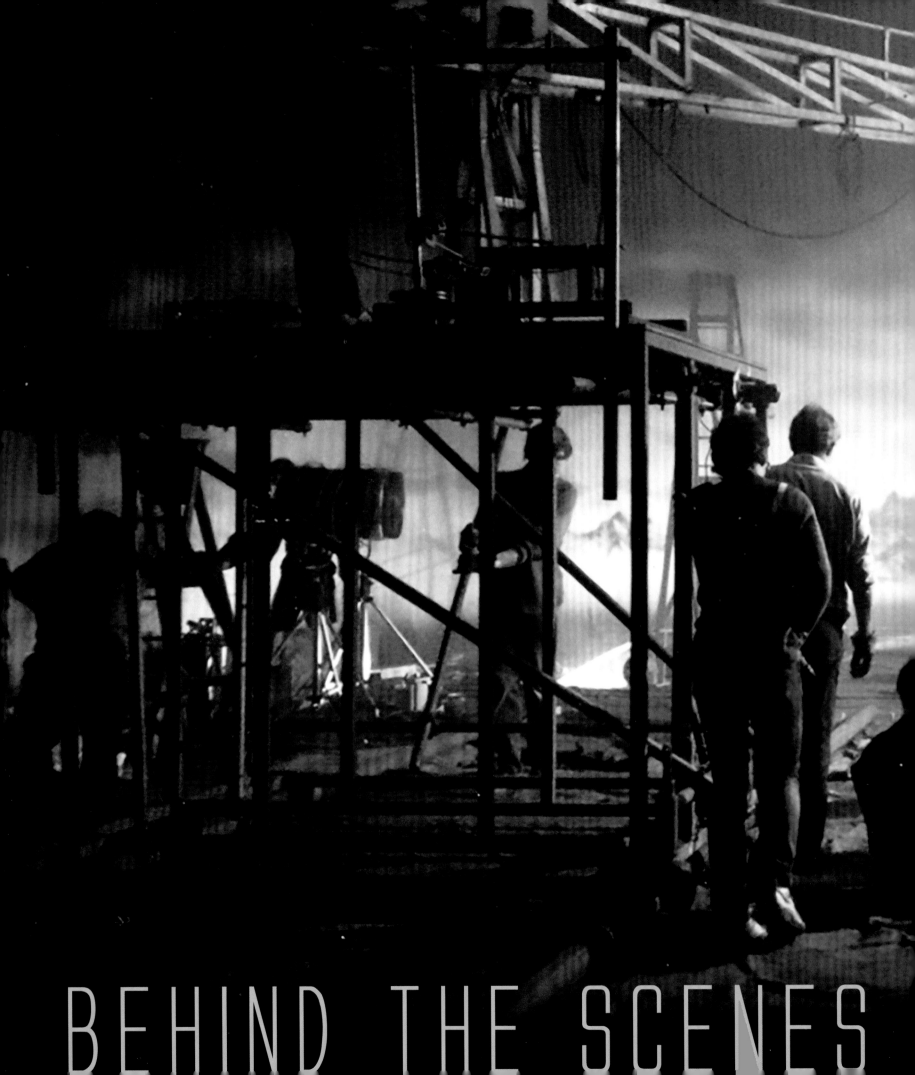

BEHIND THE SCENES

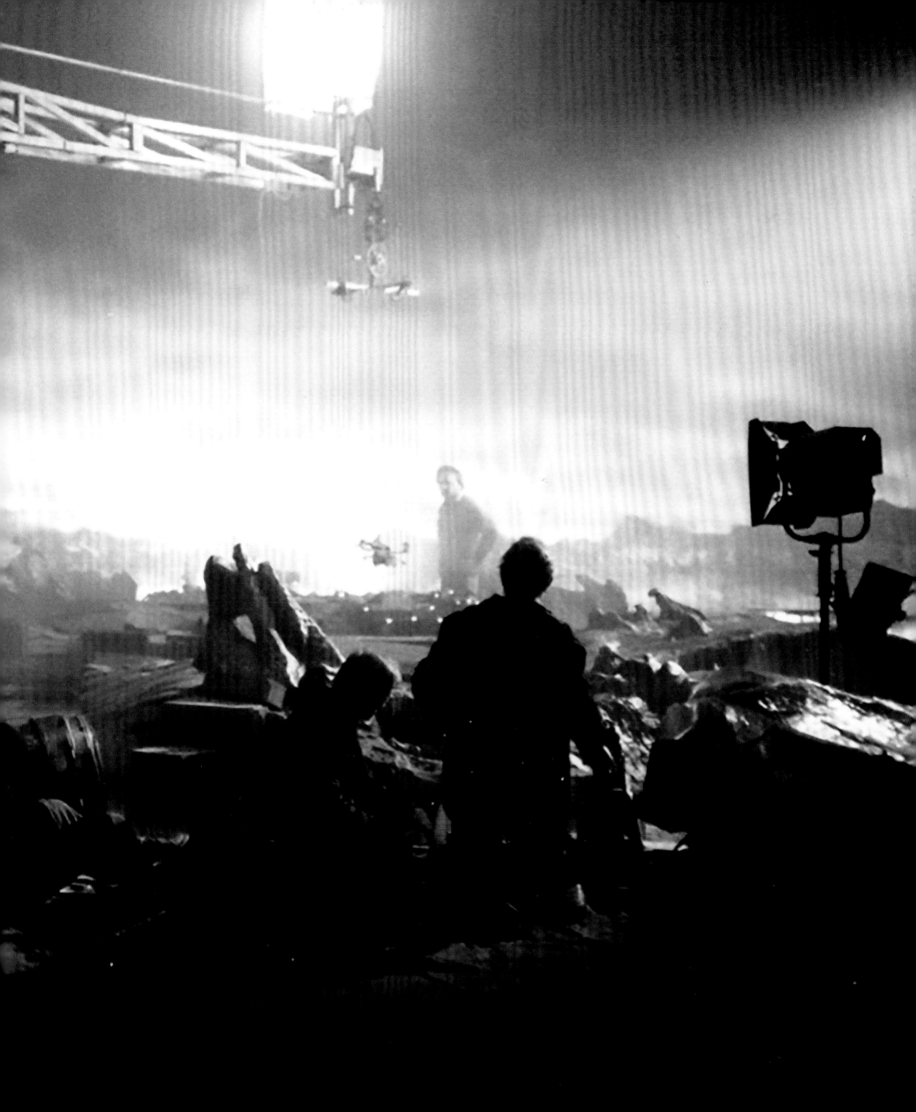

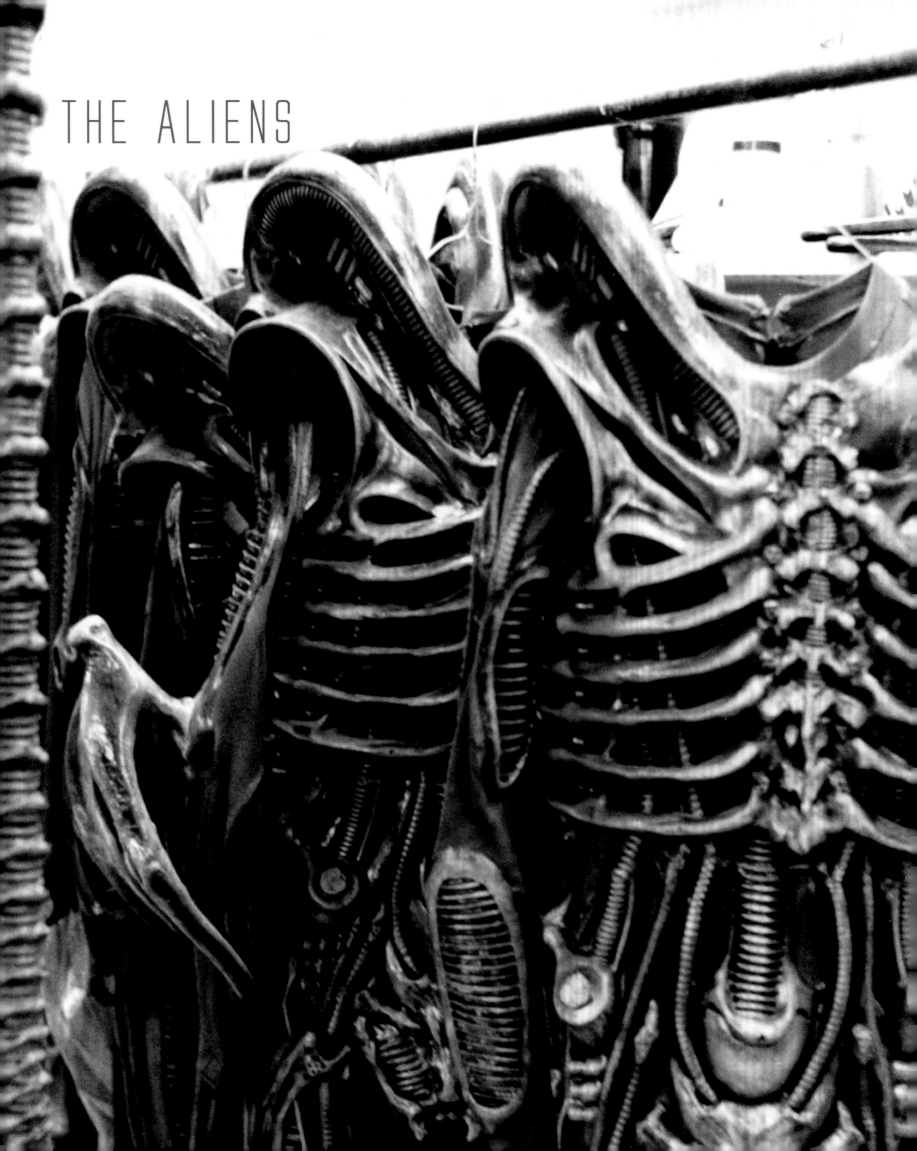

THE ALIENS

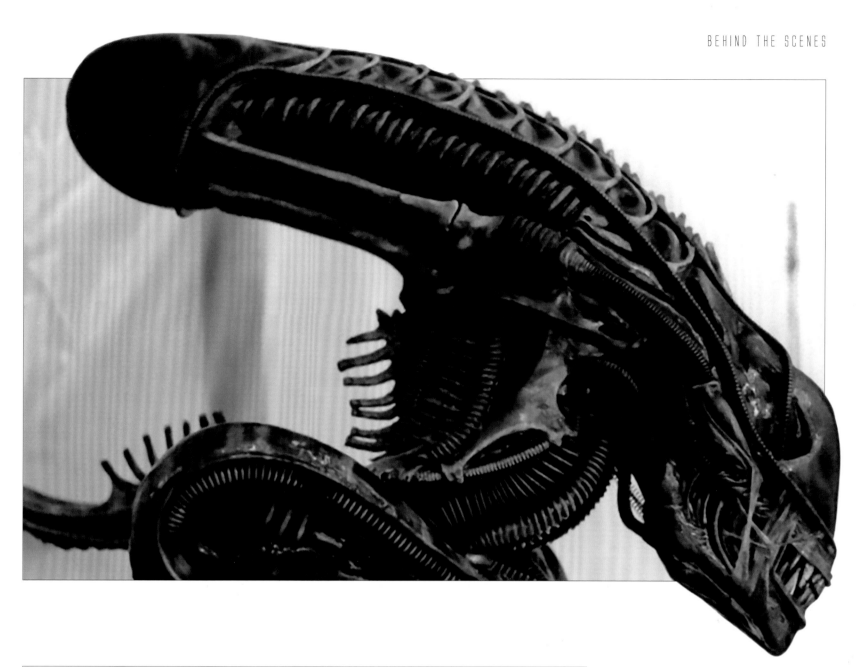

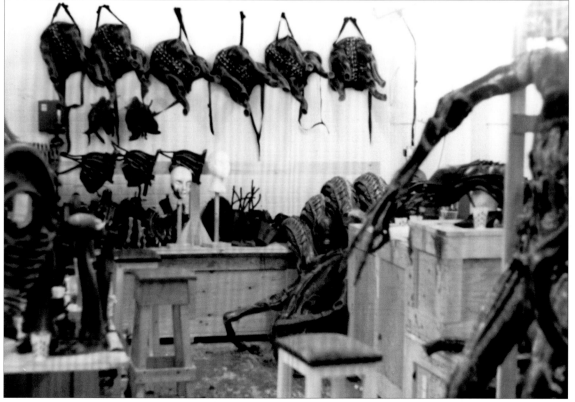

OPPOSITE: As with the original film, the creatures were played by men in suits, but the lighting and framing disguised this, making the aliens appear and disappear from shadows.

ABOVE: Tom Woodruff built the head sculpture based off the stunt head in *Alien*.

LEFT: Only six complete alien suits were actually made for the film.

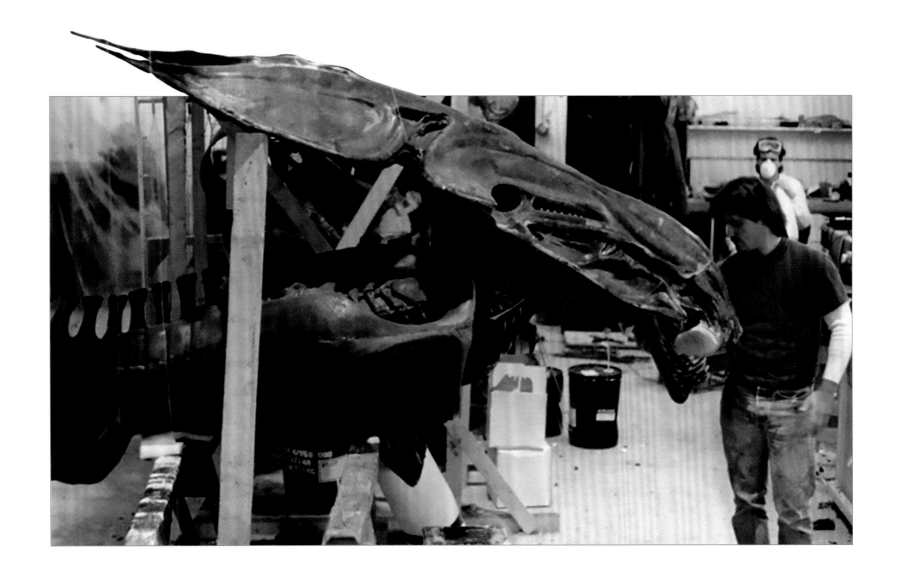

"EVERYONE TALKS ABOUT THE SPECIAL EFFECTS, BUT NOW I SEE IT AND HOW IMPRESSIVE IT ACTUALLY IS—IT STILL STANDS UP. WHO'D HAVE THOUGHT IT AFTER ALL THESE YEARS?"

CARRIE HENN

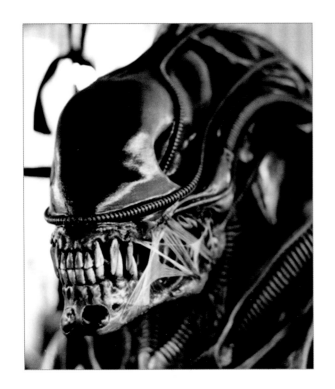

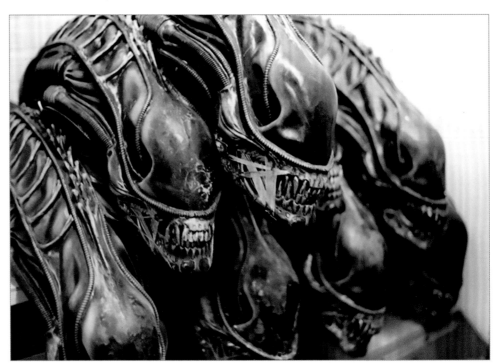

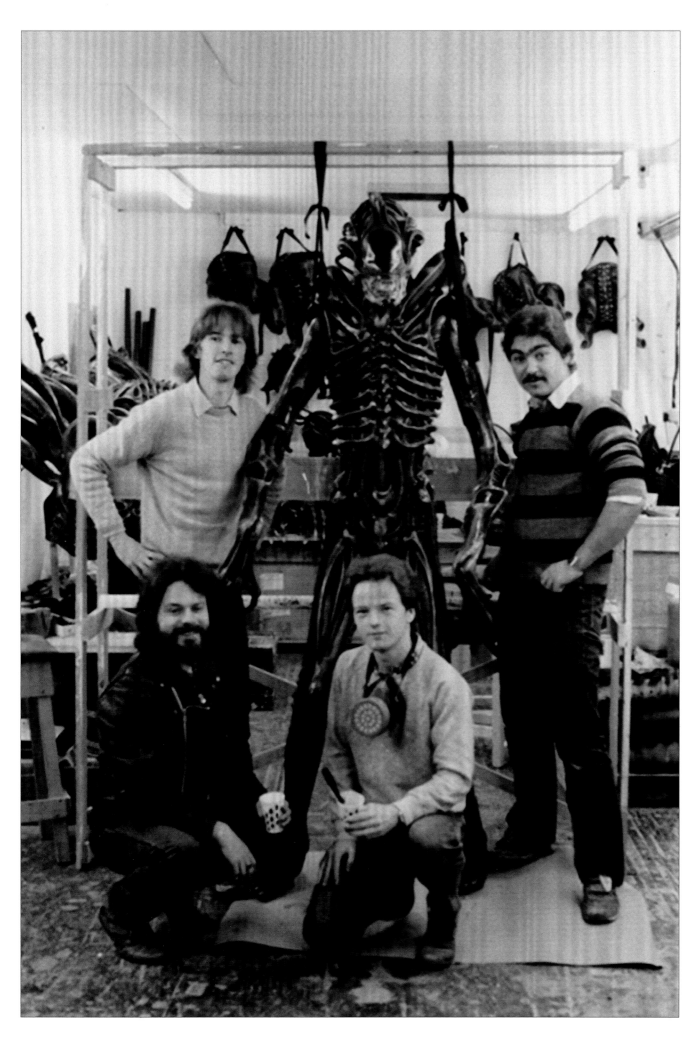

OPPOSITE BOTTOM:
Close-up images of the alien warrior heads. Cameron didn't want a smooth surface on the head of the alien as in the first film, preferring to see the varying shapes of it.

THIS PAGE: To achieve the slime effect on the aliens, copious amounts of K-Y Jelly were used. Pictured here are members of Stan Winston's crew, including Graham High (bottom left), and Lindsay McGowan (bottom right).

RIGHT: Corrugated tubing was used on the legs but painted string served as the piping on the arms.

OPPOSITE TOP: From left to right: John Rosengrant and Tom Woodruff place the ribbing and coloring on the helmets.

OPPOSITE BOTTOM: 'Mark II' of the alien, as opposed to the first film, offers a more weaponized look, a hard, bone-like structure on the head. Woodruff describes it as "another generation of alien, slightly mutated."

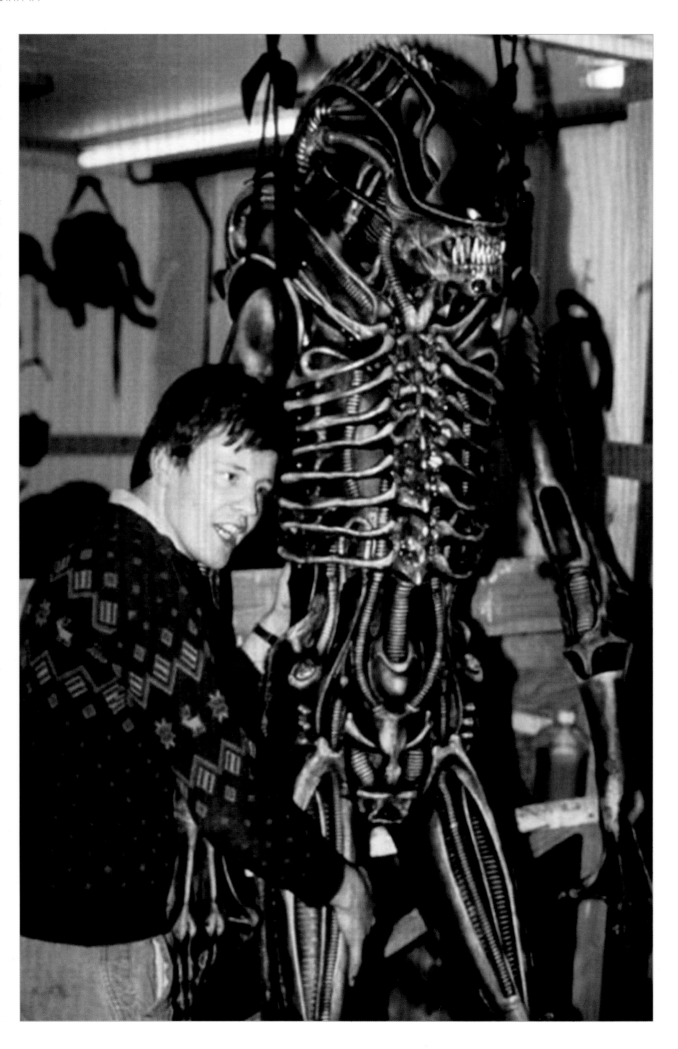

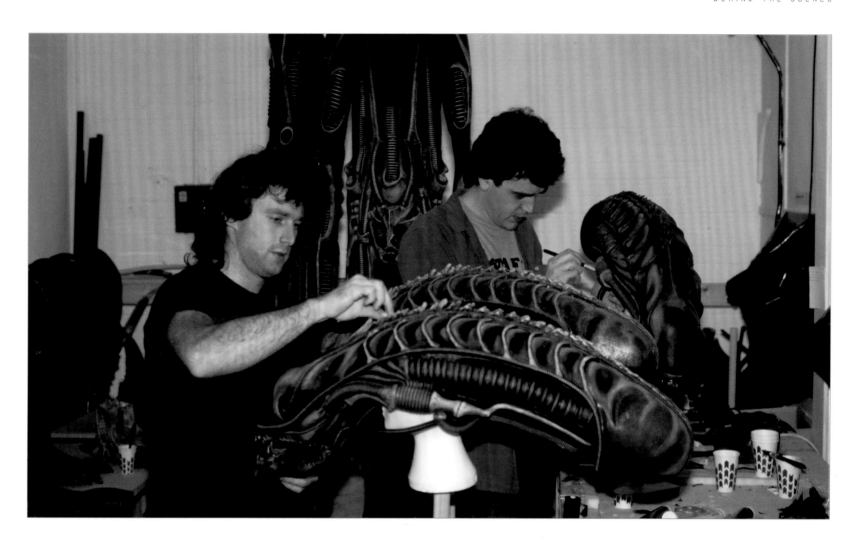

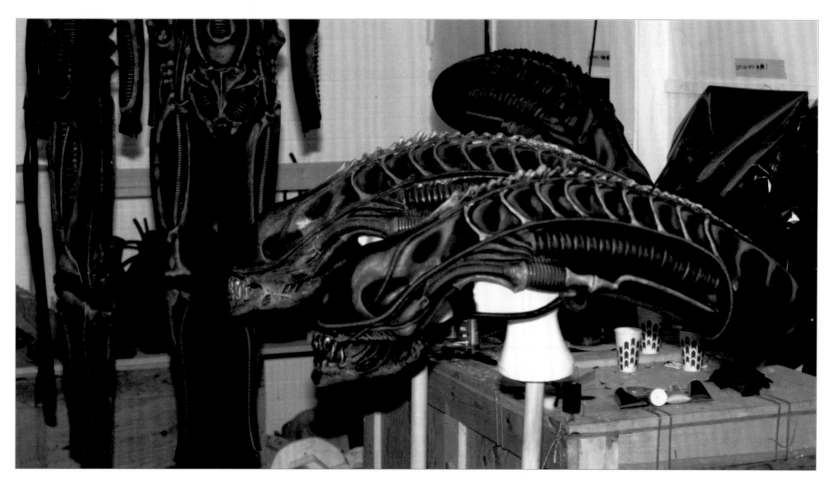

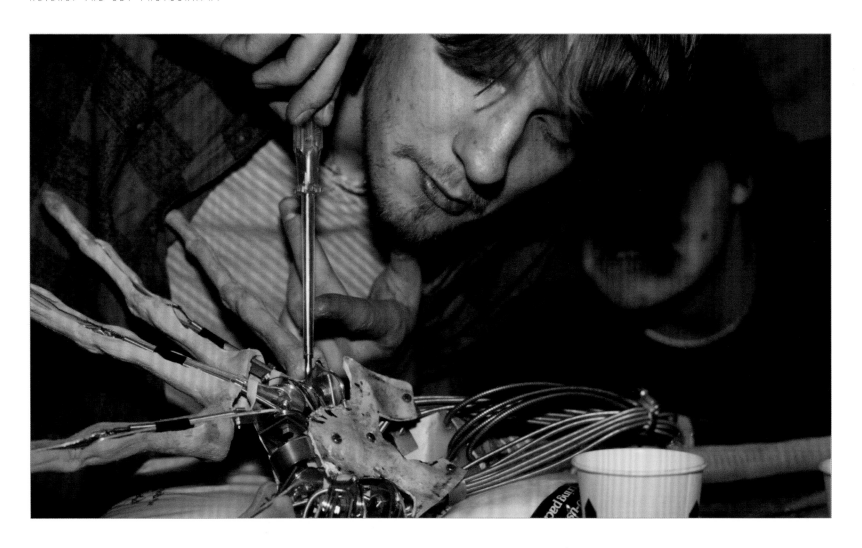

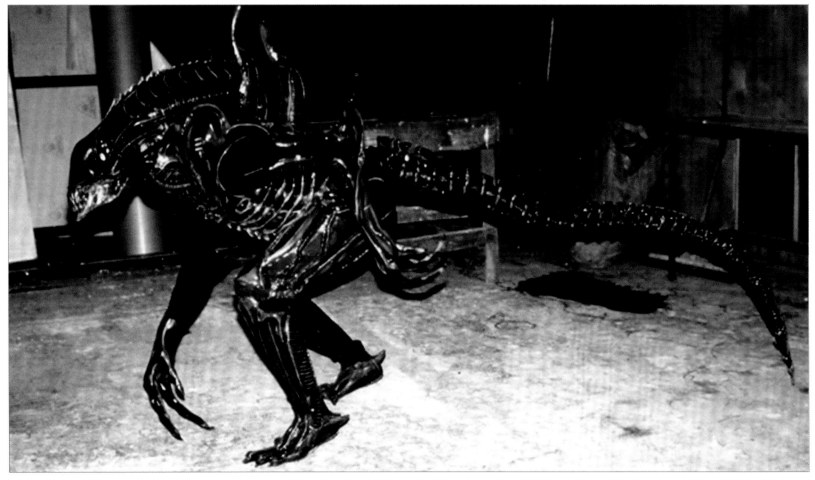

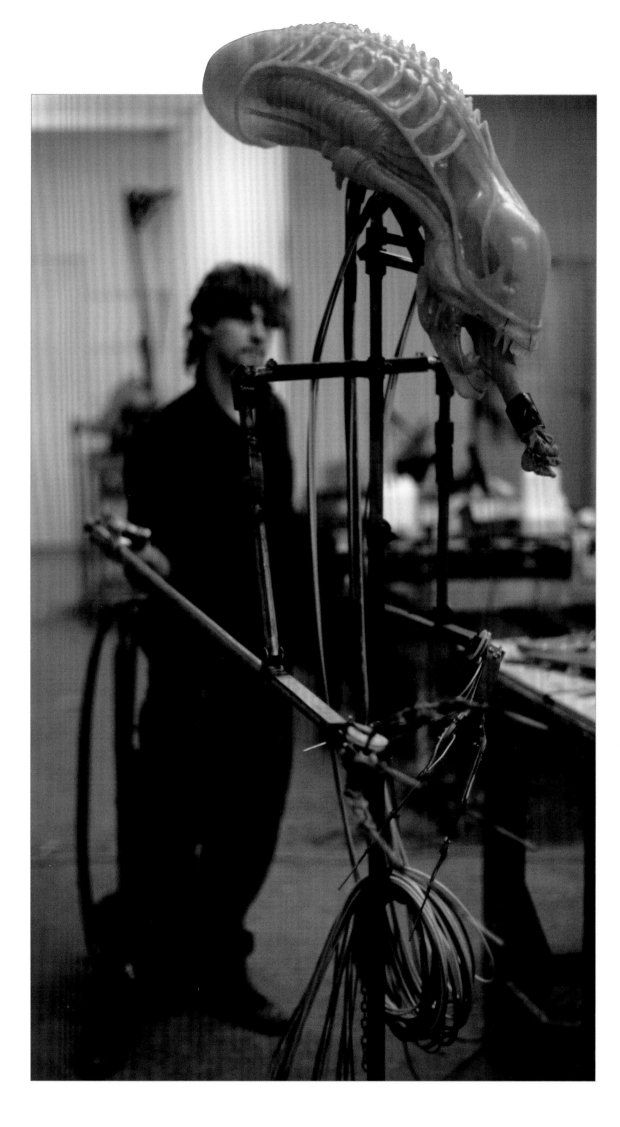

OPPOSITE TOP: Visual effects artist Rick Lazzarini and future film director Stephen Norrington calibrate the animatronic facehugger. Of the two working puppets, one could be pulled along the floor, its legs moving via a gear mechanism to simulate scuttling.

OPPOSITE BOTTOM: The back pipe plaster casts on the costume (originally created by H.R. Giger for "balance") measure 17" x 7" x 7" and were painted gray. The fin on the spine has bone protrusions and measures 16" x 7".

LEFT: The second jaw or 'attack tongue' is a muscle with a secondary mouth on the end used for killing and eating. It was operated by a puppeteer using a spring-action lever.

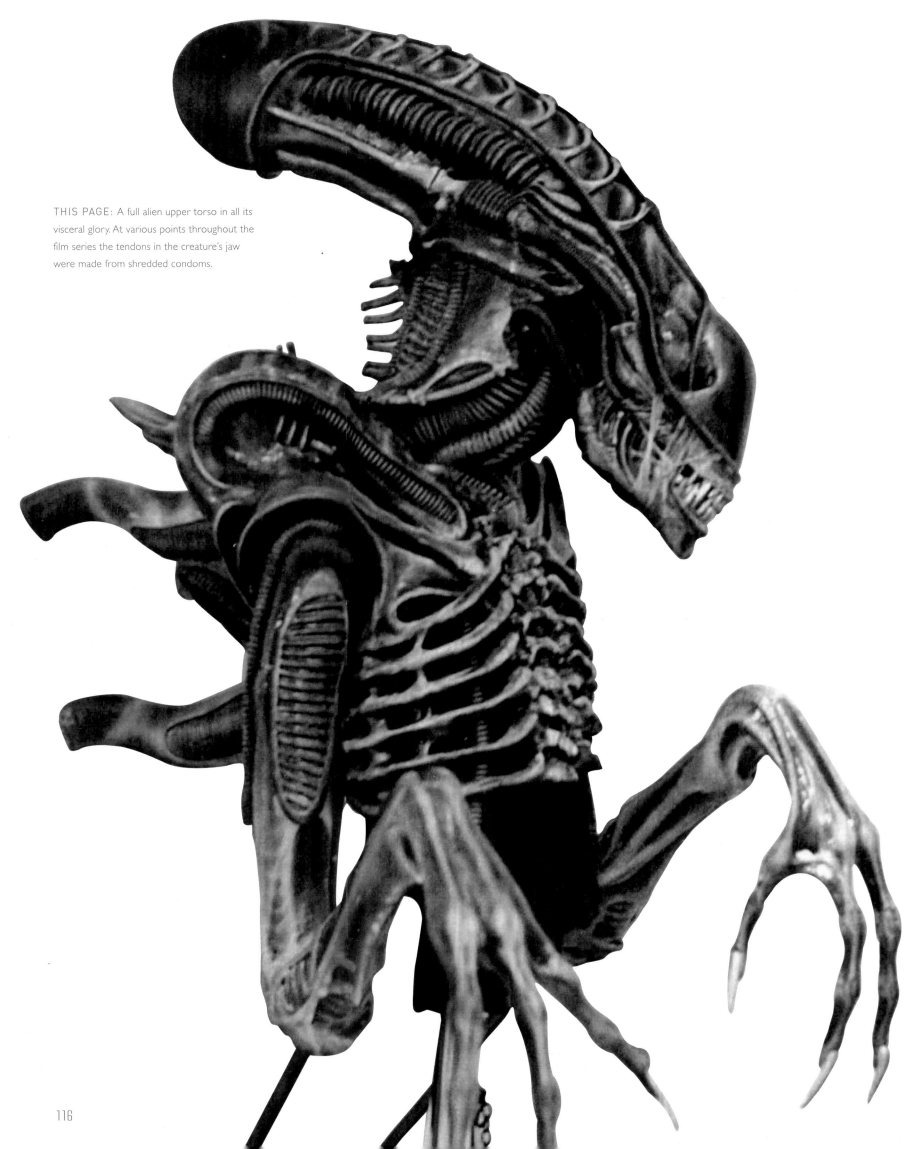

THIS PAGE: A full alien upper torso in all its visceral glory. At various points throughout the film series the tendons in the creature's jaw were made from shredded condoms.

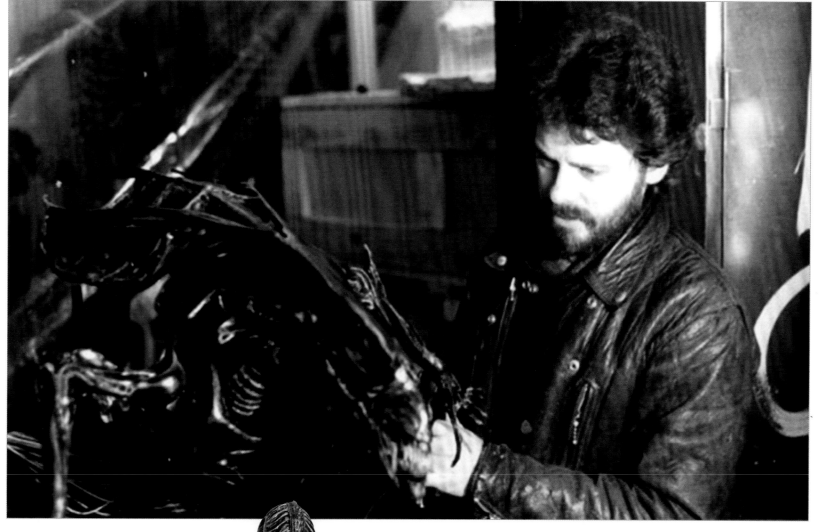

"IN TERMS OF
THE PHYSICAL
STRUCTURE OF
THE QUEEN, THERE
IS LESS OF THAT
MECHANICAL FEEL
AND LESS
OF A COMPLETION
OF FORMS."

TOM WOODRUFF ON THE
ALIEN QUEEN DESIGN (ABOVE)

LEFT: In *Alien* the xenomorph had six
webbed fingers; in *Aliens* this was changed to
two fingers and a thumb. The hands are much
longer, possibly for purely aesthetic reasons but
possibly also because these aliens are more
mature and fully developed than the original
film's single star beast.

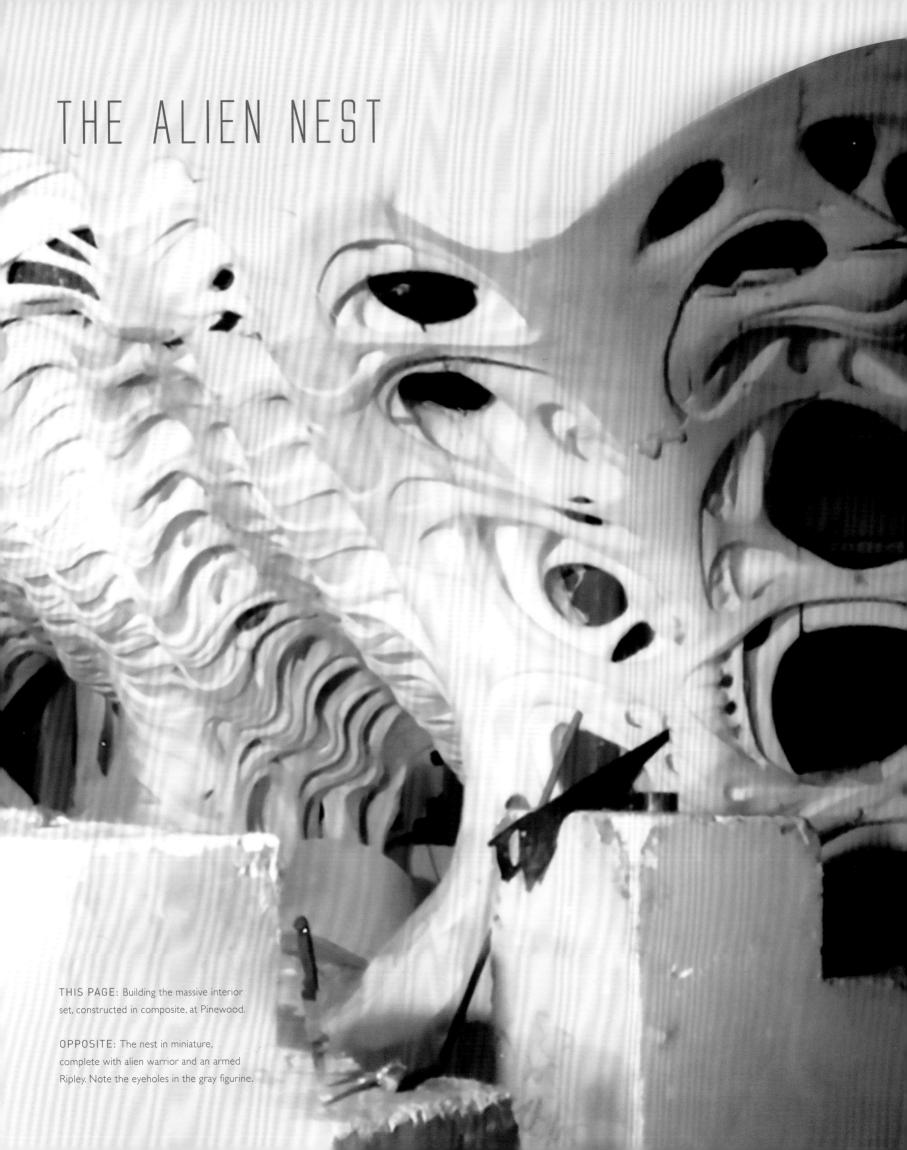

THE ALIEN NEST

THIS PAGE: Building the massive interior set, constructed in composite, at Pinewood.

OPPOSITE: The nest in miniature, complete with alien warrior and an armed Ripley. Note the eyeholes in the gray figurine.

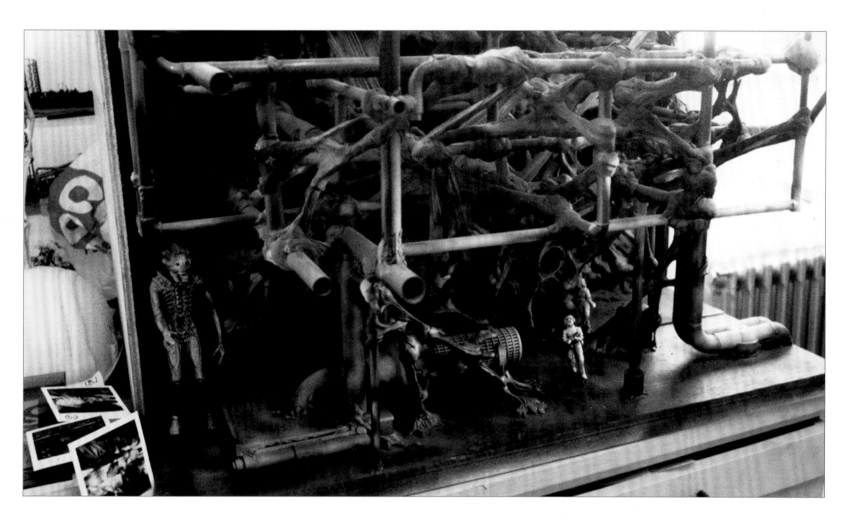

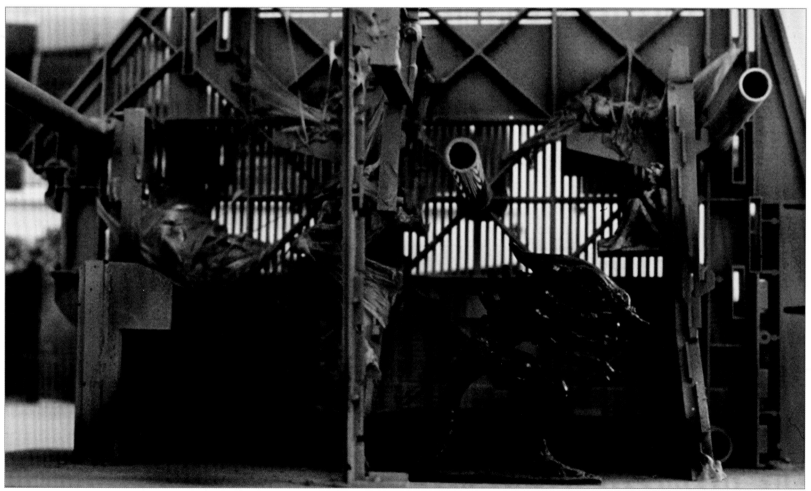

LEFT: The alien nest set under construction. CH: "I didn't understand at the time how they were going to put it all together and make it look realistic. Because you see things and they're like, 'Well, this is only half the colony and we're going to make it look like a big old colony'. It was really amazing to see the process."

EFFECTS

"SO STRANGE TO SEE THE DUMMY UP
CLOSE, THE DETAIL IS QUITE AMAZING.
I DON'T REMEMBER SEEING IT AFTER
IT WAS FINISHED—IT'S FASCINATING
TO SEE ALL THE DETAIL NOW."
CARRIE HENN ON THE DUMMY OF HER MADE BY
THE SPECIAL EFFECTS TEAM

BELOW: Tony Gardner works on the
cast of Bishop post-queen-attack.

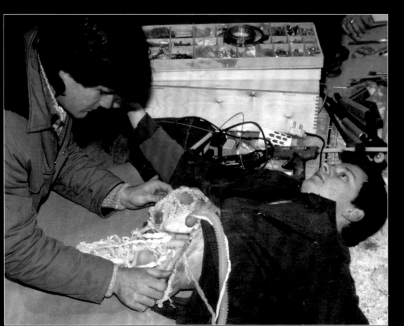

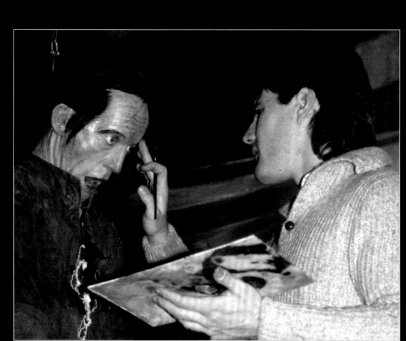

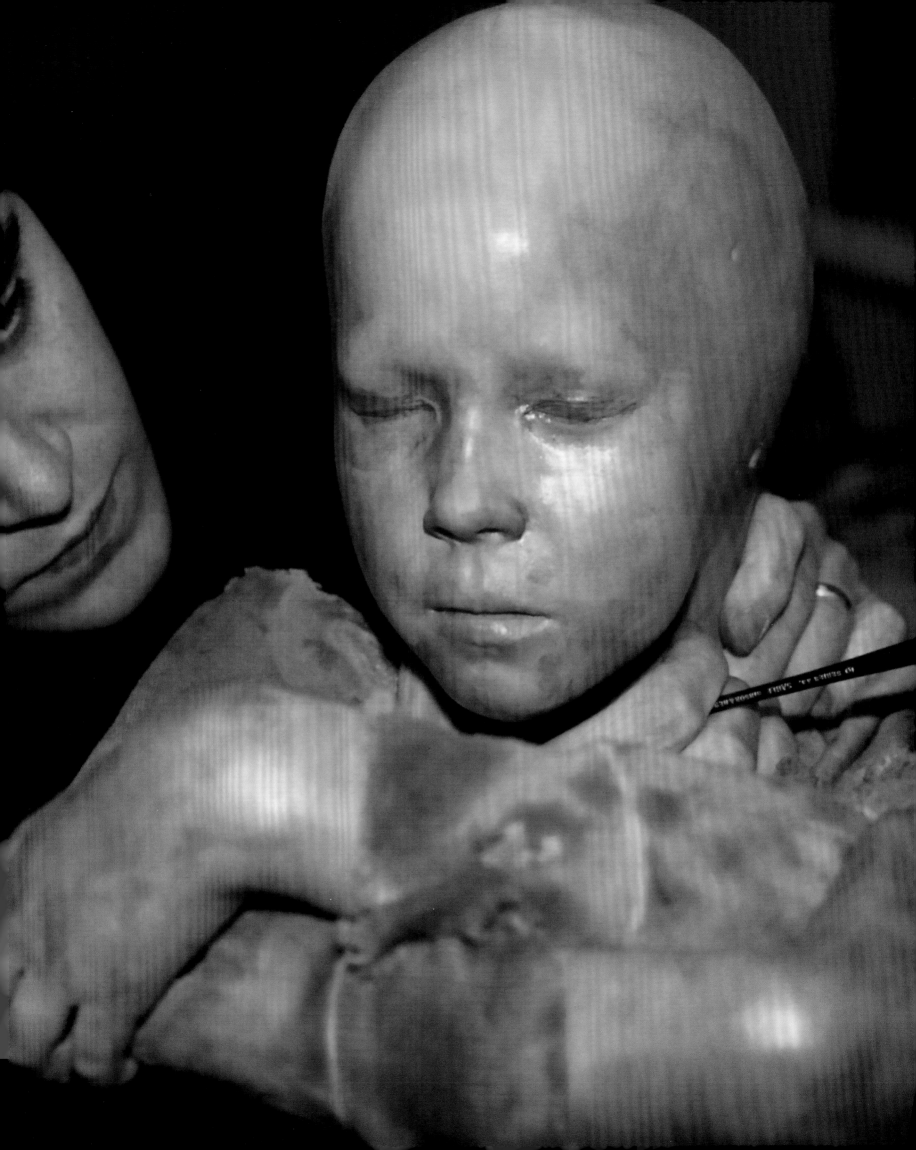

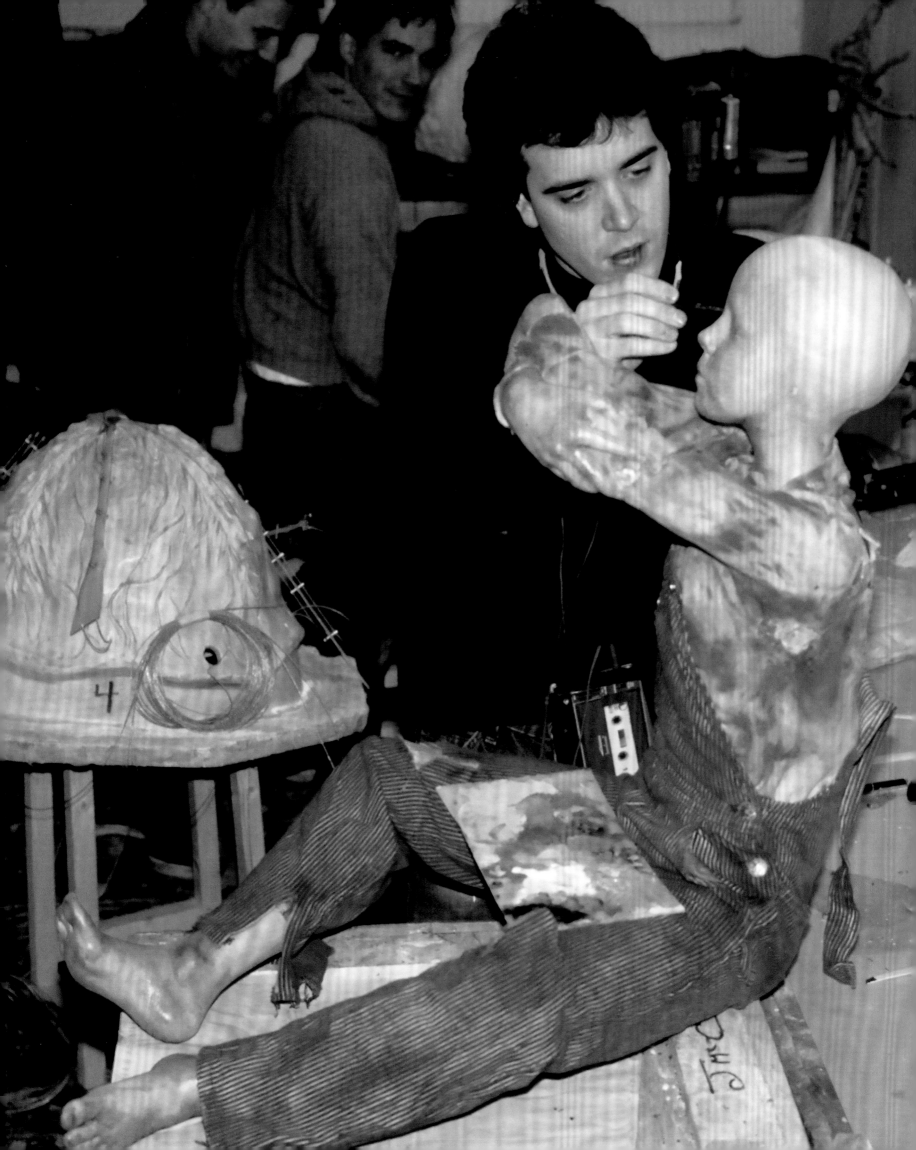

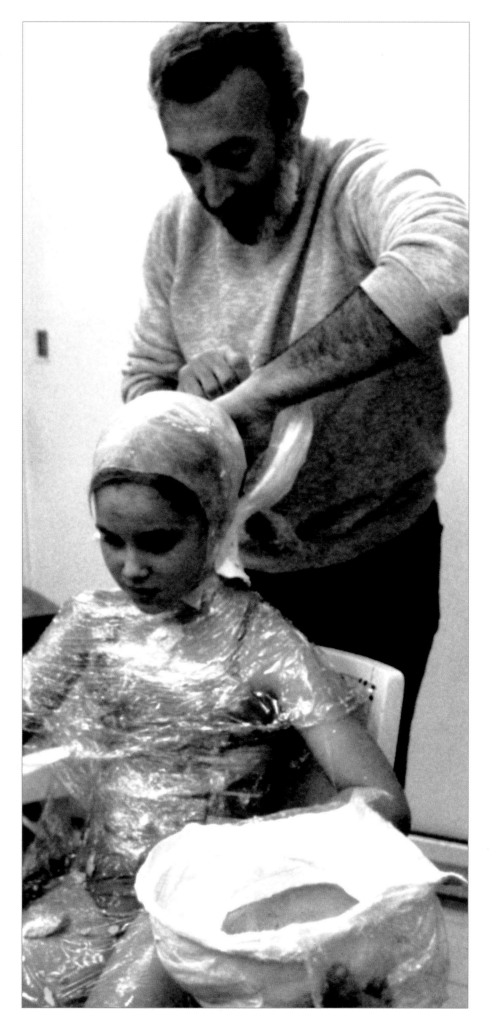

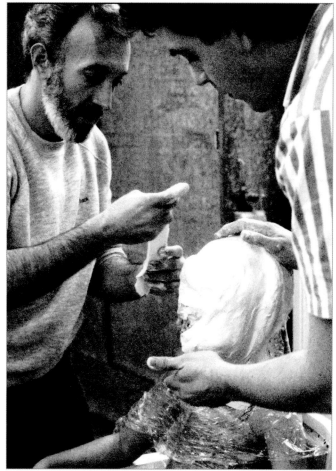

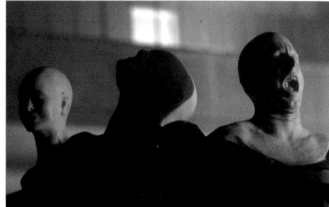

OPPOSITE: Tom Woodruff adds skin tones to the Newt mold. To his right is a mold of an alien egg.

LEFT: CH: "This picture makes me tear up. Stan Winston was a kind, genuine and compassionate man. I feel honored to have had the opportunity to work with him."

TOP: CH: "This mold took a very long time to make. I was very anxious to have my face completely covered—I absolutely hated having to go through it. Stan was so calming during the process, it helped make it easier. They made a mold of my face and one of my body, and made the doll from that. Only when Sigourney is running down the corridors is she carrying the doll. The rest is me."

ABOVE: Various castings of Bishop's reaction after being speared by the queen.

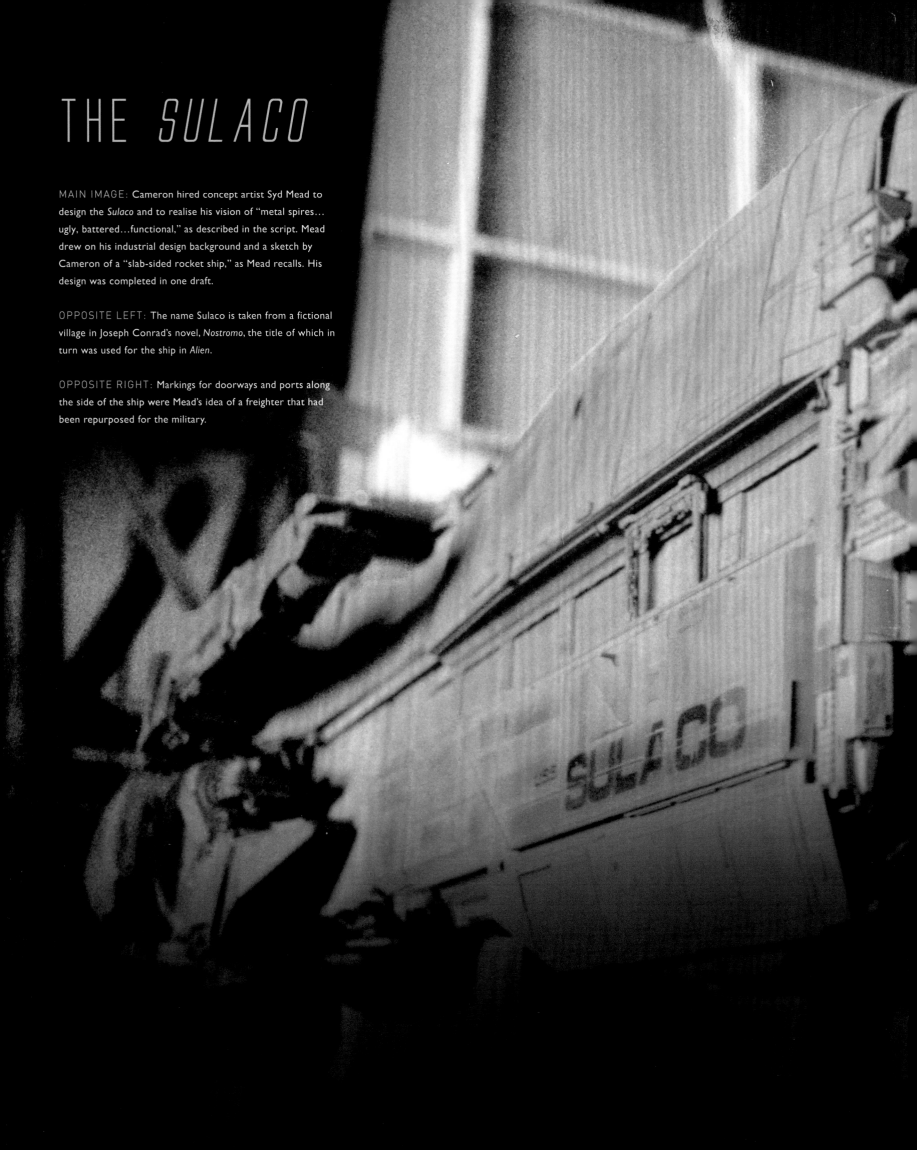

THE *SULACO*

MAIN IMAGE: Cameron hired concept artist Syd Mead to design the *Sulaco* and to realise his vision of "metal spires… ugly, battered…functional," as described in the script. Mead drew on his industrial design background and a sketch by Cameron of a "slab-sided rocket ship," as Mead recalls. His design was completed in one draft.

OPPOSITE LEFT: The name Sulaco is taken from a fictional village in Joseph Conrad's novel, *Nostromo*, the title of which in turn was used for the ship in *Alien*.

OPPOSITE RIGHT: Markings for doorways and ports along the side of the ship were Mead's idea of a freighter that had been repurposed for the military.

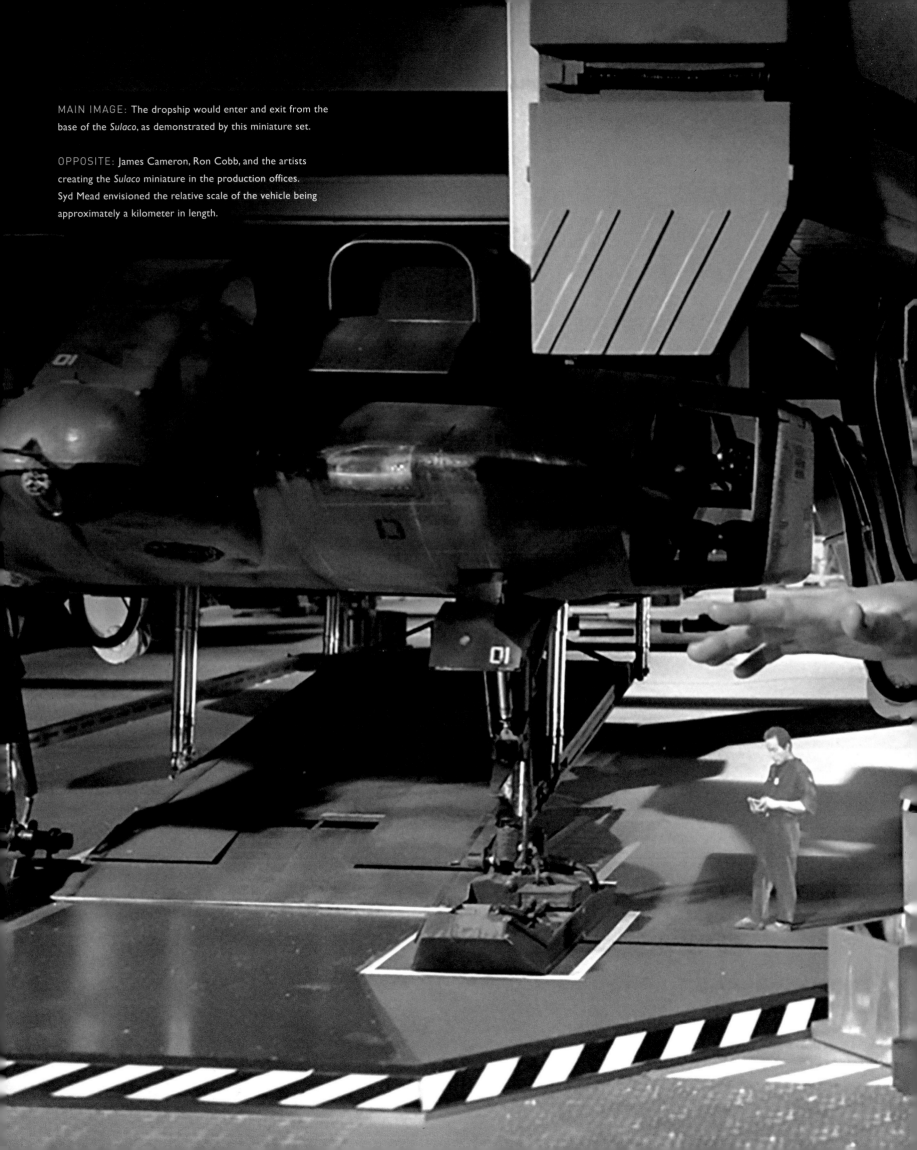

MAIN IMAGE: The dropship would enter and exit from the base of the *Sulaco*, as demonstrated by this miniature set.

OPPOSITE: James Cameron, Ron Cobb, and the artists creating the *Sulaco* miniature in the production offices. Syd Mead envisioned the relative scale of the vehicle being approximately a kilometer in length.

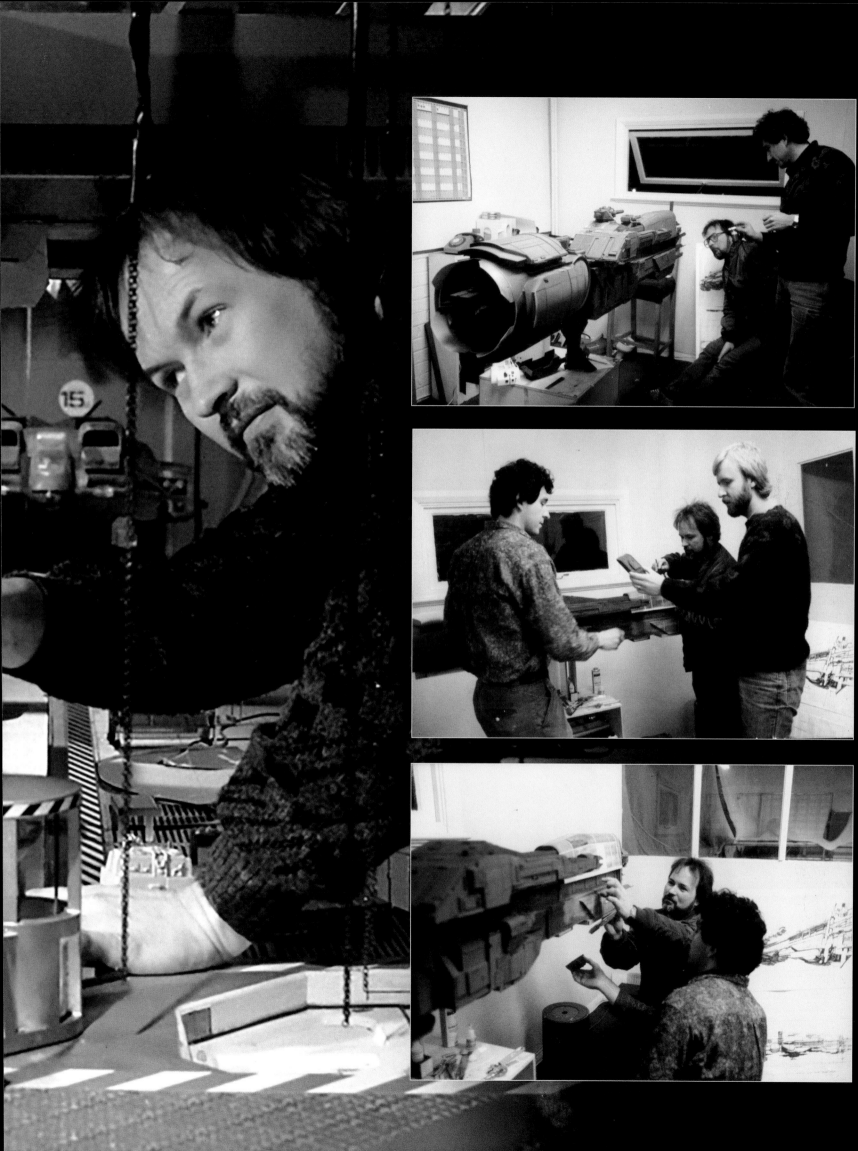

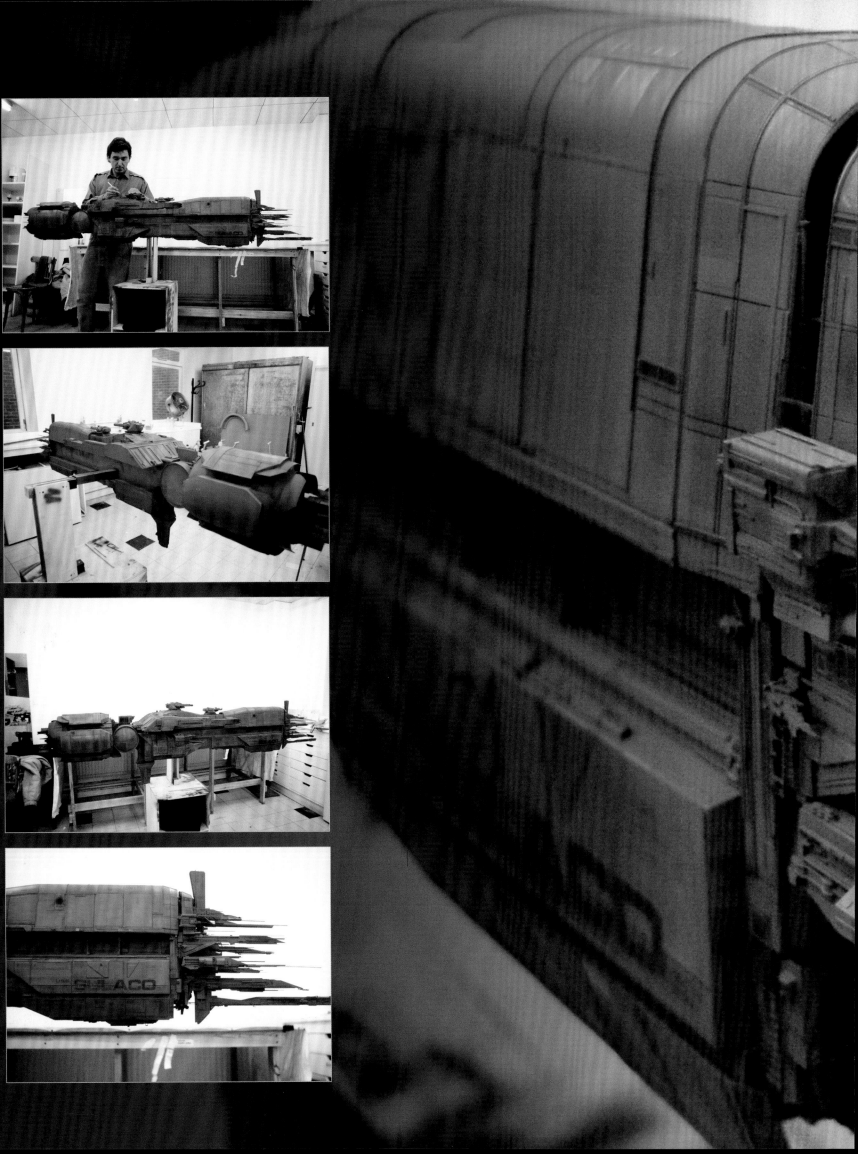

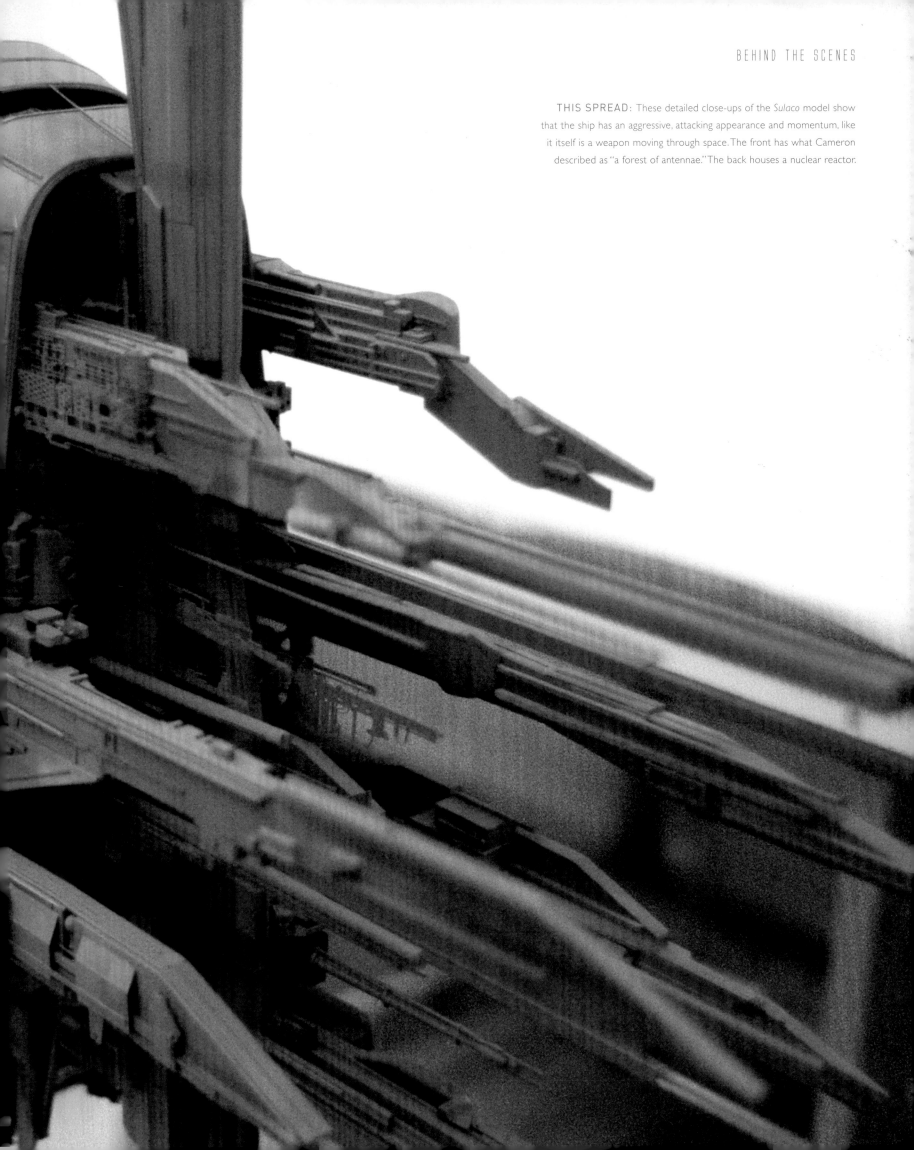

THIS SPREAD: These detailed close-ups of the *Sulaco* model show that the ship has an aggressive, attacking appearance and momentum, like it itself is a weapon moving through space. The front has what Cameron described as "a forest of antennae." The back houses a nuclear reactor.

THE DROPSHIP

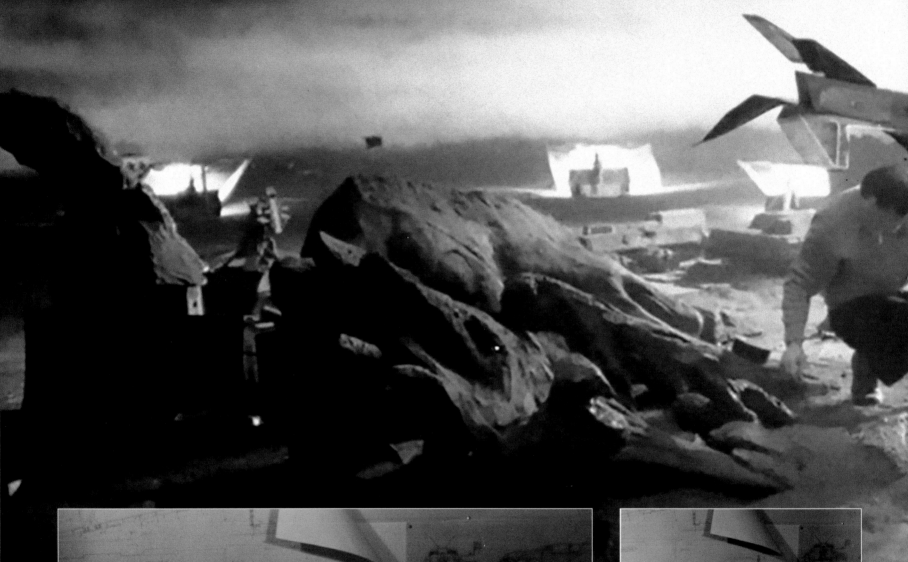

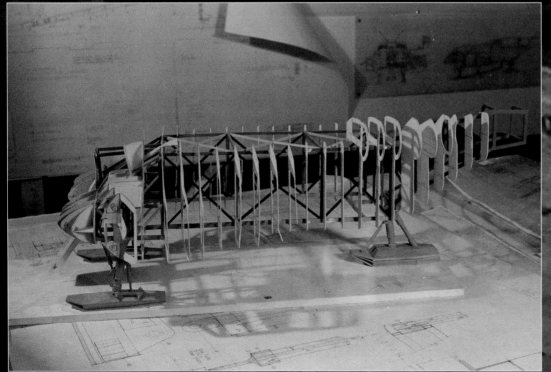

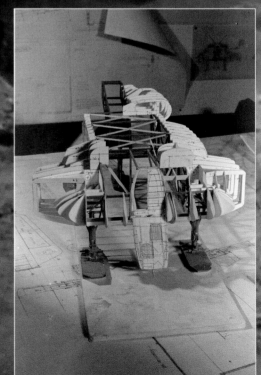

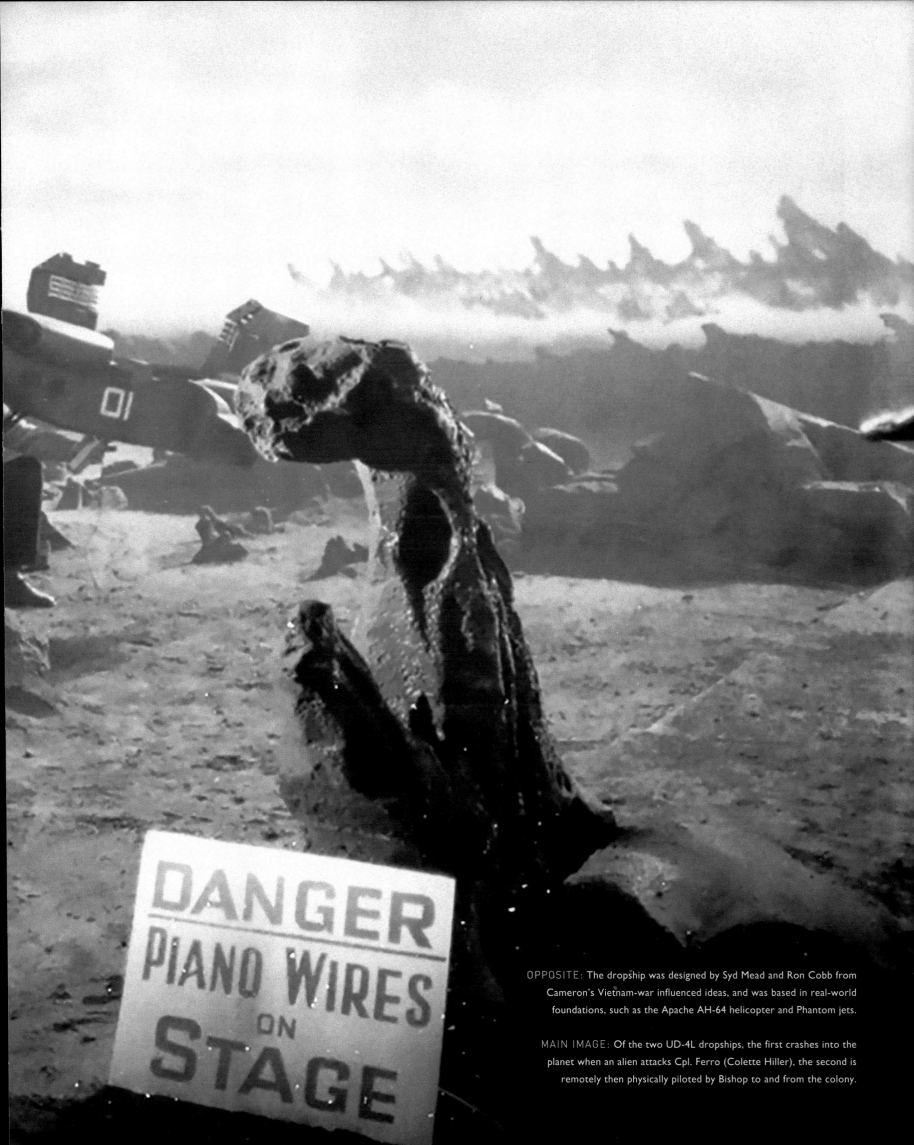

DANGER
PIANO WIRES
ON
STAGE

OPPOSITE: The dropship was designed by Syd Mead and Ron Cobb from Cameron's Vietnam-war influenced ideas, and was based in real-world foundations, such as the Apache AH-64 helicopter and Phantom jets.

MAIN IMAGE: Of the two UD-4L dropships, the first crashes into the planet when an alien attacks Cpl. Ferro (Colette Hiller), the second is remotely then physically piloted by Bishop to and from the colony.

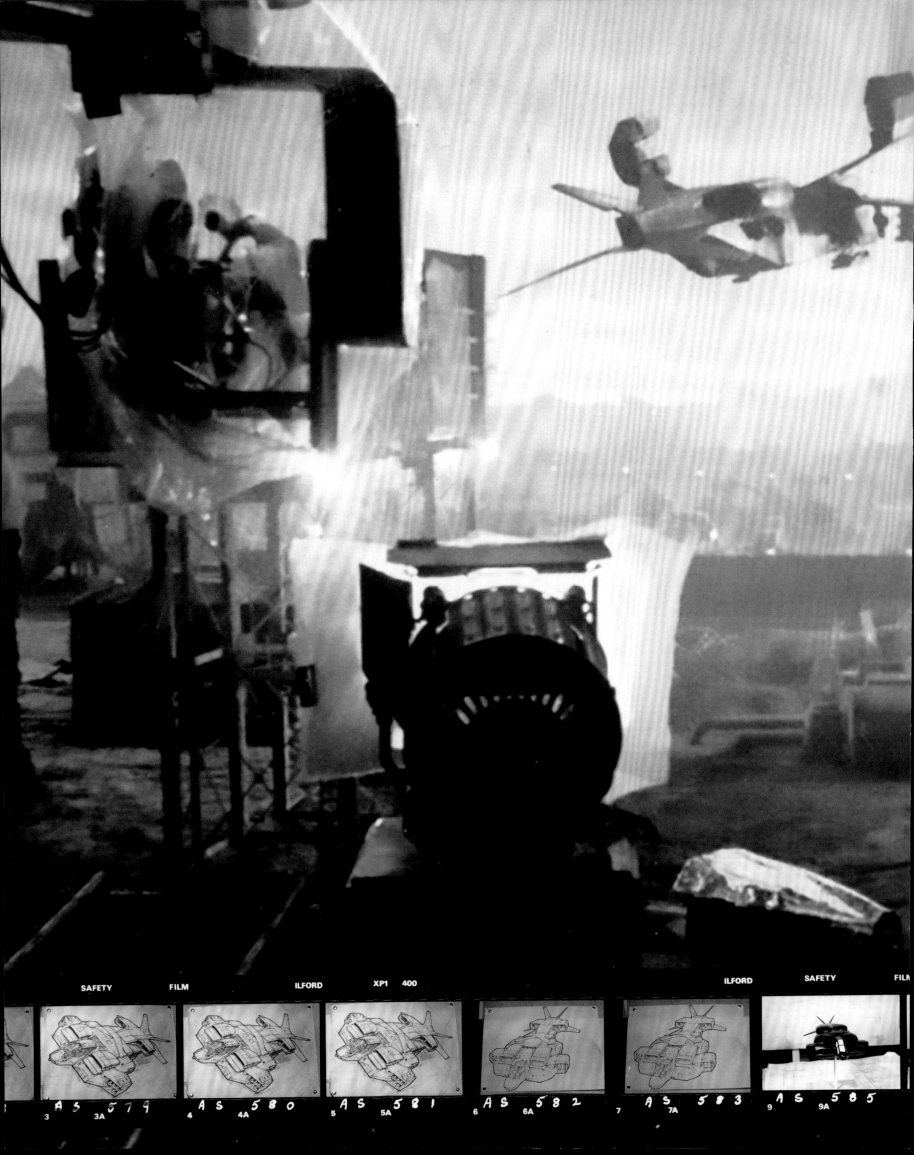

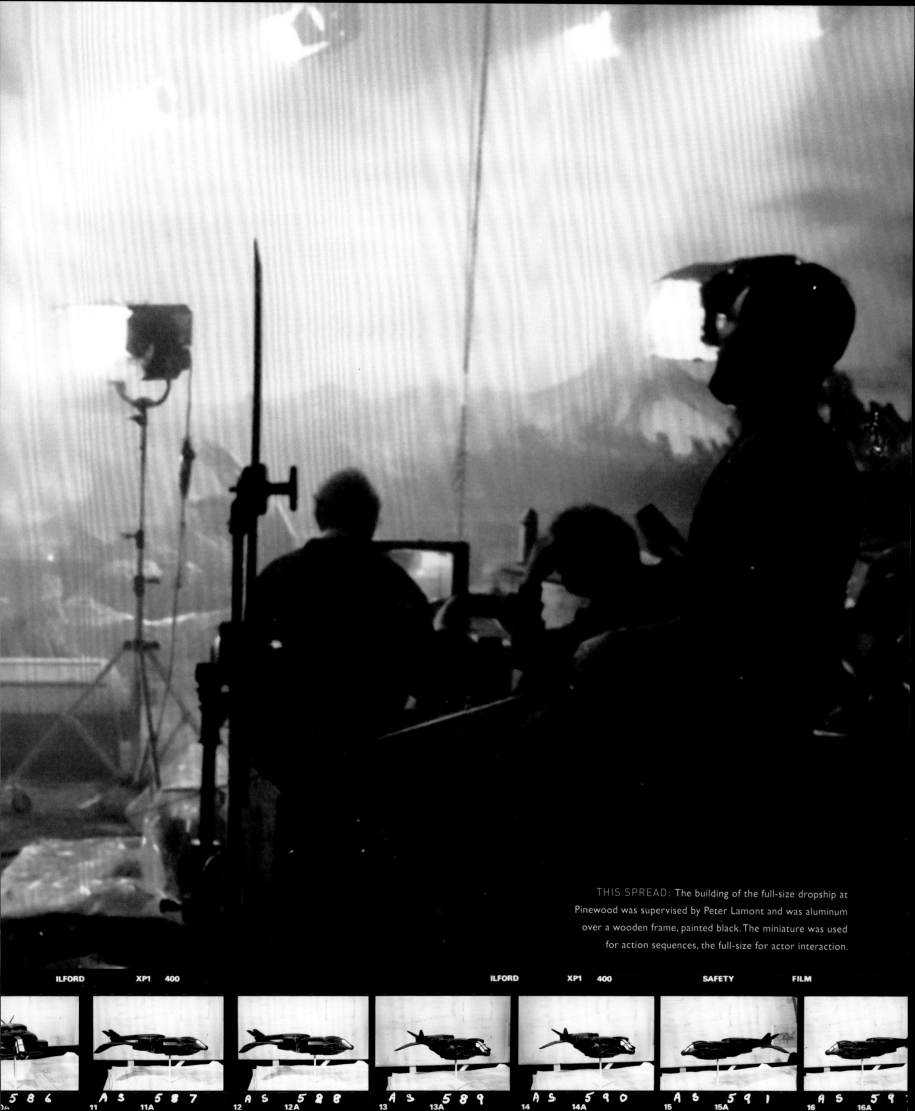

THIS SPREAD: The building of the full-size dropship at
Pinewood was supervised by Peter Lamont and was aluminum
over a wooden frame, painted black. The miniature was used
for action sequences, the full-size for actor interaction.

ILFORD XP1 400 ILFORD XP1 400 SAFETY FILM

THE APC

MAIN IMAGE: The Armored People Carrier (APC) is used to transport the marines on the surface of the planet, functions as a command post and communication post, features rail Gatling guns mounted on the front, a rail cannon atop the center, and is powered by two fusion turbine generators driving four super conductive engines—one in each wheel. The design was worked on by both Mead and Cobb. An old air towing tractor, model ATT77, was used as the base unit. As it was crammed with a massive engine and salvaged aircraft parts, there was no space for any actors inside.

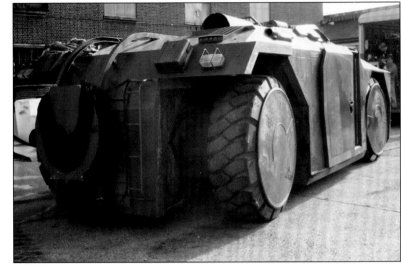

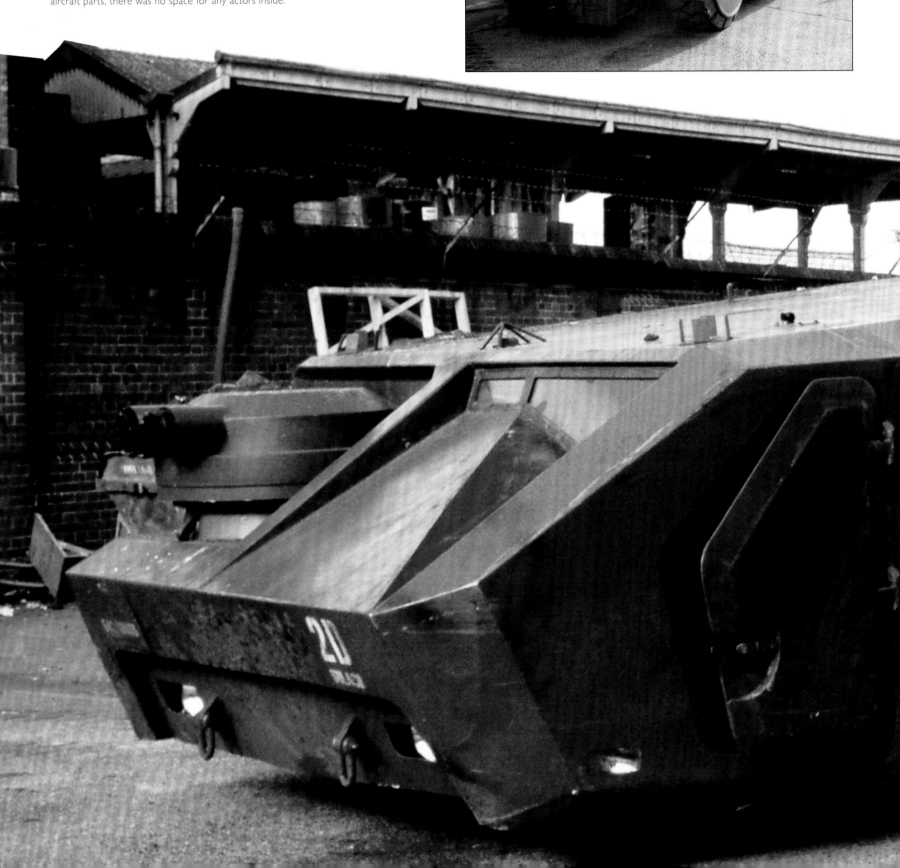

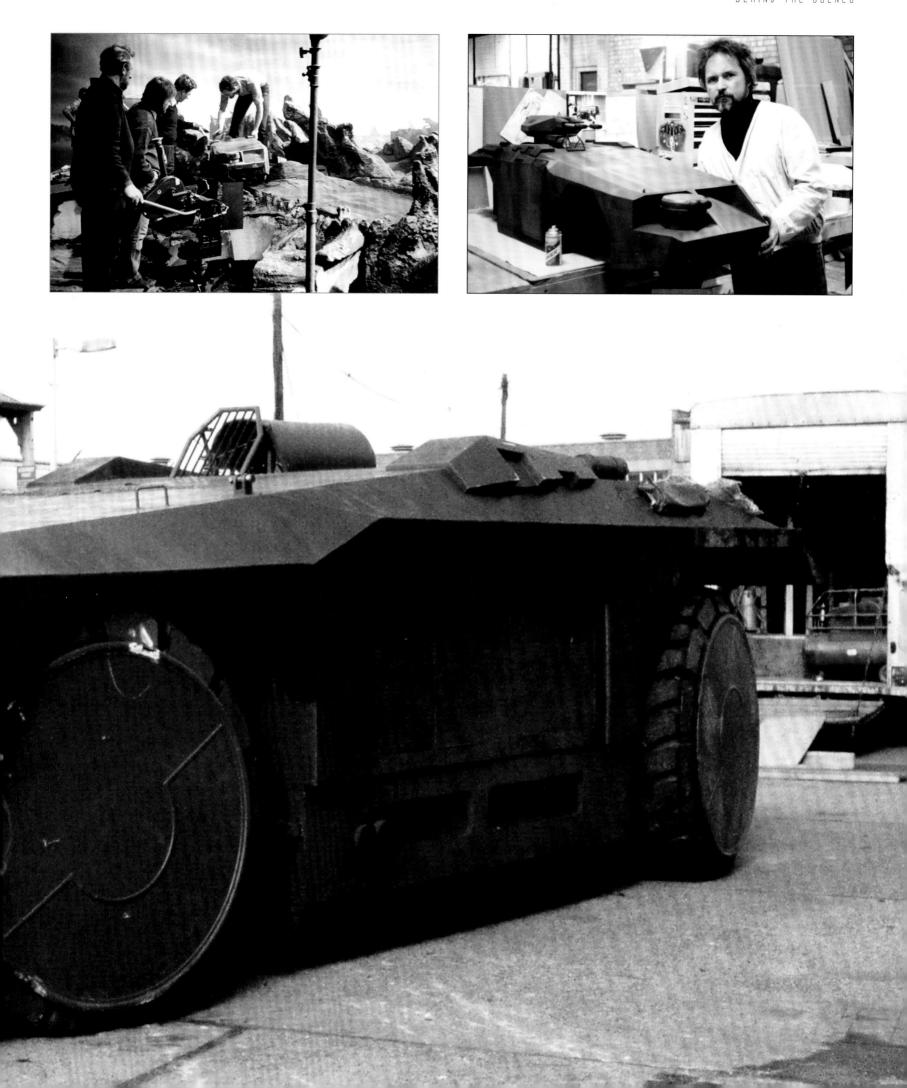

WEAPONS AND EQUIPMENT

THIS SPREAD: The handheld and personal technology in *Aliens* is all rooted in real-world logic and parts. Ripley's flamethrower (**A**) comes from M16 rifles and M203 handguards; the motion tracker (**B**) used by Frost and Hicks, built from various elements including a Kango power drill as the main foundation, a darkroom lamp, and a Vivitar flashgun meter; the helmets (**C** and **E**) are fitted with a video camera to transmit images back to command and infrared sighting, the structure of the helmet inspired by US army standard-issue helmets in World War II, the Korean War, and the Vietnam War. Originally some of the helmet video cameras were meant to be fully functional, filming the actual action in the scene, but this did not come to pass; the targeting system (**D**) has its origins in the helmets of Apache helicopter pilots; the handgun (**F**) is Heckler & Koch VP70 without any additions or adaptations; the smartgun's battery unit (**G**), commandeered from a children's toy gun; the plasma rifle (**H**) features a Thompson submachine gun along with a Remington 870 shotgun and Franchi SPAS-12; LB5A1 rifles (**I**), plus scope, used as background weaponry in the *Sulaco*'s armory; the M56 smartgun (**J**) uses a motorcycle handlebar for the trigger; parts of the smartgun (**K**), made from a Steadicam stabilization system; Hudson's knife (**L**), which he lends to Bishop for his parlor trick—during the display there is no danger of Hudson being hurt due to Bishop's programming preventing him from harming a human.

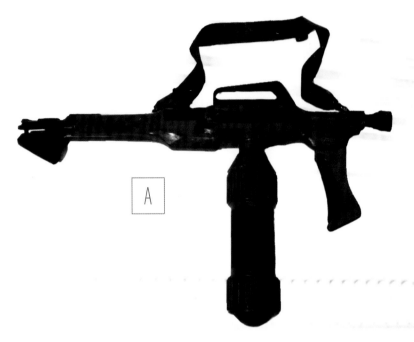

A

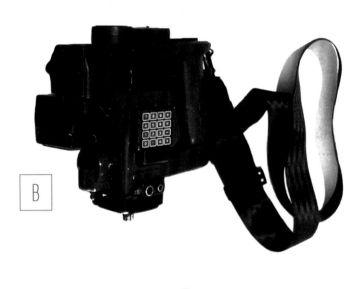

B

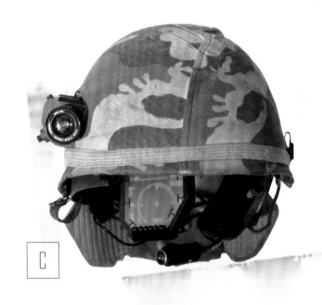

C

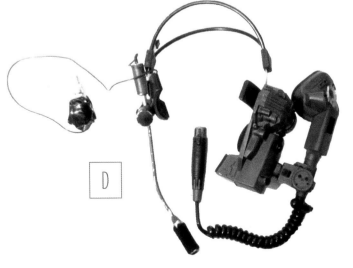

D

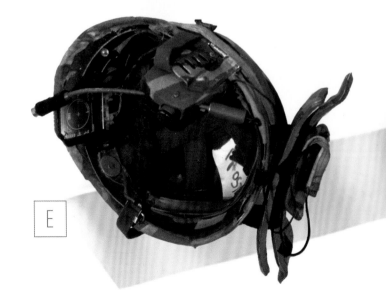

E

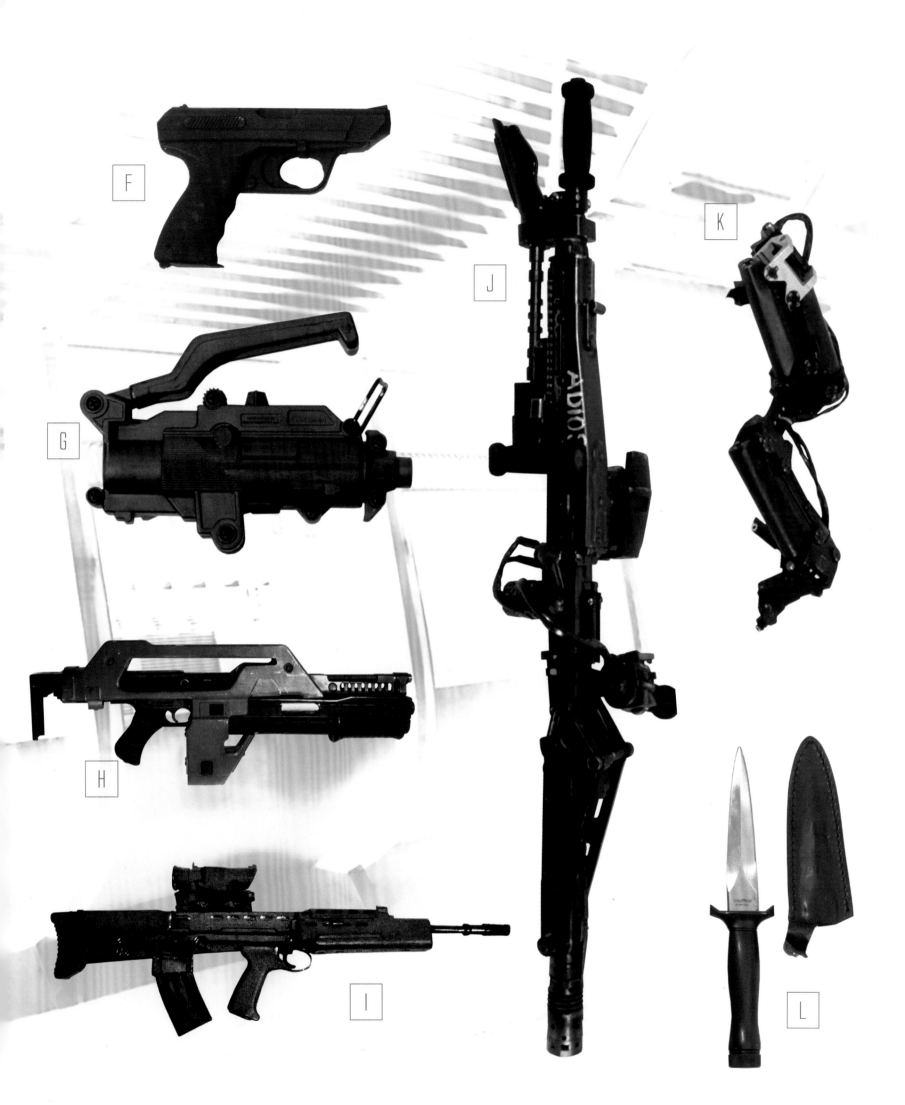

F

G

H

I

J

K

L

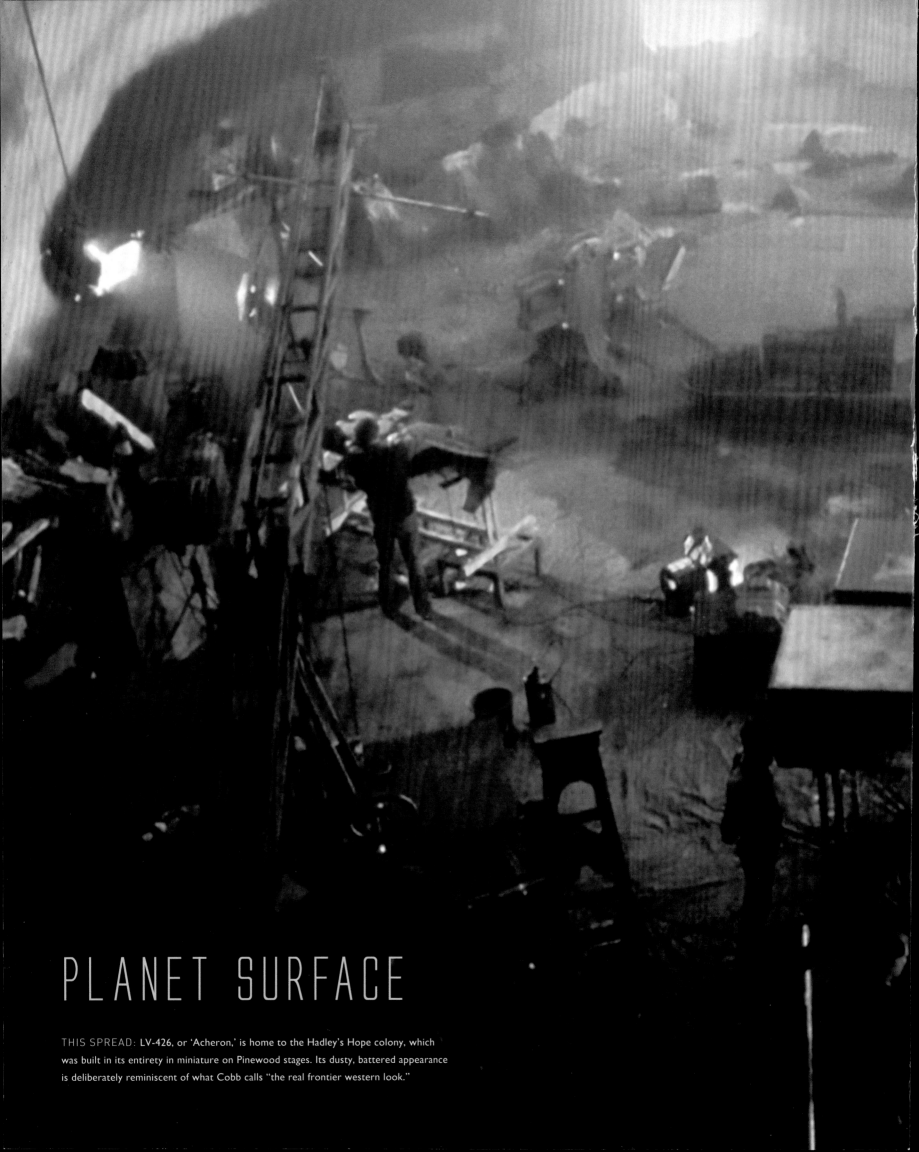

PLANET SURFACE

THIS SPREAD: LV-426, or 'Acheron,' is home to the Hadley's Hope colony, which
was built in its entirety in miniature on Pinewood stages. Its dusty, battered appearance
is deliberately reminiscent of what Cobb calls "the real frontier western look."

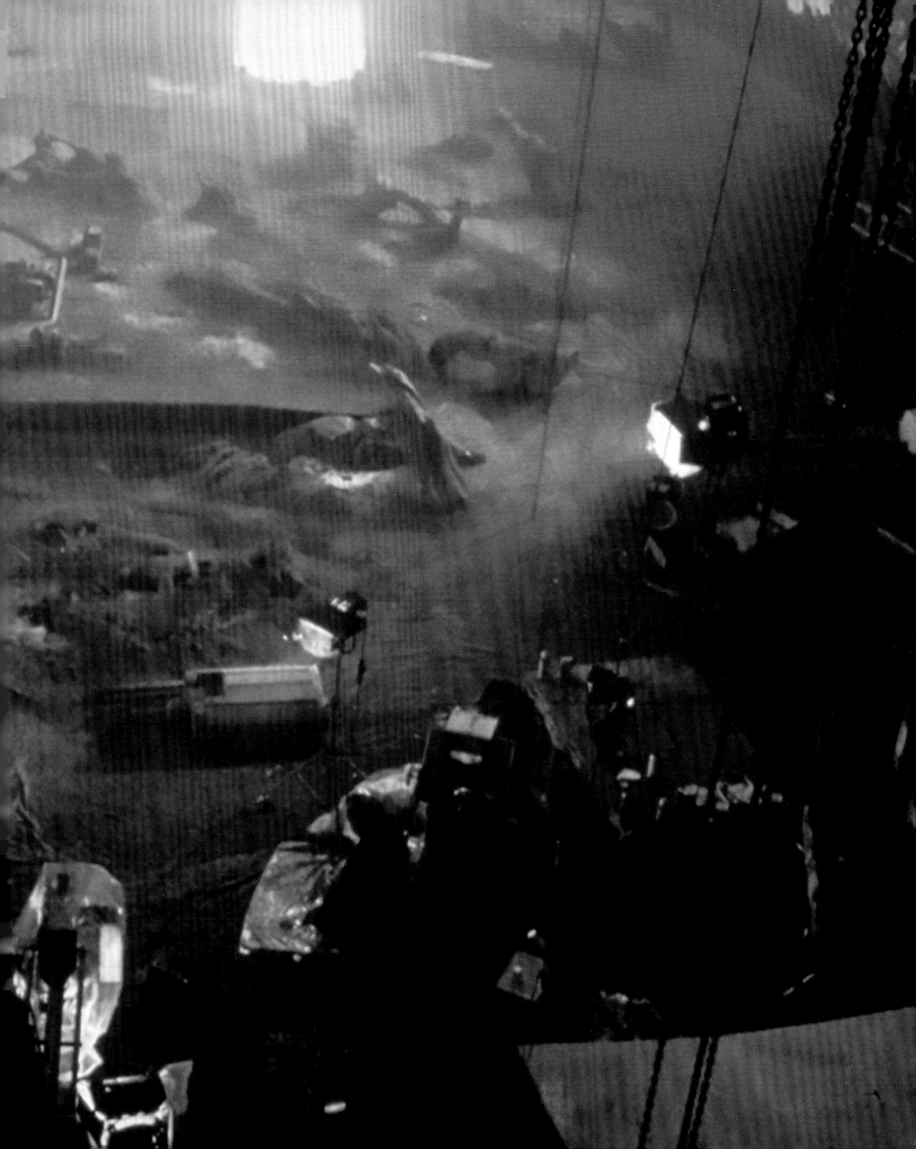

RIGHT, BELOW RIGHT AND OPPOSITE BOTTOM: The look of the Jorden family's tractor is, like all of the vehicles in the film, stripped-back and rugged. As Mead describes it: "No frills and very functional."

FAR RIGHT AND OPPOSITE TOP: Cobb took a more imaginary approach to the colony look rather than an actual, scientifically sound building in a far-flung future outpost. The slanting walls were made so to deflect jet blast. Everything was modular so that it could be "snapped together," he explains.

BELOW: Placing the colony transmitter uplink tower and the dish Bishop realigns to remotely control the second dropship. To patch in manually to the transmitter it is a 180-meter/40-minute crawl from where the survivors have embedded themselves, but Hudson agrees that "Bishop should go. Good idea."

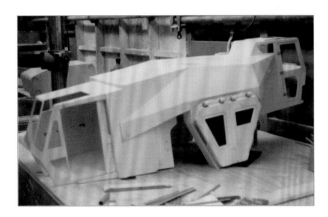

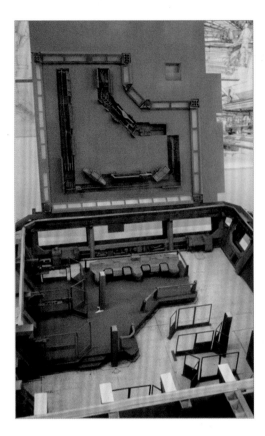

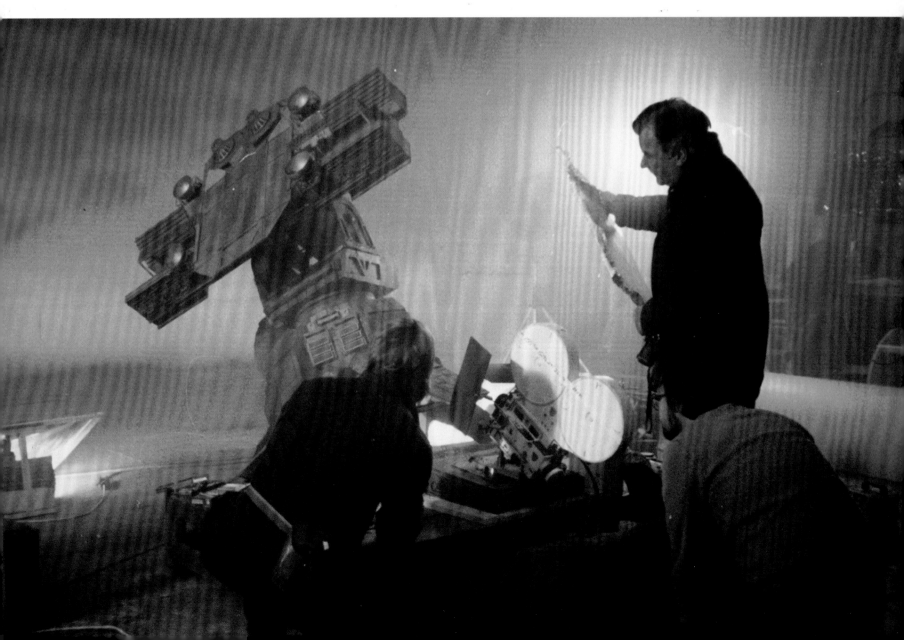

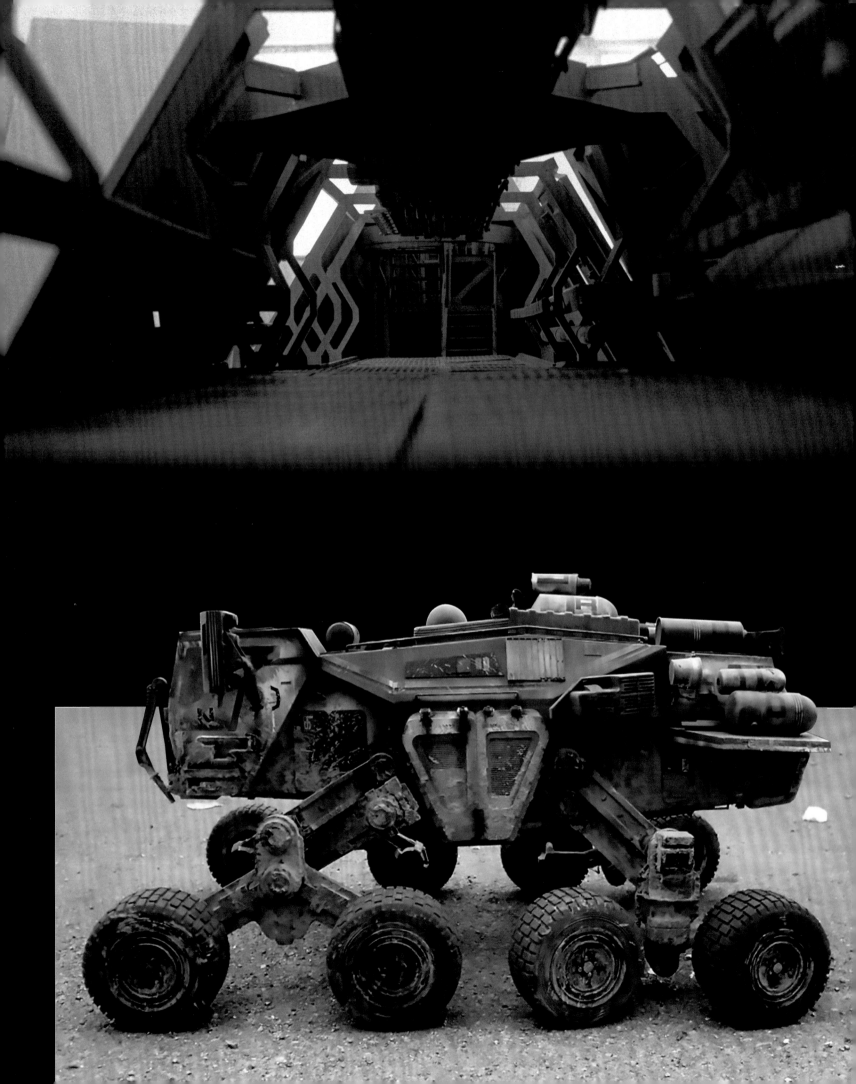

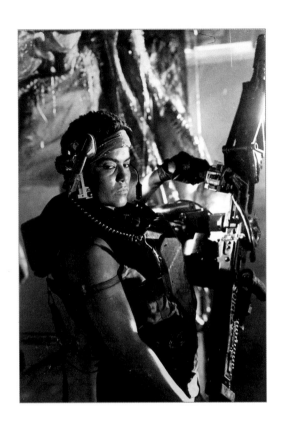

"IT'S A WAR FILM AND IT WAS ALL ABOUT
WORKING-CLASS JOES ON A MISSION AND
I THINK THAT KIND OF GENRE FILM, THE
WAR FILM, TAPS INTO SOMETHING THAT
OBVIOUSLY KEEPS ON GOING AND TAKES THE
IMAGINATION. IT'S PRETTY TIMELESS."

JENETTE GOLDSTEIN ON THE LASTING LEGACY OF *ALIENS*

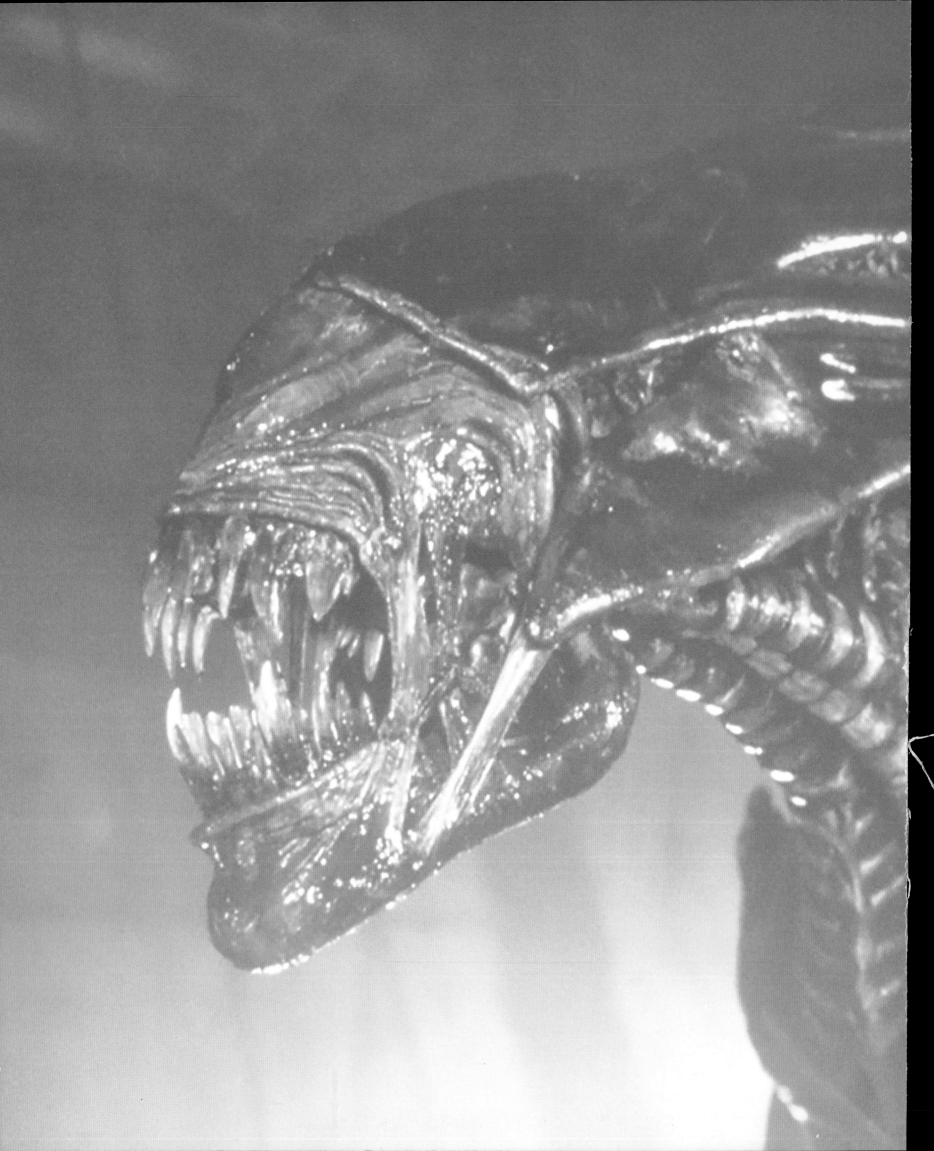